709

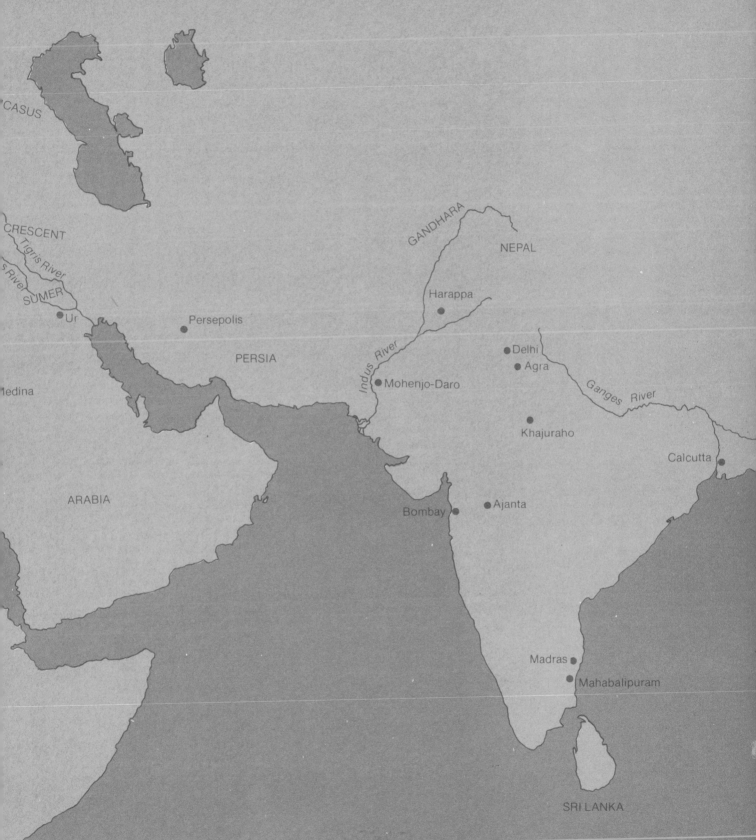

CASUS

CRESCENT

Tigris River

s River

SUMER

Ur

Medina

ARABIA

Persepolis

PERSIA

GANDHARA

NEPAL

Harappa

Indus River

Delhi

Agra

Mohenjo-Daro

Ganges River

Khajuraho

Calcutta

Bombay

Ajanta

Madras

Mahabalipuram

SRI LANKA

Introducing Art

709

INTRODUCING ART

A first book on the history and appreciation of the visual arts

Donald Richardson

John Murray

This book is dedicated to the memory of Rosamund A.V. McCulloch (1905–71) — inspired artist and inspiring teacher of teachers.

John Murray (Publishers) Ltd
50 Albemarle Street
London W1X 4BD

First published 1984 by Longman Cheshire Pty Limited
© 1984 Longman Cheshire Pty Limited

This edition published 1984 by John Murray (Publishers) Ltd

Designed by Vicki Hamilton
Cover design Mark Hammond
Set in 11/12 Plantin (Linotron)
Printed in Hong Kong
by C & C Joint Printing Co., (H.K.) Ltd

British Library Cataloguing in Publication Data

Richardson, Donald
 Introducing art: the first book on the history
 and appreciation of the visual arts.
 1. Art
 I. Title
 700 N7425

ISBN 0-7195-4190-5

Contents

Acknowledgements

The author acknowledges the invaluable assistance of Messrs Lee B. Grafton, D.J. Keyes and N.W. Richardson in the preparation of sections 9–11, 12 and 27 respectively, and of K.A. Sutcliffe, Archaeological Branch, Department of Aboriginal and Islanders Advancement, Queensland Government, for advice on section 4.

The author gratefully acknowledges the following sources and holders of copyright who have generously given their permission for the reproduction of illustrations in this book:

The Accademia, Florence
The Advertiser, Adelaide
Airlines of South Australia
Alte Pinakothek, Munich
The Art Gallery of New South Wales, Sydney
The Art Gallery of South Australia, Adelaide
Association Pour la Diffusion des Arts Graphiques et Plastiques
Australian Information Service
The Australian Museum, Sydney
The Australian National Gallery, Canberra
The Australian War Memorial, Canberra
Ballarat Fine Art Gallery
Mr W.P. Balson
Bendigo Art Gallery
The British Museum, London
Castlemaine Art Gallery and Historical Museum
The City of Hamilton Art Gallery
The City of Mildura Arts Centre
The Cleveland Museum of Art
The Courtauld Institute, University of London
Mr Noel Counihan
The Department of the Premier and Cabinet, Adelaide
Ms Margaret Dodd
Mr E.S.B. Elcome
Fondation Maeght
Fondation Vasarely
The Freer Gallery, Smithsonian Institution, Washington
Gemeentemuseum 's-Gravenhage, The Hague
Robin Gibson Gallery
The Glyptothek, Munich
Rudy Komon Gallery
Göteborgs Konstmuseum, Gothenburg
The Robert Hardy Picture Library
The *Herald and Weekly Times*, Melbourne
The High Commissioner for Pakistan
Kröller-Müller Stichting, The Netherlands
The Lenhaus, Munich
Mrs Yulla Lipchitz
Musée Fabre, Montpellier
Mr Grant Mudford
Musée Rodin, Paris

The Museum of Applied Arts and Sciences, Sydney
The Museum of Fine Art, Boston
The Museum of Modern Art, New York
The Museum of the Duomo, Florence
Nasjonalgalleriet, Oslo
The National Gallery, London
The National Gallery of Victoria, Melbourne
The National Institute of Anthropology and History, Mexico City
The National Library of Australia, Canberra
The National Museum, Delhi
The National Trust
Oslo Kommunes Kunstsamlinger, Munch-Museet
Mr Brian Peake
The Peter Stuyvesant Trust
Mr and Mrs G.C. Phillips
The Queensland Art Gallery, Brisbane
Mr Lloyd Rees
Réunion des Musées Nationaux, Paris
Rijksmuseum-Stichting, Amsterdam
Sandak Inc., New York
Mr Robert Smith
Royle Publications Ltd, London
Societé Anonyme, Yale
Societé de la Propriété Artistique et des Dessins et Modèles, Paris (SPADEM)
The South Australian Jubilee 150 Committee, Adelaide
The South Australian Museum, Adelaide
Statens Museum for Kunst, Copenhagen
Stedelijkmuseum, Amsterdam
The Tasmanian Museum and Art Gallery
The Uffizi, Florence
The Vatican Museum, Rome
The Villa Borghese, Rome
The Villa Giulia, Rome
United States of America Information Service
The University of Sydney
The Victoria and Albert Museum, London
Ms Ellen Waugh
Mr Lyndon Whaite
Mr A.M. Wight
Ms Lyn Williams

How to use this book

Introducing Art has been written at three levels of difficulty simultaneously.

Students who only wish to look at the illustrations and read their captions should receive a basic, yet comprehensive, insight into the subject. Those who wish to go into more detail should study the complete text in addition. Those who wish to study still further should complete the *Things to do* at the end of each section also.

New terms are italicised the first time they appear in the text, where they are defined or explained. The index also gives the approximate pronunciations of foreign and unusual words and names which are not rendered by the English spelling.

. . . skill, especially human skill . . .
Concise Oxford Dictionary (1950)

Then shall we set down the artists . . . as mimics of a copy of . . . virtue, or of whatever else they represent, who never get in touch with the truth?
Plato (lived 428–348 BC)

Only the poet . . . doth grow in effect another Nature, in making things either better than Nature bringeth forth, or . . . such as never were in Nature . . .
Sir Philip Sidney (1595)

Poetry . . . takes its origin from emotion recollected in tranquillity.
William Wordsworth (1815)

A work of art is a corner of nature seen through a temperament.
Emile Zola (late 19th century)

The artist's work is the ordering of what in most minds is disordered.
I.A. Richards (1924)

The artist is the creator of beautiful things.
Oscar Wilde (1891)

Art is most simply and most usually defined as an attempt to create pleasing forms.
Sir Herbert Read (1931)

People will come to understand the meaning of art only when they cease to consider that the aim of that activity is beauty
Leo Tolstoy (1896)

A work of art is an expressive form created for our perception through sense or imagination, and what it expresses is human feeling.
Suzanne K. Langer (1957)

. . . art is vision or intuition.
Benedetto Croce (1913)

What turns something from a piece of nature into a work of art is magic.
David Hockney (1980)

Art is the expression of the highest level of a cultural epoch.
Laszlo Moholy-Nagy (1938)

. . . a man-made object demanding to be experienced aesthetically.
Irwin Panofsky (1955)

. . . art is something we do intentionally . . . things humans make or do.
Richard Wollheim (1972)

Art is anything you can get away with.
Marshall McLuhan (1967)

If it sells, it's art.
A director of Marlborough Fine Art Ltd (1950s)

1 What is art?

As the statements on the page opposite show, many great people over the ages have attempted to define art. Although each of these statements makes a good point, none is quite adequate in itself — and some of them conflict.

Certainly human skill is involved in making art (Concise Oxford Dictionary), but so too are imagination (Langer), vision and intuition (Croce), and even the 'magic' referred to by Hockney. Plato was right to say that copying nature is part of it, but, as Sir Philip Sidney said, an artist's work improves upon nature. This is done by placing nature in a certain kind of order (Richards) so that the work is not a mere copy of nature but a beautiful thing in itself (Wilde), a pleasing form (Read). See **1.1** and **1.17** for examples of this kind of art.

But this describes only part of art. Art is also about expressing human feeling (Langer) and temperament (Zola), recalling emotion in tranquillity (Wordsworth). Some of our feelings and emotions are about things which are not beautiful (Tolstoy); the Goya picture (**1.2**) is an example of this kind of art.

The artist often creates things such as never were in nature (Sir Philip Sidney again). You will find examples of this in sections 24 and 26.

The last two statements in the list reflect the cynicism felt by those who are confused by the many abstract styles of the art of this century, and also the fact that twentieth century artists depend upon selling their work in commercial art galleries — two things that rarely happened in other cultures and at other times.

Finally, Wollheim and Panofsky remind us that *only humans make art*. This may seem too obvious to say, but it is, in fact, a good place to start our study: art is not so much things (pictures, plays, symphonies) as the *ideas and values* of the artists who made the things.

Birds create nests and spiders make wonderful patterns of web, but we do not call this art because these animals have no choice but to make those things: they do not express ideas or values. Only humans can do this — **only humans can make art**.

The range of visual arts

Let us now concentrate on a range of things which people have considered to be art over the ages and try to see what is valuable about them.

There is something of the creativeness of the artist in each one of us, but the people we call *artists* have special gifts of perception, thought, imagination and skill which enable them to create new and original things of high quality. An artist creates something in the hope that it will cause in us (the spectators or consumers of art) a pleasurable feeling so that we will call it beautiful; or else to express ideas which stimulate our own perception, thought, feelings, or imagination. A work of art, then, can be either *beautiful* or *expressive*, or both at once.

1.1 Aristide Maillol, *The River*, 1938–43. Over life-size. A sculpture in the round which was first made in clay and then cast in lead. Maillol made a number of casts of this beautiful figure. This one is in the Museum of Modern Art, New York. (Reproduced in colour on front cover)

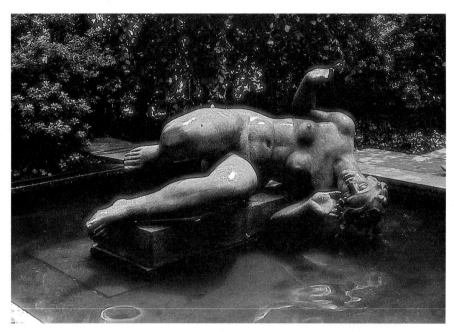

1.2 Francisco Goya, *'There isn't time now'*, from *The Disasters of War*, 1810–13. Print (etching and aquatint) All the pictures in the *Disasters of War* series are of unpleasant or frightening subjects. Can we call a picture of so brutal a subject as murder and rape 'beautiful'? The Art Gallery of South Australia

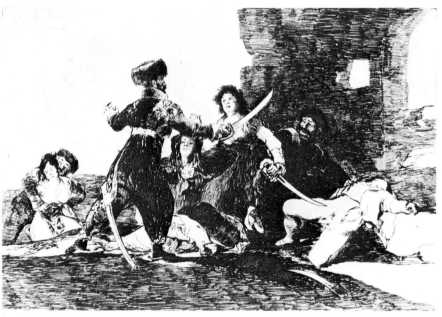

Many people would admire Maillol's sculpture *The River* (**1.1**) for its beauty, whereas Goya's scene from *The Disasters of War* (**1.2**), which expresses a range of human emotions, could hardly be called beautiful. Michelangelo's *Bound Slave* (**1.3**), on the other hand, is usually considered to be both beautiful and expressive.

Of course, art really includes music, literature, the theatre, photography and film, and television. In this book, however, we use the term only to mean the visual arts — *architecture* (the art of building; see **1.4**), the *designing* of things of use which are to be produced by craftsmen or in a factory, *sculpture* (the art of making statues), and the art of making *pictures* (by drawing, painting, collage, or printing).

Art, then, is not just the painting of pictures, as many mistakenly believe.

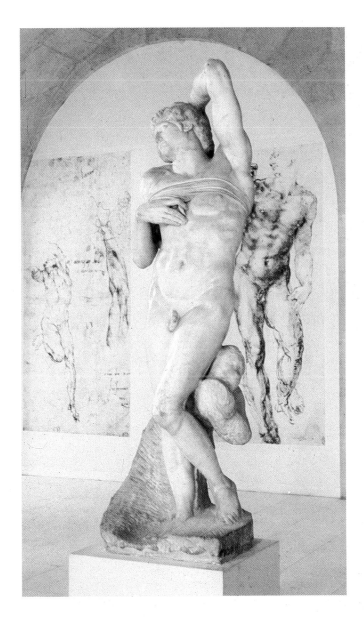

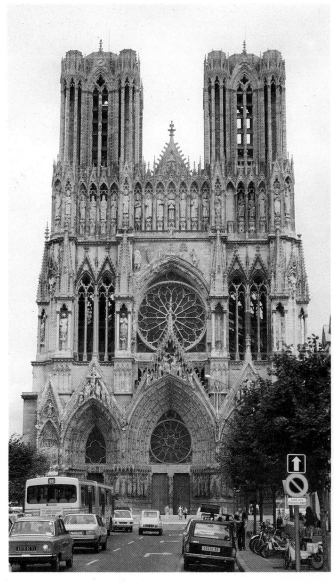

Fine art and applied art (or design)

Pictures and sculpture are the *fine arts*. The designing and making of buildings and machines, utensils such as pottery, clothing and jewellery, advertisements and packaging, books and stationery, furniture and furnishings is *applied art* or *design*. An applied artist (or designer) has to make things that are not only beautiful or expressive, but *useful* as well (**1.9, 1.20**).

1.3 (left) Michelangelo, *Bound Slave*, c. 1513. Marble. A sculpture in the round which was made by carving a block of stone. Michelangelo used the nude figure to express human emotions and hopes. Louvre, Paris

1.4 (right) Notre Dame, Rheims. A Gothic cathedral, built on the arch principle progresively throughout most of the thirteenth century.

FINE ARTS

beauty . . . expression . . . usefulness

APPLIED ARTS (DESIGN)

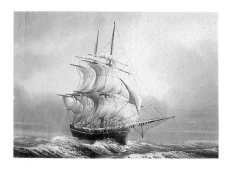

1.5 Painting as a craft. Although painted by hand and using the traditional fine-art materials of oil paint and canvas, because this picture is one of many identical to it, it has to be called a work of craft, rather than a work of art.

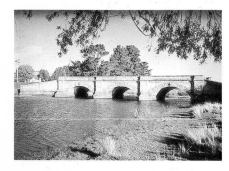

1.6 Bridge over the Macquarie River, Ross, Tasmania. Stone. Designed by John Lee Archer in 1836. Daniel Herbert carved the decorations.

Craft

We expect artists and designers to be continually producing new and original ideas. It is immaterial whether these ideas are expressed in oil paint, marble, lead, clay, or paper and string — it is the quality and originality of the idea that counts. Look at the picture of a sailing ship (1.5). It has been painted by hand, using oil paint on canvas — materials used by artists for centuries. Yet it came from a shop which had a dozen or more just like it, all painted by hand in oils on canvas. These pictures show a degree of hackneyed skill; but we cannot call them art because they are simply representations of an outmoded nostalgia and lack original ideas. They were produced in much the same way that cups and saucers are produced, and we must call both these pictures and the cups and saucers craft. It is the originality of the ideas, not the material, that decides whether a work is art or craft. Look, for example, at Margaret Dodd's *Holden Bride* (27.65). It is a pottery sculpture, made of the same material as cups and saucers, yet because it expresses original ideas it is art, whereas the sailing ship picture is craft. It helps us to understand our subject if we can really recognize that the things people make can be classified into works of art, design or craft.

Craftsmanship — the skill the Concise Oxford Dictionary talks about — is a skill needed by artists just as much as by craftspersons and designers.

What good is art?

Very few people ever earn their living from art; in this sense, therefore, it seems to be of very little use to most of us. But you will find that the more you know about art the more meaning life will have for you. Great buildings and fine pictures can give a feeling of enrichment and uplift, and it is in this sense that art can be of very real use to us all. Works of art are the product of ideas about the world and about life, and contemplation of them can help us to a fuller understanding of human life (1.16).

What is good art?

Some people judge a picture or sculpture according to whether it is *naturalistic* (i.e. true to nature) or not. This on its own is not a very good yardstick. Have you ever seen a naturalistic building or heard a naturalistic song? The only really sound way to judge any work of art is according to its *aesthetic value*. Briefly, this means: does it achieve any of those aims which artists have when they create works of art? When studying any work of art, ask yourself these questions:
- Is it beautiful?
- Is it expressive?
- Is it useful?
- or — Is it any of these in combination?

The time it took to make an article, or the value or quantity of the material used, have no bearing on its aesthetic value. An ugly sculpture made of solid gold has less aesthetic value than a piece of coloured paper or canvas that a Turner has produced (1.18). What counts is the sensitivity, imagination, training, and skill of the artist. The nineteenth century painter Whistler, when asked how he could have the audacity to ask 200 guineas for a picture that had taken only a few hours to paint, replied, 'I ask it for the experience of a lifetime.'

Similarly, the *subject*, or *literary content*, of a work has little bearing on its aesthetic value. Chardin's paintings of pieces of meat and cooking

pots (**1.17**), and Goya's pictures of atrocities (**1.2**) have more aesthetic value than many prettily painted pictures of beautiful humans or handsome animals because the pictures themselves, rather than their subject matter, are very beautiful or very expressive.

Remember, art is made only by humans. Nature is not art, although of course we do judge nature aesthetically. Who has never found the shape or colour of a leaf beautiful, or felt threatened by a thundercloud?

A bridge, a popular song, or a press-stud are all human creations and therefore we can and should judge them aesthetically (**1.6**). Many architects, engineers, industrial designers and photographers would never admit to being artists, but this does not prevent us from judging the aesthetic value of their products. How often do we decide that they have none? Think of this scale of aesthetic values the next time you look along a street or around your classroom:

very ugly	very beautiful
	Dimension of beauty

frivolous, weak	profound, moving
	Dimension of expression

inconvenient to use	convenient to use
	Dimension of usefulness

1.7 Scale of aesthetic values

What makes good art?

Usefulness

It is usually easy to see whether a work of applied art is useful or not. Anything is useful if it performs well the function for which it was designed. If a kitchen is convenient to work in, we say it is *functional*, and this is good art or design. Works of fine art are useful in indirect ways. They contribute to our personal development and well-being.

Often fine artists make innovations in taste or design which influence changes in the style of the applied arts. Our furniture and automobiles would not be the shapes they are if it were not for the influence of fine artists, such as the Cubists of 1910–30, on contemporary designers (**1.19, 1.20**).

Expression

In speech we can give a number of different expressions to a word like 'Hallo'. Artists do something like this with their subjects and materials. Portrait painters emphasise the features that best express their subject's character and can show whether they admire their subject by their use of colour and other means (**1.16**). These are things which an artist can do, but even the most expensive camera cannot — unless, of course, an artist is using the camera (**1.8**).

If you have seen a teapot made to look like a beehive, a bowl in the form of a lettuce-leaf, or a service station like an Elizabethan house, you will easily recognise that they fail to express their function — aesthetically they are shams and frauds. On the other hand, a well designed modern car can express well its ability to move swiftly and efficiently.

1.8 Grant Mudford (Australian, b 1944), *El Paso, 1976.* Photograph. By carefully manipulating exposure, printing and paper, and by waiting patiently for the right lighting conditions, Mudford creates photographs which are much more than snap-shots. The Art Gallery of South Australia

1.9 Ceramic cooking pot, c. 10 cm diameter. From the Sepik River area of Niugini. A functional object, but the decoration is an actual part — not just added on afterwards. Australian Museum, Sydney

Beauty

What makes a work of art beautiful is often a very complex matter, however. We have to take into account what we call the *composition* or *form* of the work.

Form is the *relation* of one part of a thing to its other parts. When a Turner paints a landscape, for example, he rarely just copies down what he sees before him. He rearranges the various parts of his subject to make a balanced and harmonious picture, and it is this relation of the parts that governs whether a picture is beautiful or not (**1.18**).

It may help you to remember that 'form' means 'relation' if you think of the ways we use the word in ordinary speech. We say it is 'good form' for a man to give up his seat for a woman, and here we are speaking of the relation between people. And we speak of the 'form' of an athlete, by which we mean physical condition, the harmony of the body. Just as we admire people whose physical proportions are harmonious, so we admire works of art that have harmonious proportions. The word 'composition' is often used in literature and music, too, in the same sense as we are using it here (see **1.19**).

The form of a work of visual art consists of the relation of all the shapes, colours and textures in the work to each other. If they are arranged so that the work is *balanced* and *harmonious*, this is another way of saying the work has formal beauty or good form.

Applied art does not mean art (in the sense of something beautiful or decorative) applied (in the sense of stuck on) to something useful. In a well designed article, both function and decoration will have been considered by the artist from the beginning (**1.9**).

All this leaves a good deal of opportunity for personal interpretation and evaluation, and people's opinions of works of art often differ radically. This is not necessarily bad — indeed one of the most valuable features of art is that it is something about which people can and should make up their own minds. The facts about art are relatively simple, and those who are used to studying and comparing works of art largely agree upon certain standards of quality. These standards often are, as you would expect, different from those of less experienced people. It is certain that your own taste will change from time to time — indeed this has happened to art itself over the ages: the criteria by which the Middle Ages judged aesthetic value are quite different from those of the Renaissance. But you will learn to make wise judgements only if you listen to and read the opinions of those more experienced in the arts and, above all, study works of art for yourself. Never reject an acknowledged work of art out of hand. If its value escapes you just now, come back to it again later on. You may then find values in it which you didn't suspect before.

Representational and non-representational art

Representational artists treat their subject matter realistically or naturalistically (**1.10**, **1.11**). However, some artists value formal beauty or expression so highly that they either suppress subject matter or do without it entirely (**1.19**). *Abstract* artists represent only a summary of the essential features of their subjects, but the subject can usually still be discerned (see **24.27–24.31**). A less absolute form of this approach is called *stylisation*, *formalisation* or *conventionalisation* (see **7.3**, **7.12**, **7.13**).

Non-representational (sometimes called *non-figurative*) artists ignore subject matter completely and synthesise their work from the basic ele-

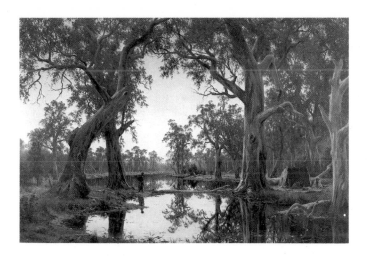

ments of colours, shapes and textures (**1.19**). Architects and musicians, of course, have always worked in this way and it helps to understand abstract or non-representational visual art if you consider it as if it were music. When you admire a piece of music, is it because of *what* it sounds like (what it 'represents') or because of *how* it sounds? The same applies with abstract art and non-representational art — how it looks is more important than what it looks like.

By now you will have realised that the way an artist works is nothing like the way a camera works. Most painters and sculptors throughout history have changed the natural appearances of their subjects for the sake of beauty or expression, or both. They are creators, not copiers. If you think an accurate portrayal of nature should be the only aim of an artist, consider this: have you never seen a photograph of yourself that did not look like you? A camera takes a very naturalistic impression of how you look at one fleeting instant only, but an artist can take into account the lasting things about a model. We all know someone who has a pleasant character but a less pleasant appearance. A camera can catch only appearances, whereas an artist is able to penetrate beneath the surface and reveal a person's character. Most of the sculpture and painting of the past has been representational. What distinguishes good representational art is not, as many believe, the amount of detail shown but whether the artist has represented well space and distance, the volume and weight of objects and figures, and character, emotion and drama (see **1.16**, **1.32**, **24.43**, **24.44**).

Most creative painters and sculptors, even the realists and naturalists, attempt to 're-create' their subject matter — they make visual *metaphors*, rather than imitations of nature. One way of doing this is to make the human body stand for, or symbolise, a piece of nature (**1.1**) or a human condition (**1.3**).

Sometimes a great expressionist or abstract work reminds one of a child's work, and this can be confusing. In such cases remember that, whereas a child works in the only way he or she knows, a great artist more or less consciously chooses a style (see **24.41**).

Talking about art

The personal and subjective nature of art can make discussing it very frustrating. Remember that whenever you say things like 'That's cool',

1.10 Henry James Johnstone (1835–1907), *Evening Shadows*, 1890. Oil on canvas. The photographic quality of this picture classifies it as naturalism — in fact, it may be even more naturalistic than the photograph **1.8**!
The Art Gallery of South Australia: gift of A.Y.S. Sparks

1.11 Horace Trenerry, *The Pines*, c. 1942. Oil on canvas. Although this picture clearly represents a real scene it can hardly be described as 'photographic' or 'naturalistic', compared with **1.10**. However, it is *realistic*. The Art Gallery of South Australia: bequest of Miss G.A. Hardy

or 'How ugly!', you are not using words that have fixed and universal meanings. You are simply putting into words the effect the work has had on your emotions; its effect on others may be quite different. If you want other people to understand what you feel, you must always go on to explain *why* the work has the effect it does on you. In other words, you discuss its form, expression and function; or the style of the artist; or how subject matter has been treated; or anything else you may consider relevant. To be able to do this you must first analyse the work and your thoughts, define your terms, and use them consistently.

Things to do

1 Which of these could be called works of art? Give reasons for your opinions.

a tree	a kitchen table
a garden	a bird's nest
a beautiful scene	a grocery business
a backdrop for a play	a sports arena
a mathematical equation	a teapot
a building	an army
a factory	a scientific theory

2 Make a list of local buildings you consider beautiful.

3 Make a list of local buildings you consider ugly.

4 Name something you know that is

beautiful and expressive	beautiful only
beautiful and useful	useful only
useful and expressive	expressive only

5 List at least three arts that could be called applied arts.

6 Find a picture of a great painting, sculpture or building and explain how the artist has achieved his/her aims. Consider the beauty, expression and usefulness of the work, and locate each of these qualities on a scale of aesthetic values.

An introduction to painting

The type of realistic or naturalistic painting you will probably know best dates from the Renaissance, the period beginning about the fourteenth century AD when the civilised way of life of the ancient Greeks and Romans was revived. This was really the beginning of our modern way of life and the time of the 'old masters' of art, the most famous of whom is probably the Italian, Leonardo da Vinci (1452–1519).

During the early part of the Renaissance, pictures were painted in *tempera* (powdered pigments mixed with raw egg which, when dry, binds the pigment to the surface to be painted) on wooden panels grounded with *gesso* (a mixture of plaster of Paris and glue-size), or else in *fresco*, which means that the pigments are mixed with water and painted on to a freshly plastered wall so that the paint becomes part of the wall's surface (*fresco* is Italian for *fresh*). Both these *media* are sometimes used today. A picture painted on the wall of a building is called a *mural*.

By the fourteenth century, painters in northern Europe were using *oil paint*. In this medium powdered pigment is mixed with oil (usually linseed oil) which acts as a binder and the pictures are usually painted on *canvas* stretched over a frame. Two of the greatest masters to use the oil medium were the Flemish Jan van Eyck (*c.* 1385–1440) and the Dutchman Rembrandt van Rijn (1606–69; see **20.6**). Rembrandt is famous for *portraits* which reveal the character of his models, and he painted many

self-portraits. One of his most famous pictures, *The Night Watch*, is a group portrait.

The nineteenth century French painters called the *Impressionists* specialised in *landscapes*. They realised that we only see things because light is reflected from them and that white light is made up of the basic colours. Consequently they tried to capture the effect of light by using *broken colour* (see **23.16**, **23.17**).

The first truly abstract and expressionist art was not produced until this century. The Spaniard Pablo Picasso (1881–1973), was perhaps the most famous 'modern' artist. 'Modern artist', by the way, is not a good term to use because it simply means an artist who is painting today, and many use realistic styles. All artists were 'modern' once. It is better to speak of 'an Expressionist' or 'an Abstract painter' than of 'a modern artist' (see section 24).

In *watercolour*, pigments are ground in water-soluble gum. This makes excellent paint, especially when laid on paper in thin, transparent *washes*. In recent years, water-based paints which are very durable have been developed. They have *acrylic* or *polyvinylacetate* (PVA) as binders and can be applied thinly or thickly (with *impasto*), thus combining the advantages of both oil and watercolour media.

One of the problems a painter has to face is the representation of space and volume, because painting is the only art that can give the illusion of an extra dimension — a picture is a two-dimensional surface, but an artist can represent three dimensions by using *perspective* and *foreshortening* (see sections 19 and 20).

Things to do

1 Read more about painting by looking up the subject in an encyclopaedia. What entries would you look at?
2 Find reproductions of paintings by the artists mentioned and others of the same school or style.
3 Find further information on painting media in a reference book.
4 Try making your own egg-tempera, painting a fresco, and grinding oil paint. You will find recipes for all these in reference books.

An introduction to architecture

The word 'architecture' comes from two Greek words: *arkhos*, meaning 'chief' and *tekton*, meaning 'builder'. Thus an architect not only envisages the final shape of the building he designs and plans so that it will be functional, but he supervises the builders as well. He also has the task of making a building that will grace the landscape of which it is to become part. A building is a hollow form enclosing space, and the satisfactory arrangement of this space is one of the architect's chief problems.

Generally speaking, all the buildings ever made have been constructed on one or other of the three basic principles: using the post-and-lintel, the arch, or reinforced concrete.

The post-and-lintel principle

In the post-and-lintel principle, vertical walls or columns (the posts) support horizontal ceilings and tops of openings (the lintels or beams). This was the only principle known to the ancient Egyptians and Greeks and has been used widely in Australia. It is particularly appropriate when the material to be used is timber or stone slabs; however, there is a limit to the span of a lintel before its own weight will cause it to break.

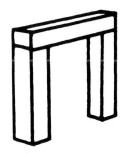

1.12 The post-and-lintel principle of construction

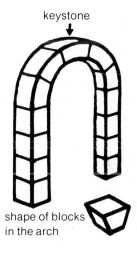

1.13 The semi-circular (or round) arch

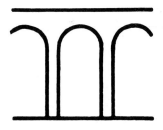

1.14 An arcade — arches placed side by side. See also **17.7**.

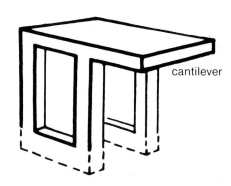

1.15 Ferro-concrete construction principles, including the cantilever. The stability of this system depends upon the building being firmly anchored in the earth (footings).

1.16 Two pictures of the Dutch Post-Impressionist artist, Vincent van Gogh: the one on the right painted by John Peter Russell, an Australian who knew him well; and the other a self-portrait, painted in 1889, after van Gogh had cut off his own ear (the bandage is still in place). Russell's study (painted in 1886) is calmly detached, whereas van Gogh's shows the tension and emotion in his life at that time. Russell's picture is in the National Museum Vincent Van Gogh, Amsterdam, and the self-portrait is in the Courtauld Institute, London.

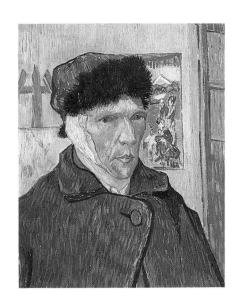 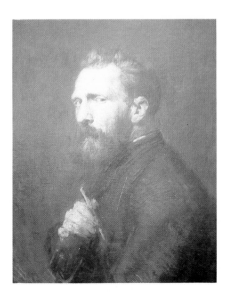

1.18 (below) Joseph Mallord William Turner, *Val d'Aosta*, c. 1836–37; 91 × 122 cm. Although perhaps appearing abstract, this picture represents a storm in the mountains of northern Italy. The artist has used the full resources of oil paint on canvas: *impasto* (thick paint) and *glazes* (thin, transparent paint). National Gallery of Victoria.

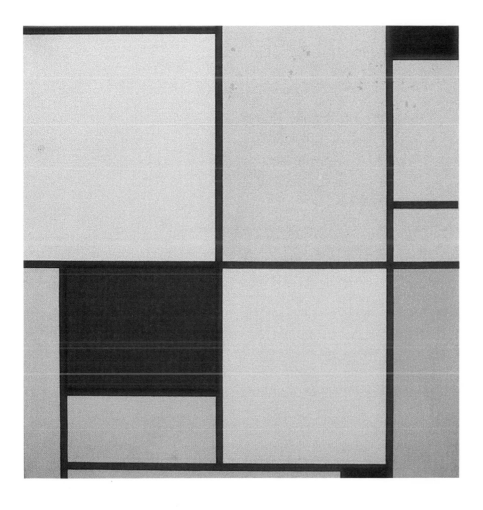

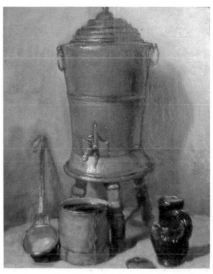

1.17 Jean-Baptiste Chardin, *The Copper Cistern*. Oil on wooden panel; 28.5 × 23 cm. The artist has seen beauty in the colours and textures of ordinary things. Louvre, Paris

1.19 Piet Mondrian, *Composition I*, 1921. Oil on canvas. As the name suggests, this picture is not 'of' anything; the artist has arranged shapes and colours to achieve as perfect a balance and harmony as possible. This approach is more like that of a composer of music than of a photographer. Note that this 'modern' picture was painted 60 years ago. Gemeentemuseum, The Hague. © SPADEM, Paris, 1982

The arch principle

In this case the walls support *domed* or *vaulted* ceilings and roofs, and arched openings. The ancient Romans, who did much to develop the arch, used semi-circular arches. In the Middle Ages, pointed (or Gothic) arches were used (see **17.24, 17.29**). Until quite recently most churches in Australia were built with Gothic-arched doorways and windows. Bricks or blocks of stone of a special tapered shape are used in the arch. They are supported by wooden *centring* until the last block — the *keystone* is laid. Arches, domes and vaults can span a much wider space than lintels can (see **16.7, 17.17**).

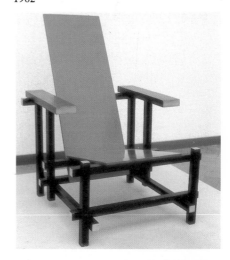

1.20 Gerrit Rietveld, Chair, 1918. Wood. In creating this – one of the earliest examples of modern furniture design — Rietveld was influenced by paintings such as that in **1.19**. Stedelijkmuseum, Amsterdam

1.21 Barrel vault (left) and groin, or intersecting barrel vault (right). See also **17.10**.

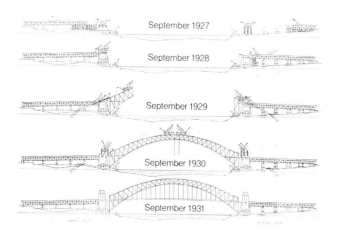

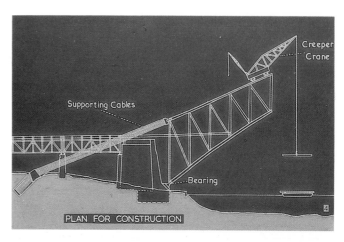

1.22 Stages in construction of the Sydney Harbour Bridge, 1925–31. Steel girders, riveted together. Enormous engineering skill was required to start from each end and to have the structure meet perfectly in the middle (which it did). Designed by the British firm of Dorman Long

1.23 Construction of the Sydney Harbour Bridge, 1925–31. The supporting cables made it possible to cantilever the structure and support two massive cranes during building.

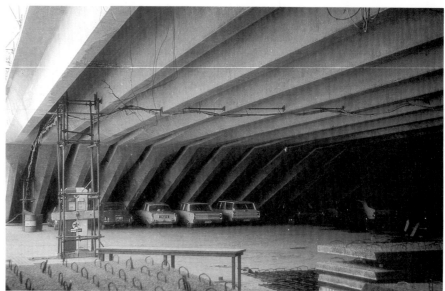

1.24 Jorn Utzon, Sydney Opera House, 1959–74. Ferro-concrete. Note the span of these beams which support the whole building and compare with **1.6**.

Reinforced concrete

Reinforced concrete (or *ferro-concrete*) is concrete in which steel bars have been set. This is the strongest and most versatile building material, and modern architects use it in the construction of very tall buildings and to span exceptionally large rooms and openings. Compare the spans in **1.6** and **1.24**.

Sometimes roof- and floor-slabs are *cantilevered* out over the walls. Although the cantilever itself is not new (a tree's branches are cantilevered out from its trunk) the invention of reinforced concrete early in this century enabled modern architects to cantilever large spans. In some structures the steel is left exposed. Illustrations **1.22** and **1.23** show how the Sydney Harbour Bridge was constructed using the cantilever principle.

Things to do

1 List local buildings in which the post-and-lintel principle has been used.
2 List local buildings in which the semi-circular arch has been used.
3 List local buildings in which the Gothic arch has been used.
4 Find at least one example of the use of a dome and one of the use of vaulting.
5 List as many examples of cantilevers as you can.

An introduction to industrial and commercial design

Like the architects, the *designers* of the articles we use every day and the *commercial artists* who design TV graphics, advertisements, packages and displays, have to take into account beauty, function and expression in their work.

Sometimes people think that the beauty in everyday articles lies solely in their decoration. This is not so. Beautiful articles of use, like beautiful pictures, sculptures and buildings, are those in which the shapes, colours and textures are harmonious and balanced. The most striking advertisements are often those in which simple lettering, well placed and coloured, forms the main design. Cluttered advertisements are hard to read.

To be functional, an article of everyday use must not only be designed to perform its function well, but also made of durable material and made to last a reasonable time. In this century, machines have often taken over the work of craftsmen; but, properly used, machines can make articles that are more durable, beautiful and functional, not less so — and cheaper too.

The pictures on pages 14–15 trace the evolution of the 'piping shrike' motif (the badge of the State of South Australia) from its origin in 1904 to a number of designs for logos in the 1980s.

Things to do

1 Make sketches of two well designed articles and two poorly designed articles in your home or school.
2 Make a piece of pottery, or a wooden spoon or paper knife, remembering the principles that have been outlined in this section.
3 Look in a local department store and list all the really well designed articles.
4 Develop a motif (a flower, a shoe or a vehicle) into a logo for a festival or a trade-mark (refer to **1.25–1.29**).
5 Make a scrap-book of articles illustrated in magazines — one section for good design, one for bad.

An introduction to sculpture

A *sculpture in the round* is fully free-standing (**1.1, 1.3**). This means that it is not attached to a background, and that it is possible to walk around it. A *sculpture in relief* is attached to a flat background — the head of the Queen on a coin is an example. If the form of the relief stands out very much, this is *high relief*; if it projects very little, this is *low relief*; and if the form is actually sunken into the background, this is *intaglio* (**1.30**).

Plastic materials like clay or soft wax are worked by a building-up process called *modelling*. To give it a more permanent form, the plastic material is *cast* in bronze or some other metal (see **1.1**). Casting is a complex process which involves making a mould of fire-resistant material, pouring in the molten metal, and removing the mould after the metal has cooled. Stone and wood are *carved*; the *sculptor* must visualise the figure to be carved in the sold block before commencing to carve (see **1.3**).

Most ancient peoples, like the Egyptians and the early Greeks, made sculptures which express little movement, the figures always facing frontwards in a rigid attitude. We call this style *archaic* and the stance of the figures *frontal* (**1.31**). In the fourth century BC, Greek sculptors developed a very realistic style which was revived during the Renaissance

1.25 John Gould, *White-backed Crow-shrike* — a lithograph from the book *Birds of Australia* published in London by John Gould in 1848. A factual drawing by an ornithologist of the bird we now call the piping shrike.

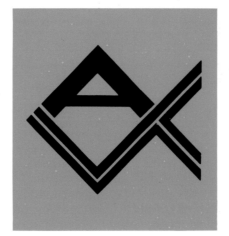

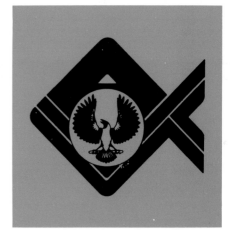

1.26 (above, right) The official badge of the state of South Australia. The piping shrike has been drawn in an heraldic position (the bird is rarely seen in this position, actually). Drawn in 1904 by Robert Craig.

1.27 Various adaptations dating from the 1970s of the SA state symbol by the Department of Agriculture and Fisheries (now two separate departments) for logos on publications. The piping shrike interacts with a schematic fish and a capital A (for Agriculture) and 'df' (Department of Fisheries).

1.28 Lyndon Whaite, Symbol for 150th Jubilee of South Australia — an adaptation of the piping shrike motif as a logo together with suggestions for its use throughout the Jubilee celebrations. Designed in 1980.

1.29 Airlines of South Australia logo, 1981. On the left, as used in publicity and, on the right, gracing a Fokker Friendship.

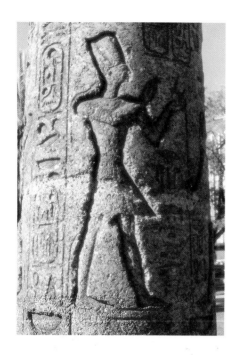

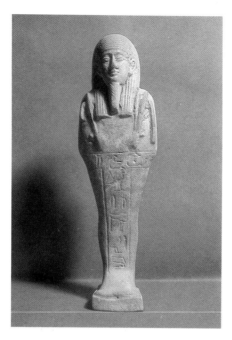

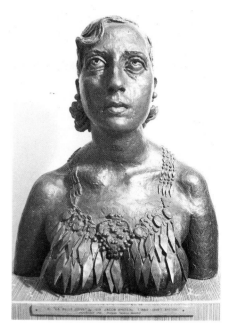

1.30 (above) Intaglio relief from an Egyptian column. Made about 1330 BC. South Australian Museum

1.31 (centre) A *ushabti* from an ancient Egyptian tomb. Ceramic. Height approximately 16.5 cm. Frontal sculpture. The Art Gallery of South Australia

1.32 (right) Sir Jacob Epstein, *The Beautiful Jewish Woman*. Bronze. Life size. Purchased in 1933. The Art Gallery of South Australia

by artists such as Michelangelo (1475–1564). Sir Jacob Epstein (1880–1959), a great modern sculptor, created many realistic or expressionistic sculptures in bronze (**1.32**), but he believed that stone should always retain the feeling of rigidity and mass that is natural to it. Consequently he used the archaic and frontal style when working in stone. The archaic style occurs in traditional art still practised by some peoples today, and is used by some modern Western sculptors who believe that it is best for stone or wood.

Things to do

1 List three sculptures in the round that you have seen, and three examples of relief sculpture.

2 **(a)** Make a carving from a piece of soap or soft wood, or from a block of plaster which has been set in a cardboard carton.

 (b) Make a clay model and cast it in plaster.

3 From reference books, find examples of all the styles and techniques listed and fill in this table:

Style or technique	Example
high relief	
low relief	
intaglio	
modelling	
carving	
archaic sculpture	
frontal pose	
a sculpture by Michelangelo	
a sculpture by Epstein	
ancient Greek sculpture	

4 List the names of as many famous sculptors as you can.

5 Find further information on the media and methods of sculpture.

2 The Stone Age

We know that the first humans appeared at least two million years ago, because archaeologists have been able to date the artefacts they left behind. Stone-Age people had hands and a brain superior to that of the other animals, and they learned to use fire and to make tools and weapons from natural materials such as wood, stone, bone, horn and ivory.

In this section we trace briefly the development of art through the Stone Age in Europe. The term Stone Age does not apply everywhere to exactly the same period; similar developments occurred in other places at other times (see section 4).

The Old Stone Age (Palaeolithic period)

During what we call the Palaeolithic period or Old Stone Age, which lasted from at least 1 000 000 BC until about 10 000 BC in Europe, humans were nomadic hunters. They had no permanent homes but followed the game they hunted for food and dressed in the skins of animals they caught. They sometimes sheltered in caves, but probably did not live in them. Architecture had not originated.

Palaeolithic man made primitive axes from flint and other hard stones, sharpening them by chipping with other pieces of stone. They were roughly shaped and had no handles. We call them *hand axes* or *fist hatchets*, and they are often found in the places where their makers used to live. Gradually, the stone implements became more skilfully made and their shapes more symmetrical. They show that Palaeolithic man had immense skill in stone-working and could make an article that was both functional and beautiful.

Making stone implements may not seem a very significant thing, but it was mankind's first step towards the science and technology of today. For example, people learned that big things (rocks) can be made up of little things (chips), and this kind of thinking led to the theory of atoms.

Palaeolithic people also made implements from bone and horn (fish-hooks and harpoon- and spear-heads); and necklaces from shells, teeth and bone. Drawings were incised on the implements, probably because it was believed that this would increase their effectiveness through the power of magic.

They painted, on the walls of caves, remarkably fine pictures of the animals hunted by the tribe. Many of these pictures survive today, preserved by the action of the limestone walls of the caves themselves. There are many such caves in France and Spain; the most famous are Lascaux (France) and Altamira (Spain). Caves seem to have been sacred places rather than dwellings, because mostly the pictures are deep in dark and inaccessible caverns, where the artists would have had to use candle-light or firelight to see well enough to work.

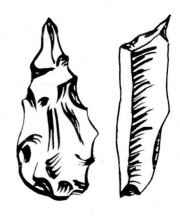

2.1 Flint fish-hatchet. Old Stone Age. Europe. Length 20 cm.

2.2 Stone point. Old Stone Age. Europe. Such implements would have been used for cutting meat and drilling holes in skins.

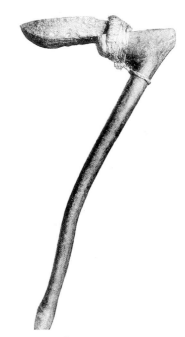

2.3 A stone adze with a wooden handle. Maori (modern)

2.4 Painting of a running pony in Lascaux Cave, France. These ponies were hunted for food and the artist has drawn two arrows flying towards the animals, probably as part of a hunting-magic ritual. The symbol at the top may be a trap or enclosure and, if so, an example of the first writing.

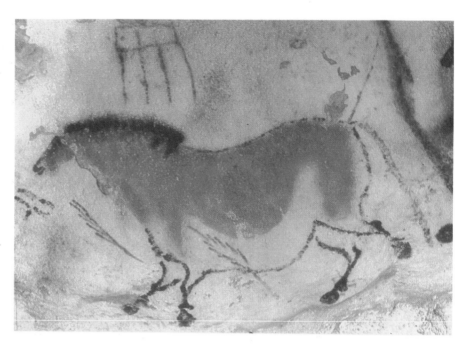

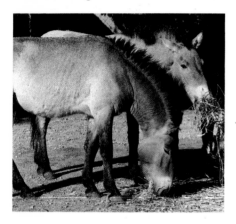

2.5 Two Przewalski horses in the Adelaide Zoo. A few descendants of the pony in **2.4** still exist in zoos around the world. Their bristly manes and rounded bellies have been well captured by the artist in **2.4**. *Advertiser* photograph

We think these pictures were painted as part of the fertility- and hunting-magic which they believed would help to increase food supplies, because this kind of belief has been recorded from more recent primitive people. The pictures are surprisingly realistic. Of course these early artists had to make their own brushes and paints: they used pieces of white clay, coloured earths (*ochres*) and charcoal, ground to powder and mixed with water on a flat stone or bone palette, or else used these as crayons.

Only a few examples of Palaeolithic sculpture have survived. The best known are small stone or bone figurines and clay forms of animals which originally were completed with the actual heads of animals killed in the hunt.

The New Stone Age (Neolithic period)

The Neolithic period lasted from about 10 000 BC until about 5000 BC in Europe. Neolithic people were more skilful than their forbears. They developed new technology: wheels, pottery, bows and arrows, and the plough. They sowed seeds, wove cloth and baskets, and domesticated animals. In short, they became farmers rather than hunters and gatherers. Another development that occurred during this period was trade: commodities such as salt and flint were traded over long distances.

Stone tools were worked until their surface was polished, and some of them were *hafted* (fitted with handles); this distinguishes them from those of the Palaeolithic period. The two names are from the Greek for 'old' (*palaeo*), 'new' (*neo*), and 'stone' (*lith*).

No paintings have survived from this period, probably because caves were no longer religious centres and because the people no longer depended upon hunting for their survival.

However, Neolithic people developed the first *architecture*. They built huts and villages and also open-air temples, many of which have survived. They set up large roughly hewn stones, which we call *menhirs* or *megaliths* (*mega* = great), at sacred sites. Stonehenge, on the Salisbury Plain in Wiltshire, England, is one of these sacred sites. It is a *cromlech*, a series of concentric rings of standing single stones and *trilithons* (three

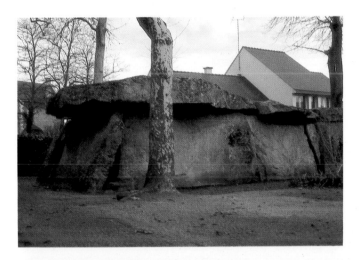

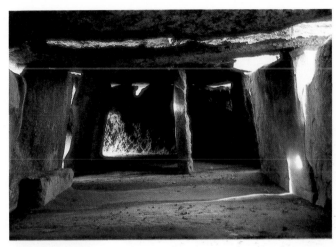

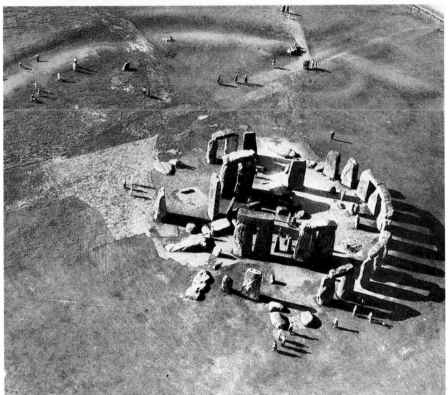

2.6 Dolmen, Bagneux, Loire Valley, France. Built 3000–2000 BC. 23 m long. Built of sandstone slabs which occur naturally about 400 m away, it was originally covered with earth to make what is called a *burial barrow*.

2.7 The inside of the dolmen **2.6**. Archaeologists found little of interest in this dolmen because it had been used as a barn for centuries before they discovered it.

2.8 Stonehenge, England. 2000–1000 BC. Two concentric rings of trilithons, partly ruined. The people give scale to the stones.

stones arranged in post-and-lintel form). *Dolmens* are arrangements of standing stones with large flat slabs forming a roof (**2.6**). They were originally covered with earth, which has since been washed off by rain in many cases, and were built as communal tombs by the first farmers.

Things to do

1 Paint a picture using only white and coloured earths and charcoal.
2 Find photographs of all the artefacts and structures mentioned in this section.
3 Study examples of art produced by Australian Aborigines (see also section 4), and compare them with Stone Age art.
4 Try to shape a piece of hard stone by working it with another piece of stone (protect your eyes with plastic glasses).

3 The Bronze and Iron Ages

People living in Europe eventually discovered how to make implements from metals. These implements were, of course, much superior to stone implements. In other parts of the world, however, the Stone Age persisted for many more centuries. Australia is one of these places. The terms Stone Age, Bronze Age and Iron Age refer not only to European time periods, but also to stages of development of peoples living in similar technological conditions in more recent times (see section 4).

The technique of making **bronze**, an alloy of tin and copper, was the first discovery in metallurgy. It occurred about 3000 BC in Europe. By then the first great buildings and cities were appearing in Egypt, Mesopotamia (now called Iraq) and the Indus Valley (in India). Civilisation (*civis* = city) had begun. Each civilisation had an organised system of government and each had its own method of building and its own religion; these will be studied in more detail later. Some of the people could read and write; and they constructed irrigation systems based on the great rivers which watered their lands.

Iron was first used about 1000 BC. It replaced bronze particularly as a material for making weapons and armour, but bronze has continued to be used up to the present day for other purposes (see **1.32**).

Dating

In this and the preceding chapter we have dealt with *prehistoric* time — the time before events were recorded. Archaeologists and historians do not always agree on the precise dating of the remote events we have discussed, and you may find dates differ from book to book. Also, the ages occurred at somewhat different times in different places. However, all agree on the broad sequence of mankind's development.

Whereas we count dates since the birth of Christ in the usual way, dates before Christ are counted backwards. Dates before the birth of Christ are followed by BC; those after the birth of Christ are preceded by AD, which is short for *Anno Domini*, Latin for 'in the year of our Lord'.

Remote past　　200 BC　100 BC　AD 100　AD 200　　Present day

Birth of Christ

Things to do

1 Construct a time scale ranging from 100 000 BC to the present day. Compare the length of the Palaeolithic with the time since the birth of Christ.

2 For a relatively short period before bronze was discovered, another metal was used for tools, but it has not been mentioned in this simplified account. Try to discover which metal this was.

3 The main Bronze and Iron Age civilisations are discussed in succeeding sections, but the following should also be studied:

- Celtic ornaments
- the barrow-builders
- the La Tène culture
- the Hallstatt period
- the Animal style
- Scythian art

4 List as many contemporary uses for bronze as you can.

4 Traditional art of Australia, Africa and Oceania

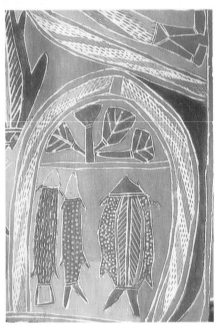

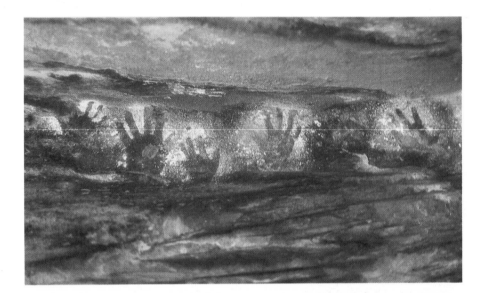

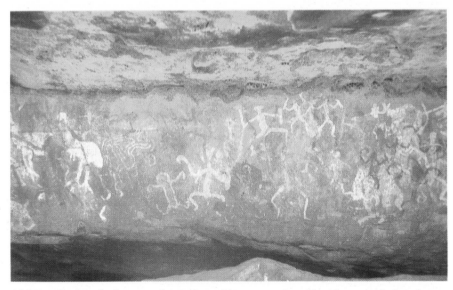

4.1 (above) A bark-painting from Arnhem Land, representing a pool with fish and lilies. In the large fish, the backbone has been shown ('X-ray' painting). Photograph: Mr Brian Peake

4.2 (top right) Stencilled hands, Mt Grenfell, NSW. Pipe clay has been blown from the mouth over the artist's hand placed on the rock

4.3 (right) Painted rock-shelter, Mt Grenfell, N.S.W. Pictures have been superimposed on each other over the centuries, but dancing men and an emu can be discerned

Although the forbears of modern Europeans evolved out of the Stone Age and learned how to make weapons and utensils of bronze and iron, people in many other parts of the world did not develop in this way. Why this should be so is a question that is still not resolved, but it is a fact that until their first contact with Europeans over the last few centuries, the aboriginal inhabitants of America, Australia, Africa and the islands of the Pacific (Oceania) possessed only Stone Age technology and lived in conditions that must have been very like those existing for Stone Age people.

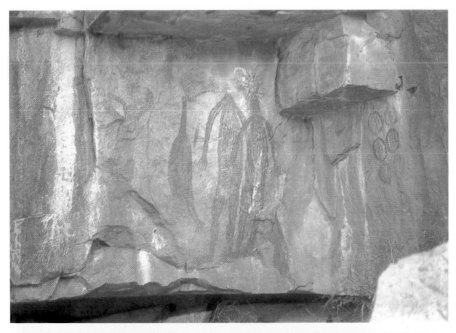

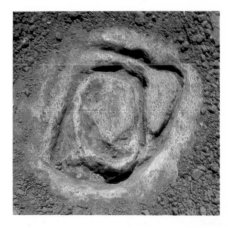

4.4 (left) Spirit-figures from a rock-shelter in Katherine Gorge.

4.5 (above) Tasmanian Aboriginal rock engraving, The Bluff, Devonport. It may be a symbolic representation of a shellfish.

4.6 Incised horizontal rock-surface, Panarammittee, South Australia. Emu and wallaby-tracks and other symbols.

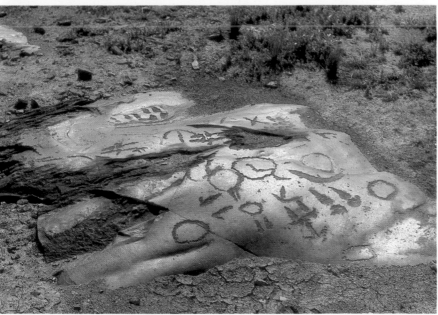

4.7 (below, left) Incised vertical rock face, Chambers Gorge, South Australia. Probably related to the Wandjina heads of north-western Australia, which are associated with rain and thunderstorms.

4.8 (below, right) Spirit-figures from a vertical rock face in Chambers Gorge, South Australia.

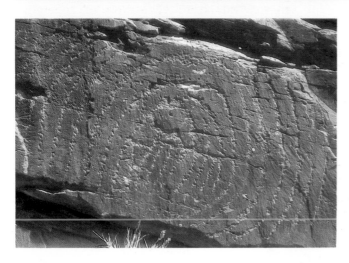

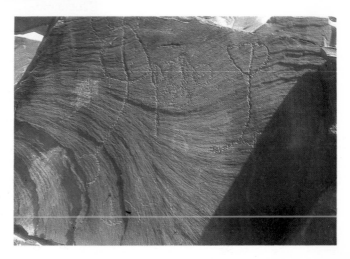

The art of primitive peoples is *realistic* rather than *naturalistic*: it represents real things (usually people and animals), but is rarely a photographic copy of nature. Separate parts of the subject are shown in their most recognisable aspects and all important things have to be included, whether or not they could actually be seen — for example, the Australian Aborigine often shows the skeleton and main internal organs of an animal in a painting (**4.1**). Individual expression has little place in primitive art, as most of the motifs are handed down from generation to generation with little change apart from becoming more and more conventionalised and symbolic. According to our definition in section 1, this is *craft* rather than *art*. It is easy to see how writing could develop if this process were continued over a long period, as it did in Europe and China, for example (see **12.2**).

The Australian Aborigines

The Australian Aborigines probably originated in Asia and crossed from southeast Asia via Niugini more than 40 000 years ago, fanning out and establishing small tribal groups across the continent. When the first white settlers came to Australia, they found that the Aborigines were nomadic hunters who had no knowledge of metals. While some of their stone implements were hafted and polished, as were those of Neolithic man, many were only chipped. The Aborigines of Tasmania evidently had no polished or hafted tools at all.

In spite of the inhospitable conditions the Aboriginal people developed a most satisfactory lifestyle for which they relied upon a sensitive and detailed knowledge of their environment. This lifestyle tended to vary from one area to another: in those areas of the continent that provided a plentiful supply of water and food, they constructed substantial shelters and exploited the seasonal variations in plant and animal abundance within their tribal area. In the drier, less productive parts, their life was more nomadic and their shelters less permanent.

Aboriginal society was highly structured, with a most complicated kinship and clan/skin system.

For their artefacts, Aborigines obviously had to rely on materials available within the environment and, although they never used metals, their stone implements were highly developed and a wide range of stone tools has survived. Several major technological discoveries were made, including the invention of the *woomera* and *boomerang*.

Art was an important means of passing on myths and tribal rites, and information important for survival, from generation to generation. Although the idea of 'art for art's sake' was not unknown to them, most of the many kinds of pictures they made served some useful purpose. Some tell a story and others impart information about hunting and food-gathering. Those used in ceremonies of hunting-magic or fertility-magic were an essential part of the Aborigines' religious life.

Archaeologists believe that one of the earliest art traditions was the *engraving* or *incising* of designs on flat rock surfaces. Examples of these can be found throughout Australia (**4.5**). They were made by striking the rock to remove chips 1–2 cm deep. Some outlines were filled in with small chip-marks ('pecked type'). By this means, extensive areas were engraved and, although the meaning of the designs is not known, they have survived tens of thousands of years. Later, human and animal figures and tracks were represented in these *pictographs* (**4.6**).

Painting on the walls of caves or rock-shelters is one of the most com-

mon forms of Aboriginal art. Rock paintings represent animals and scenes from the hunt, spirit-beings (e.g. the *mimi* people) and legendary figures from 'the dreamtime' (such as *Wandjinas*). There are also stencilled hands and, in Queensland, even stencilled complete human figures. Stencils were made by mixing ochres with water, putting the mixture in the mouth, and blowing it around the object to be represented.

In Arnhem Land, if the animal represented is living, its skeleton and internal organs, or its tracks, are often shown (**4.1**). Such pictures are often referred to as *X-ray pictures* (but not, of course, by the Aborigines). Good examples of X-ray pictures appear on the $1 banknote — a reproduction of the work of Aboriginal artist David Malangi. A red ochre background was sometimes considered necessary to give the picture magical power.

Paint was made from ochre, a soft rock (oxide of iron) which can be found in a range of colours from yellow, through red to deep, rich brown. White pigment was obtained from pipe clay, ashes or emu dung, and black from charcoal. These pigments were ground to powder and mixed with fixatives such as blood, raw egg, animal fat, sap, honey or wax to make paint which was applied with the fingers or with a brush skilfully made from kangaroo fur or a feather, or the chewed and frayed end of a twig. Blood used in paintings, of course, gave them special spiritual significance. Some Aboriginal languages have few names for colours — generally they have words for black, white and red only.

Painting of rock faces is rarely practised now. However, painting on the smooth inner surface of sheets of bark is common in the northern parts of Australia.

The many different painting styles over the continent, ranging from the more naturalistic, yet richly decorative, in Arnhem Land (**4.1**) to the more symbolic and stylised in the desert areas (**4.6**), are the expression of some 40 000 years of Aboriginal adaptation and change. All initiated men knew the symbols and patterns, and most were able to act as artist during ceremonies. In some regions this situation still exists. Sometimes pictures were painted over repeatedly as part of ceremonial tradition, and this practice contributed to conventionalisation of the motifs (**4.3**).

Aboriginal art, created as part of a ceremony, was not intended to last after the ceremony ended — the making of it was more important than the work itself. Although a rock face may have had to be similarly painted the next year when the rite was re-enacted, the location of the painting and its surrounds were often of greater importance than the painting itself. Consequently, bark paintings and grave-posts were usually left to crack and rot away.

In some parts of Australia, mainly the central areas, totemic designs were engraved or incised on pieces of wood or stone called *tjuringas* — sacred objects which preserved the soul of the person or clan. The exposed sapwood of the trunks of living trees was carved in some regions, and these carvings were associated with burial or initiation areas (**4.9**).

The Aborigines engage in body decoration; modelling figures in the sand and making them from wax, grass and clay; and carving figurines and grave-posts from wood. String, fishing nets, bags and baskets are skilfully and beautifully made from various vegetable fibres, animal fur and human hair.

Many wooden weapons were carved and painted in the belief that this would increase their effectiveness, or to represent the totem of the user.

In Arnhem Land excellent canoes are still fashioned from bark and, although this art has died out elsewhere, the craft was practised widely

4.9 (left) Incised tree, Molong, NSW, marking the grave of Yuranigh, who died in 1853.

4.10 (right) Grave-posts used in the Pukamunni Ceremony on Melville Island.

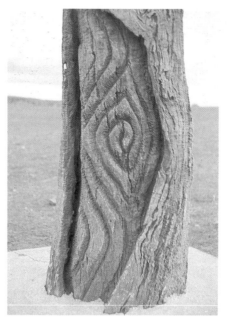

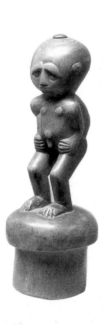

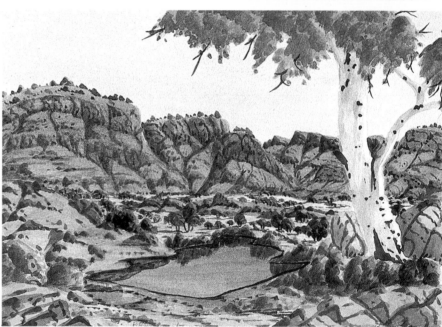

4.11 (left) Wooden stopper for a jar. Asante (Ghana). Museum of Mankind, London

4.12 (right) Watercolour by Benjamin Landara, Hermannsburg Mission. Early 1970s? (Reproduced in colour on front cover)

throughout Australia (**4.14**). Trees from which bark for canoes has been cut are often found beside major rivers (for example, the Murray-Darling system; **4.15**) and in coastal areas.

In the 1950s and 1960s, Aborigines of the Arunta tribe at Hermanns-burg Mission in the Northern Territory painted their land in water-colours using the Western tradition. The first to do this was the late Albert Namatjira (1902–59), and some of his relatives followed him (**4.12**). Their art is a unique adaptation of Western technique and Ab-original attitudes to the landscape, involving both keen observation and some stylisation.

The Africans

The most notable 'primitive' sculpture is done by the black Africans. Its

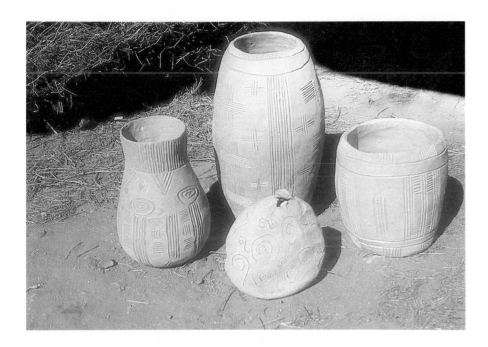

primitive forms and expressive power were discovered by European artists early this century, and influenced the Expressionists and Cubists (**4.17**).

In many examples of wood and ivory carving, the cylindrical form of the original material can be seen underlying the whole work. In these works the figure is reduced more or less to geometric solids — cones, cylinders and cubes (**4.11, 4.16**). Carved wooden masks are often very impressive.

The Yoruba and Benin people (West Africa) made fine portraits of their kings and ancestors in bronze. It is not known whether they learned the art of bronze-casting from the ancient Egyptians or from the Portuguese in the colonial period.

The Bushmen of the Kalahari Desert (South-West Africa) had a desert culture similar to that of the Aborigines of arid Australia. They made rock paintings as naturalistic as the best of the Old Stone Age pictures, but used a wider range of colour. They seem to have been the only primitive painters able to represent animals in forshortened positions.

Possibly related to Bushman art are the wonderful rock paintings in the Tassili area of the Sahara. They represent men and pastoral and jungle animals, and must have been painted long ago, when the desert was fertile.

The Oceanians

The natives of Oceania — the Polynesians, Melanesians and Micronesians — had no metal technology when they first came into contact with people of European origin. There is a rich variety in their art, as might be expected over so vast an area.

Traditional buildings, in general, are made of palm leaves and similar materials but, in New Guinea, Borneo and New Zealand there are buildings to which the term architecture could be applied. In New Zealand the Maoris made fine wooden buildings (*whares*) of which certain parts, such as door-posts and barge-boards, were elaborately carved with motifs depicting the ancestral heroes of the tribe and race. In fact, a whare was

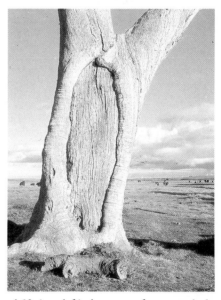

4.13 (top left) A group of pots made by Jimmy Stewart, at Amata, northwest South Australia. A number of Aborigines have become potters and use traditional but non-sacred symbols as decoration.

4.14 (top right) Canoes made from bark by Maningrida Aborigines, Darwin Show, 1970.

4.15 A river red-gum from which a canoe-bark was cut many years ago. Finniss River, South Australia.

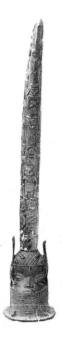

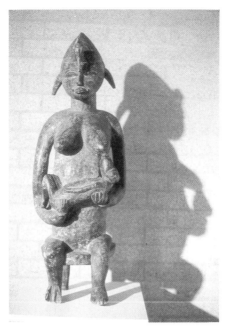

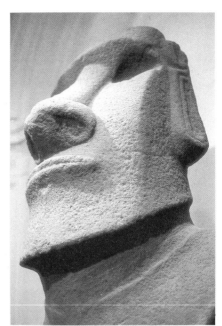

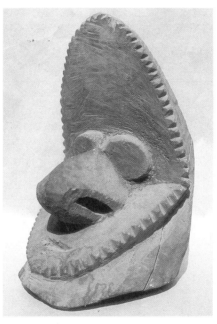

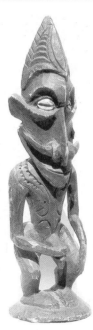

4.16 (top left) Bronze head surmounted by a carved elephant tusk — from Benin, Nigeria. Height about 200 cm. In the collection of the South Australian Museum, this is believed to be the only authentic complete example of this type of sculpture to survive.

4.17 (top, centre) Mother and Child, Ivory Coast wood carving. Height about 108 cm. Kröller-Müller Museum, The Netherlands: Jacques and Yulla Lipchitz Foundation. This magnificent sculpture was owned by Cubist sculptor, Jacques Lipchitz (see **26.27**, **26.28**).

4.18 (top right) Easter Island figure (detail). Stone. Height about 200 cm. Museum of Mankind, London

4.19 (left) Head from the New Hebrides. Wood. Height 35 cm.

4.20 (right) Wooden figure from the Sepik River area of Niugini. The eyes are inlaid shells. Height 39 cm.

regarded as actually representing the great man after whom it was named: its interior was the equivalent of his trunk, the ridge-pole his backbone, the rafters his ribs, and the barge-boards his arms (they end in the typical three-fingered hands of Maori figurative carving). Anyone entering the whare was thought to take on some of the attributes of the great ancestor.

Wood was often used in the making of canoes, canoe paddles, and clubs and in New Zealand wooden boxes for *tikis* (see below) or sacred *huias* (bird feathers) were made. These boxes were decorated with incised carvings and shell inlay in traditional patterns. The staves which were carried by the old Maori chiefs, and *tikis* (small greenstone figures that are still worn as charms by many Polynesians), were also decorated in this way. Often the carved woodwork was rubbed with a mixture of shark oil and red ochre. Common motifs are variations of the spiral and a monstrous being with a long, poking tongue and three-fingered hands.

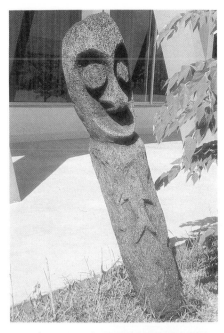

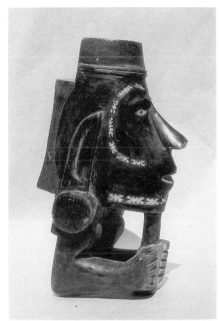

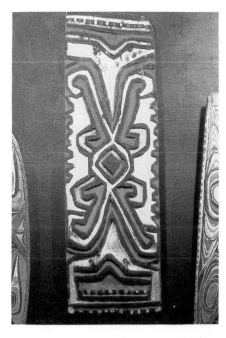

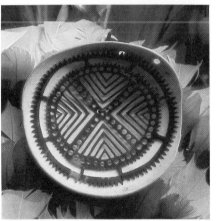

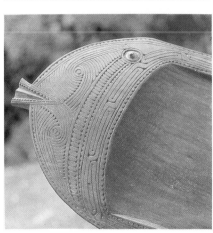

4.21 (top left) Carved fern-tree. New Hebrides. Fish is a staple food in Oceania.

4.22 (top, centre) Gnuzu-Gnuzu, a figure which Solomon Islanders used to tie to the prows of their war-canoes. Wood with mother-of-pearl inlay. Height 35 cm.

4.23 (top right) Ceremonial Board from the Upper Sepik, Niugini. Painted wood. Australian Museum, Sydney (Reproduced in colour on front cover)

4.24 (left) Detail of a ceremonial head-dress from near Port Moresby, Niugini. Incised turtle-shell and feathers. Australian Museum, Sydney

4.25 (right) Incised decoration on a fish-shaped wooden dish from the Trobriand Islands. The eye is a shell from which the outer layer has been removed.

Few of the traditional arts are still practised by the Maoris, who are becoming increasingly westernised.

Earlier inhabitants of Easter Island carved giant stone monuments representing human heads and complete figures (**4.18**) in an elongated and simplified style. The quarries from which these stones were cut still exist and some unfinished pieces lie in or near them. The present inhabitants of the island do not know how or why these monuments were carved, how they were transported, or what happened to the original inhabitants, who seem to have disappeared suddenly and completely.

Tapa is a type of cloth made in Oceania by soaking pieces of the bast (inner bark) of trees such as the paper-mulberry, beating them until they soften and spread, and felting them together to make larger sheets. Tapa is decorated with abstract designs, partly by rubbing dye on the cloth, which is stretched over boards carved in relief, by printing with relief blocks or from leaf-stencils, or by painting with a brush.

Mats and bags are woven from various fibres using a wonderful range of weaves and patterns. Ceremonial costumes are especially important in Melanesia. Masks and headdresses are made from shells, softwood, tapa, feathers and woven palm leaves (**4.24**). They are often painted with natural earth colours.

In Niugini, the men's ceremonial houses are repositories for

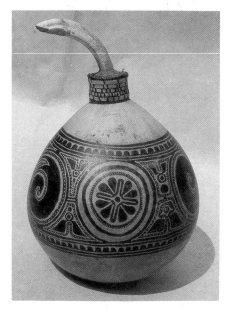

4.26 Palm-leaves skilfully plaited to wrap vegetables in the market of Santo, New Hebrides.

4.27 Tapa cloth, Fiji.

4.28 Lime container from Niugini. A dried gourd, painted and incised, with a boar's-tusk stopper.

painted shields and ancestral boards (*kwoi*) and wickerwork masks and fantastic animals (*kaikaimuni*) up to 4 metres long.

The Melanesians made cooking-pots from low-fired ceramic (see **1.9**).

Things to do

1 Read about Australian Aboriginal legends in one of the excellent illustrated books available on the subject.

2 Make a painting on a piece of bark using charcoal, ochres, and other earth colours.

3 Draw a map of Africa, Australia and Oceania, marking all the places mentioned here, and others discovered through your own research, where people still practise 'Stone Age' technology.

4 Make an incised carving in a piece of softwood (not necessarily using one of the styles illustrated in this section, but your own), and inlay the design with pieces of shell, metal, etc.

5 Make a carving in the round in such a way that the original form of the block of material remains visible.

5 The Amerindian civilisations and cultures

After Columbus' first voyage to America in 1492 Spanish, Portuguese, English and French began to settle there. But the land had already been occupied for thousands of years by people whom we call collectively 'Amerindians'. Of these, the Aztecs, the Mayas and the Incas reached remarkably high levels of civilisation and artistic skill, although they only possessed Stone-Age technology.

The 'Red Indians' of North America, many of whom were nomadic, had very impermanent homes. Many of their descendants now live in the towns and cities of Canada and the United States, although many live on reserves where they still preserve much of their ancient culture. The Mayas and (later) the Aztecs lived in Central America and Mexico. They lived in cities, made fine buildings, could write, and were very religious. Maya mathematicians invented the concept of zero, and their calendar was more accurate than our own (in 10 000 years, our calendar yields an error of three days, whereas in the Mayan calendar the error is only one day).

The Incas lived on the slopes of the Andes Mountains in what is now part of Peru and Columbia. They terraced the hillsides and built cities, roads and suspension bridges with fine masonry that was strong enough to withstand the frequent earth tremors of the region. They subdued many neighbouring peoples and built an empire stretching west of the

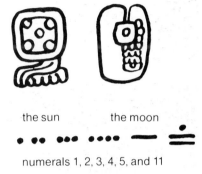

the sun the moon

numerals 1, 2, 3, 4, 5, and 11

5.1 Mayan hieroglyphics

numerals 1, 20, and 400

20 gourd dishes of gold dust

5.2 Aztec hieroglyphics

5.3 The 'Pyramid of Niches' at the El Tajin ceremonial centre, Mexico. This is a model of the temple as it would have looked when new. Its name comes from the 365 niches — one for every day of the year: something the Totonac astronomers apparently knew in 1000 BC, many centuries before their European counterparts did. Stone. Height approximately 65 m. Model in National Institute of Anthropology and History, Mexico.

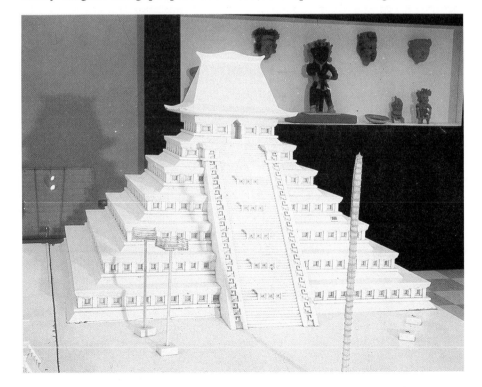

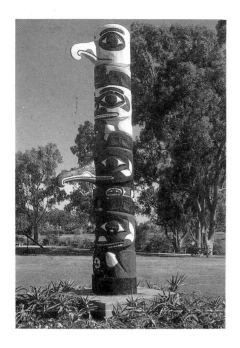

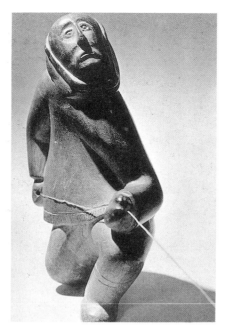

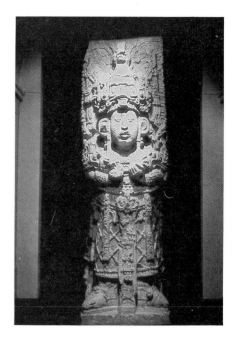

5.4 Totem-pole, carved from Western Red Cedar by a Tsimshian Indian in 1970 and presented to the children of Adelaide by the Council of Forest Industries of British Columbia. Bonython Park, Adelaide.

5.5 (centre) Man Fishing. Soap stone. Height about 25 cm. Eskimo

5.6 (right) Cast of Stela H, Copain, Honduras. Maya, AD 731. The original is of trachyte stone. Height 3.2 m. Museum of Mankind, London

Andes to as far south as central Chile. The Mayas, Aztecs and Incas had gold and silver, and the Incas knew bronze too, but they used it mainly for making ornaments.

A number of domesticated plants and animals, now common in other countries, had their origin in America. These include tomatoes, pineapples, manioc, potatoes, cocoa, tobacco (*cigar* is Mayan for 'to suck'), avocado pears, corn, balsa, mahogany, rubber, capsicum, sisal, quinine, cocaine, several members of the pumpkin family, guinea pigs and turkeys. The ruins of the Mayan temples were discovered by men searching for the sapodilla plant, which yields chicle, the basis of chewing gum!

When the Spanish *conquistadors* arrived in America they forced the people to become Christians and overthrew the civilisations they found there. The fine gold and silverwork of the Aztecs and Incas was melted down and made into coins; this money was used to pay the Spanish shipbuilders who built the Armada of 1588. It was on the ships taking this treasure back to Spain that the English buccaneers used to prey.

Architecture

The Mayas and Aztecs built pyramid-temples (*teocalli*) of stone (**5.3**). A pyramid-temple was a step pyramid with steep stairways leading to a small temple on the top. On the altar in front of this temple, the Aztec priests used to sacrifice humans to the sun god. On the top of the temple was a richly carved roof-comb. Some of these pyramids contain the tomb of an important person, as do the Egyptian pyramids.

Some of the aboriginal people who live in the southern USA still make and live in *pueblos*. These are villages made of sun-dried mud (*adobe* and *pisé*). There are no individual dwellings. The entire village is made in one piece and looks something like a block of flats. Originally there were no doors at ground level — the entrances were in the roof and ladders to them were pulled up at night to keep out raiders.

The Red Indians of the plains lived in *tepees* or *wigwams* made of skins, and the Eskimos still do in the warmer months — though for the winter

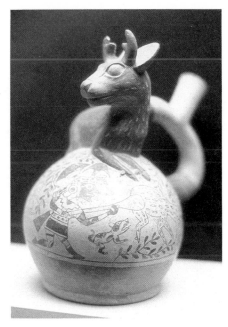
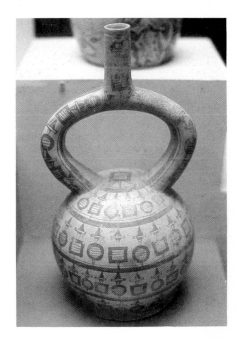

they make *igloos* from blocks of frozen snow. The igloo is actually a dome, each block shaped like a keystone (see p. 87 and **16.8**).

Ancient South American cities, like the Incan Machu Picchu, were terraced into the mountain sides. They were made of hard stone which was very skilfully carved with stone tools to make precise joints. The stones were closely fitted, without mortar, and many were irregular in shape and keyed together, making the buildings stable in earthquakes. Many of the Incan buildings were so solid that today they form the foundations of more modern structures.

5.7 (left) Quetzal-coatl, the Aztec god symbolizing the union of the earth and the sky, was represented as a feathered serpent. He was also the god of civilisation and art. Basalt. Height 1.7 m. National Institute of Anthropology and History, Mexico

5.8 (centre and right) Two stirrup-handled bottles from the Mochica culture in Peru. AD 200–750. Museum of Mankind, London

Other arts

Some Red Indians have become competent artists in the Western style, but originally their art was highly conventionalised. Traditional patterns were used in the styles characteristic of many tribal societies (**5.11**). The Mayas and Aztecs were able to draw heads in three-quarter view; no other comparable civilisation (compare, for example, the Egyptians) achieved this.

Some Red Indian tribes carved wooden masks and totem poles (**5.4**). Before the introduction of steel tools, totem poles were quite small, but later poles were very large. Their function is similar to the European coat-of-arms — they represent the history or traditions of the clan.

During the long winter months the Eskimos carve fine statuettes of stone and bone. Their realism and sense of humour are unusual (**5.5**). Many are carved simply for amusement, although some are used in fertility- or hunting-magic.

Mayan and Aztec sculpture included stone *stelae* (**5.6**), which were carved in relief on all four faces, ceramic figures, and ritual objects covered with *mosaic*. Both the Aztec and the Andean craftsmen made fine small sculptures from gold and silver.

Andean, Mayan and Aztec pottery was fine although, as the civilisations had no knowledge of the wheel, the potters used the coil method, or formed the clay over moulds.

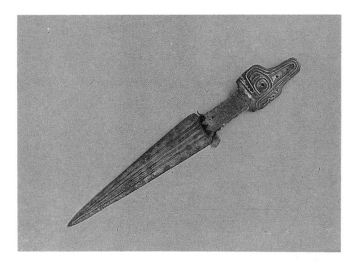

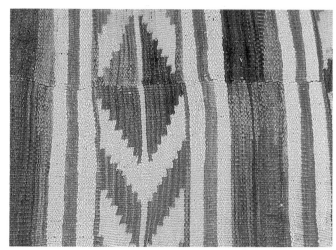

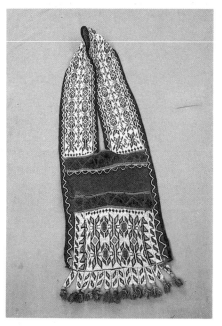

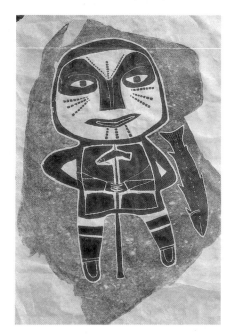

5.9 (above, left) Double-pointed fighting knife. North-west coast Indians (Tlingit Tribe). Made of iron which was probably traded from Siberia. Length 50 cm. Photograph: South Australian Museum.

5.10 (above, right) Detail of a woollen blanket. Mexican. Photograph: South Australian Museum

5.11 (left) Pouch worked in glass beads obtained by trading. From Wisconsin. Photograph: South Australian Museum

5.12 (right) Fisherman. Stone-block print. Eskimo.

All the Amerindians used a simple loom to weave complex and colourful textiles.

The Apache wove baskets so tightly that they could be used for carrying liquids. Some Eskimos have learned to print from stone blocks and seal-skin stencils, and produce fine work in these media, which are exotic to them (**5.12**).

Things to do

1 Paint or carve a totem pole similar to those made by the Red Indians.
2 Find a map of America which gives the location of the peoples mentioned here.
3 Design a totem pole using as motifs things that symbolise our modern way of life.
4 Make a stencil-print. Study examples of Eskimo printing before you do so.
5 Make a piece of pottery using the coil method.

6 Ancient Mesopotamia

6.1 Cuneiform from a relief from Nimrud. Stone. c. 880 BC. British Museum, London

Humans first became civilised (*civis* = city) in Mesopotamia, now part of the middle eastern country of Iraq. Mesopotamia means 'land between the rivers', referring to the twin rivers, Tigris and Euphrates, which water this flat silt-plain. In ancient days, this area was part of the 'Fertile Crescent' which stretched from northern Egypt across Palestine to the Persian foothills, and which was an important centre of origin of domesticated plants and animals. The early inhabitants constructed great irrigation systems in Mesopotamia, but these have been neglected and much of the land is now desert.

Ancient cities, deserted and covered with sand, are being excavated. Jericho and Eridu, among the oldest cities yet discovered, were well established by at least 4000 BC. It appears that the Mesopotamians had interests similar to our own, and that they were among the first people to have writing, architecture, mathematics and science.

There was a continuous struggle for power over the centuries. The Sumerians, who held sway from about 3500 BC, invented the *wheel*, including the potter's wheel, *arch-building* and a system of writing called *cuneiform* which was done by impressing the end of a stick (*stylus*) in a wet clay tablet. This made wedge-shaped marks (*cuneus* is Latin for 'a wedge'). Official signatures were made by rolling cylinder-shaped *seals*, beautifully inscribed in intaglio, onto the soft clay. The seals were about one inch high and made a relief impression in the clay. Some of our own alphabet is derived from cuneiform.

The Sumerians were the first people to have drilled and uniformed armies, and to have a calendar. They were also the first to divide time

241
(1 x 100 + 1 x 100 + 10 + 10 + 10 + 10 + 1)

6.2 Cuneiform numerals

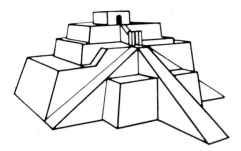

6.3 The Ziggurat at Ur, a simplified drawing of how it must have looked originally. Height about 28 m. 2300–2180 BC.

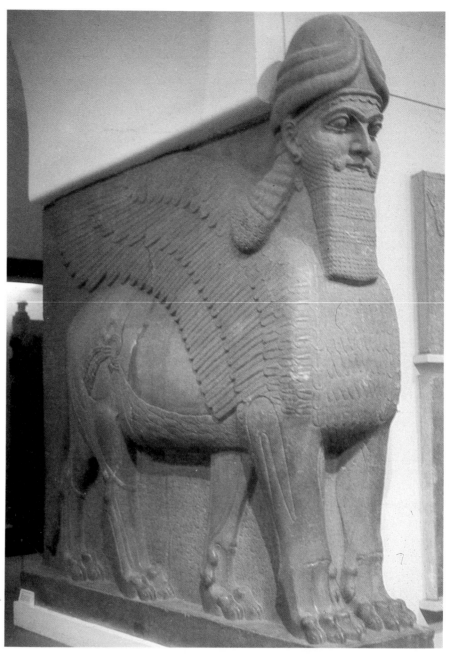

6.4 A human-headed winged lion guardian of the gateway to the throne room of Ashurnasirpal II of Nimrud. Stone. Height about 4 m. About 880 BC. British Museum, London

into units based on 60, and the circle into 360 degrees. King Hammurabi, of Babylon, formulated the world's first code of laws.

The Sumerians were followed by the Semites, Kassites and Assyrians. The Assyrians introduced the horse, made the first chariots, and invented the battering-ram and crenellated fortifications (**6.8**), all of which changed little up to the end of the Middle Ages.

The Persians built the first great empire, which stretched from Egypt to part of Greece. They were succeeded by Greek and Roman conquerors and, finally, by the Arabs, who established the Islamic culture of today.

Architecture

Because there was little wood or stone suitable for building available, the Mesopotamians could not use the post-and-lintel building principle.

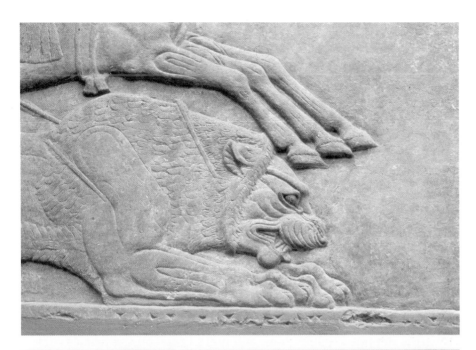

6.5 Wounded lion trampled by horses; alabaster relief from the Palace of Ashurnasirpal II showing sensitive representation of an animal. About 880 BC. British Museum, London

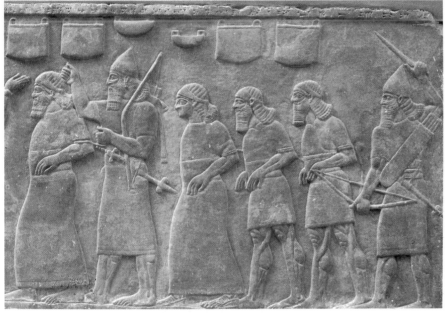

6.6 Assyrian soldiers with captives; alabaster relief from the Palace of Ashurnasirpal II showing how the sculptors of the day had difficulty showing shoulders in profile. Height of relief about 100 cm. British Museum, London (Reproduced in colour on front cover)

They developed the *arch* using bricks made from mud or clay (their universal media), and set in bitumen.

Mesopotamia is a flat land and it seems that the religion of the Mesopotamians required the building of artificial hills with temples on top (*ziggurats*). The ziggurat (**6.3**) was the dominating building in every city. It was not a tomb, like the pyramid, but was solid and built of brick. Most were built in terraces, with stairways leading to the shrine on the top. Gardens were planted on the terraces. The ziggurat at Ur was painted black on the bottom storey and red on the next. The walls of the shrine were of blue tiles and the domed roof was gilded. These colours probably symbolised the underworld, the earth, the sky and the sun.

However, there seems to have been no set form of the ziggurat, as the ruins of several different shapes have been found. The biblical Tower of Babel and the Hanging Gardens of Babylon may have been ziggurats, or buildings of a similar type.

6.7 Guilloche with rosettes

6.8 Attacking soldiers swimming a moat (two of them supported by inflated sheepskins); from the Ashurnasirpal reliefs. British Museum, London

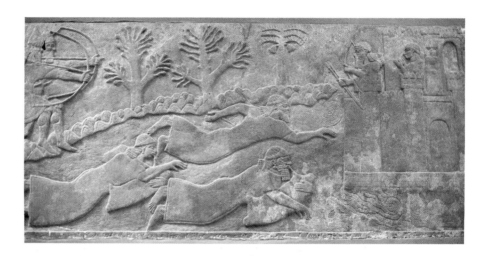

Other arts

The only painting to survive to present times is on the glazed tiles which were used in architectural decoration. The most outstanding example of this art is the procession of lions and other beasts on the Ishtar Gateway of Babylon, although numerous examples of the traditional guilloche, palmette and rosette motifs survive (**6.7**).

Apart from many clay figurines and some stone figures, there was little Sumerian sculpture in the round. The famous *Ram in a Thicket* and harp found at Ur were made of pieces of gold, silver, shell and lapis lazuli fixed to a wooden base by copper rivets and bitumen.

The Assyrians made stone sculptures of monsters with bulls' or lions' bodies, human heads and wings (*lamassi*). They were partly in the round and partly in relief and were placed at palace entrances, probably as guardians (**6.4**). One front leg in each is duplicated, and consequently· from some viewpoints they seem to have five legs. Their sculptors must have wished to make sure at least four would be visible from any side. Imported stone was often cut into thin slabs and carved in relief. The alabaster frieze from the palace of the Assyrian King Ashurnasirpal, at Nimrud, contains some of the most realistic animal sculpture of all time, although some of it is stylised and some of the conventions of primitive sculpture are evident (**6.5–6.8**).

The Persians were excellent craftsmen in bronze, gold and silver. The ruins at Persepolis, the magnificent ceremonial centre built by the Persian kings Darius and Xerxes and laid waste by Alexander the Great, are a treasure-house of Persian stone sculpture.

Things to do

1 Find a map of ancient Mesopotamia and study the location of the nations mentioned in this chapter.
2 Construct an arch by making blocks from modelling clay or soap. Refer to section 1 for the shape of the blocks.
3 Find as many examples of Mesopotamian art as you can in reference books.

7 Ancient Egypt

7.1 A view of the Nile Valley showing that there is a narrow strip of fertile irrigated land on each bank, then desert beyond. Photograph: Robert Hardy Picture Library

The Nile Valley is a relatively narrow strip of fertile land in the desert of North Africa. The people who inhabited the region in ancient times had developed an advanced civilisation by about 3200 BC. Although cities were never very important to the Egyptians, they built many fine monuments and an irrigation system which supplemented the annual floods of the Nile. They developed a system of picture-writing (*hieroglyphics* **7.2, 7.3**) on *papyrus* — a kind of paper which they made from the pith of the papyrus reed (**7.4**) by soaking it and spreading the fibres by beating.

The Egyptians were strongly religious, believing very sincerely in life after death and, for this reason, they mummified their dead and buried them in tombs which were more durable than their homes. The king (*pharaoh*) had absolute power because he was believed to be an incarnation of the sun-god himself. Much labour and money was expended on his tomb, which was furnished with richly-wrought belongings, food and statues (*ushabti*: **1.31**) and pictures of himself, his family and his servants.

The Egyptians never buried these actual people with the pharaoh, believing that their spirits would become inherent in their replicas and so serve the pharaoh's spirit (*ka*) in the next world. In the dry climate of Egypt, many of these grave objects have been preserved, and from them were derive most of our knowledge of the ancient Egyptians. However, only one tomb of a pharaoh has escaped the ravages of grave-robbers and come down to us completely intact. This is the tomb of the boy-king Tutankhamen.

7.2 Egyptian hieroglyphics: 'The king captures the men from the papyrus lands'

The most striking characteristic of Egyptian art is its size. Much of the architecture and sculpture, like the famous pyramids and the Great Sphinx, is colossal; but Egyptian art is also notable for its linear grace and sense of proportion and placement. This is particularly noticeable in the paintings and reliefs (**7.3, 7.12**).

The huge buildings were built by master-masons directing thousands of labourers, but these were not slaves and there is no evidence that they were ill-treated. They were probably farm-workers who gave this service to the pharaoh during the annual floods (between July and November) which prevented them from working their land.

Egyptian art shows little stylistic change over the 3000 years of its history.

Architecture

Houses were built of mud-brick, wood and stucco, and probably many were very comfortable. The nobility lived in fine mansions, but none of these remain to this day. This is in contrast to the temples and tombs, which were in general built of stone and intended to last.

The walls of Egyptian buildings were *battered* (i.e. sloped inwards towards the top) and the *post-and-lintel* principle (**1.12**) was used because stone was plentiful. From the appearance of surviving examples, it is probable that the earliest columns were palm trunks or bundles of papyrus or lotus reeds. Later, when stone columns were made, they were carved to represent the wooden prototypes (**7.7**).

The *mastaba* was the most common form of tomb but, during the 'Pyramid Age' (about 2800 to about 2200 BC), the pharaohs were buried in *pyramids*. There are many pyramids in Egypt, but the three best known are at Giza, near Cairo. The pyramid of Khufu (or Kheops, in the Greek form of his name) covers more than 5 hectares and was 46.7 metres high. It is the largest pyramid and is known as the Great Pyramid (**7.9, 7.10**). The two other large pyramids at Giza were built by Khafre (or Khephren) and Mycerinus.

It has been estimated that there are 2 300 000 blocks of stone in the Great Pyramid, some of them weighing up to 15 tons. Originally this huge structure was faced with white limestone, which must have shone in the sun, but much of this casing was reused to build Cairo. The Great Pyramid was surveyed with remarkable accuracy, the four sides (each 229 m long) differing from each other by only a few centimetres. Its square base deviates only 1.5 cm on one side from a truly level plane. Inside this solid mass of masonry, three corridors lead to chambers, one of which contains the Pharaoh's sarcophagus. A causeway connects it to a temple on the river bank.

The first pyramid was built at Sakkara for Zoser by the architect Imhotep, who was later deified. It is a step-pyramid.

The Egyptian *temple* was a huge structure. The statue of the god to whom it was dedicated was placed in a small dark sanctuary at its furthest end. To approach it, one had to pass through a number of larger and better-illuminated rooms. There was a huge pylon on each side of the entrance, and a pair of *obelisks* and an avenue of sphinxes in the front (**7.5, 7.6**).

There was actually very little space inside an Egyptian temple because of the massive size of the columns needed to support lintels in such a large-scale building. However, as the Egyptian religion did not require the participation of a congregation in worship, the cluttered interior did not matter.

Stone for building was often quarried a long way from the site and

7.3 Hieroglyphics carved intaglio. From the 'King list' of pharaoh Rameses II (about 1270 BC) listing the names of those of Rameses' predecessors to whom he gave offerings from his temple. Each king's name is in an oval *cartouche*. Limestone. British Museum, London

7.4 Papyrus reed

7.5 The temple at Luxor. In front of the pylon gateway is an obelisk. The recesses in the bases of the pylons held flag-poles. The ruins of the rest of the temple may be seen through the opening. Photograph: Giraudon

blocks weighing up to 200 tons were transported by barges on the Nile and on sledges and rollers over the land. Until about 2000 BC the Egyptians had only copper tools and we do not know how they hardened them to enable their masons to cut stone as hard as granite and diorite. At the building site, the stones were dragged up earth ramps which were made larger and higher as the building progressed. A temple would be filled to the ceiling with earth by the time it was completed and, as the earth was taken away, the walls were painted and carved in relief, working from the top.

7.6 Plan and elevation of a typical Egyptian temple; (a) sanctuary; (b) hypostyle hall; (c) open courtyard; (d) pylons; (e) obelisks; (f) end of avenue of sphinxes.

papyrus flower papyrus bud

7.7 Columns with papyrus flower and bud capitals

7.8 (top right) The Great Sphinx, Giza, with the pyramid of Khephren in the background. Photograph: *Giraudon*

7.9 (lower right) The Great Pyramid, Giza. Most of the outer casing has been removed over the centuries, the stones having been used in other buildings. The human figures show the scale. Photograph: *Herald and Weekly Times*

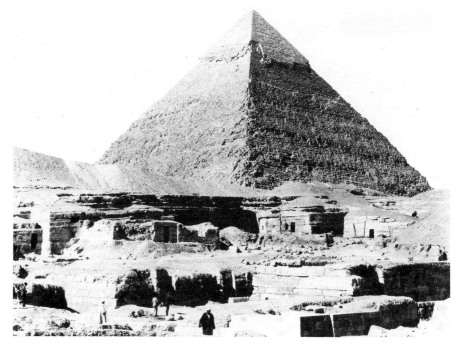

Sculpture and painting

Egyptian sculpture in the round was frontal (see **1.31** and **7.11**). Many wood or stone carvings of pharaohs have survived to today. The temple pylons and columns and inside walls of tombs were carved in relief (**1.30**) with scenes illustrating everyday life, or stories of the gods.

Many sculptured sphinxes exist in Egypt. The Great Sphinx at Giza was carved from a knoll or rock left by the builders of the Great Pyramid, plus other added pieces of stone. It is about 73 metres long, 20 metres high, and about 14 metres across the face. It appears to be the head of the Pharaoh Khephren on a lion's body. It has been damaged

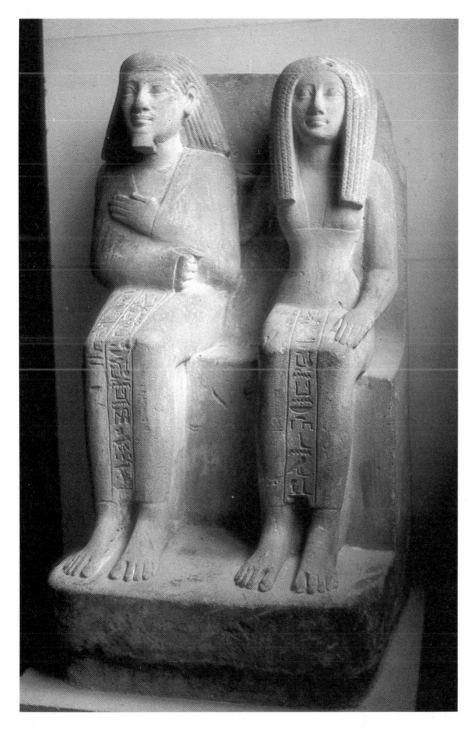

7.10 Section of the Great Pyramid: (a) limestone sheathing; (b) entrance; (c) original burial chamber; (d) concealed entrance to burial chamber; (e) the grand gallery; (f) 'the Queen's Chamber'; (g) 'the King's Chamber'

7.11 Pharaoh Djehoutineper (or Sechov) and his wife Benemer. Sandstone. About 1400 BC. Height about 90 cm. Louvre, Paris

and repaired many times. The significance of the sphinx still remains a mystery.

In painting, as in relief-carving, Egyptian artists did not aim at naturalism. For example, when they represented humans they drew the faces and limbs in profile and the shoulders, eyes and hands in front view (see **1.30, 7.12, 7.13**); and important people were drawn larger than less important people. These are all characteristics of primitive art. However, these conventions were not observed in pictures of pieces of sculpture (**7.13**), and it seems that the Egyptians, when they used primitive conventions, did so intentionally. The style of Egyptian painting and relief sculpture is in fact a very good example of *conventionalisation*.

7.12 Portion of a coloured stone relief showing the typical profile head with shoulders from front view. Vatican Museum, Rome

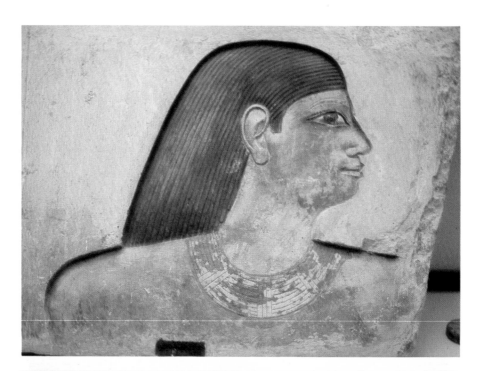

7.13 An Egyptian sculptor working on a sphinx, from a wall painting in a tomb (about 1400 BC). Note how the painter has used the front view for the sculptor's shoulders, but those of the sphinx are represented truly in profile. This means that Egyptian artists chose to represent people the way they did.

7.14 (right) Pharaoh Rahotep seated before a table of offerings and a list of equipment for this tomb. Stone relief. About 2550 BC. British Museum, London

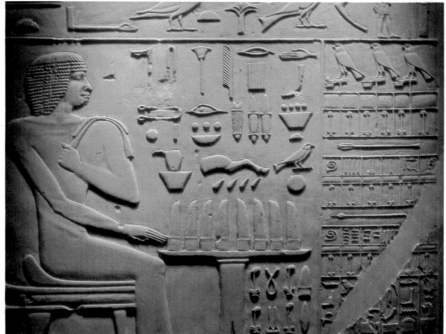

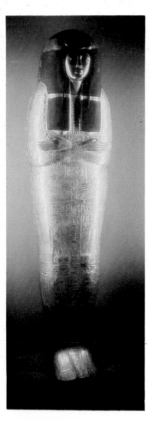

7.15 The inner coffin of the Chantress of Amen-Re. Gilded wood. About 1290 BC. British Museum, London

Things to do

1 Make a table of the dates of Egyptian royal dynasties.
2 Look up pyramids and sphinxes in a reference book and find out more about them. Try to discover the difference between the Egyptian sphinx and the Greek sphinx.
3 Paint a picture using the conventions of the Egyptians.
4 Find out what you can about the many gods of the ancient Egyptians.
5 What is the Rosetta stone?
6 Read about hieroglyphics and the development of writing to the present day.

8 The Indus civilisation

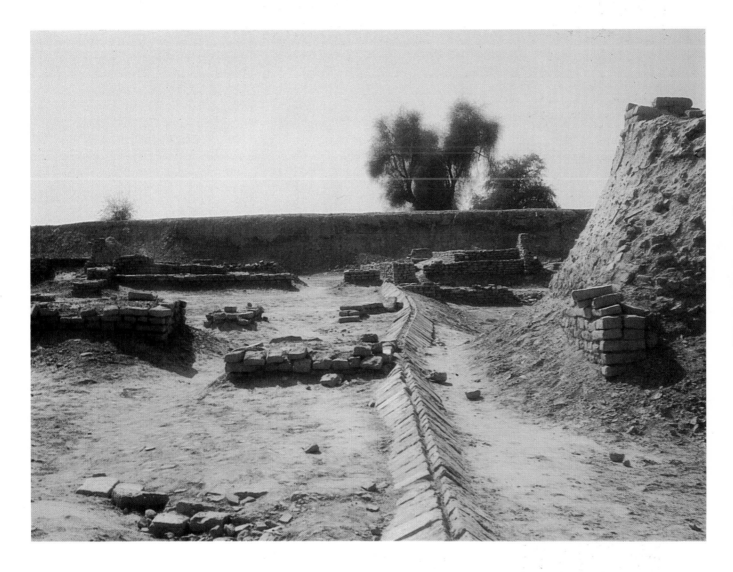

8.1 The excavation of the site of Harappa. Extensive remains of brick buildings have been found. Running through the centre of this picture is a covered brick drain.

Whereas the great civilisations of Egypt and Mesopotamia had been known, if only by repute, to Western people since ancient times, the civilisation of the Indus Valley in India was a 'lost civilisation' until its discovery early this century. However, it now appears that conditions in the Indus Valley in ancient times were similar to those in Egypt and Mesopotamia — fertile alluvial soil, favourable climate, plenty of water for irrigation, and a stone age and bronze age foundation on which to build. It is not surprising, therefore, that there should have developed, by 2500 BC at the latest, a civilisation stretching more than 1500

8.2 A corbelled arch — commonly used by the Indus builders.

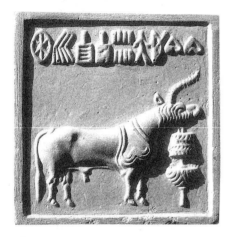

8.3 An Indus seal. Height 6 cm. We do not know how to read the writing symbols nor the significance of the single-horned animal and the other object represented. Stone. National Museum, Delhi

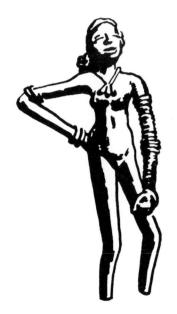

8.4 The famous copper figurine of a dancing girl, c. 2500 BC Height 10.8 cm.

kilometres along the banks of the Indus River and including 100 villages and two giant cities — Mohenjo Daro ('Mound of the Dead') and Harappa.

The citizens of these communities had their own system of writing but, because it has not yet been deciphered, we know comparatively little about them and their civilisation. It is certain that they had commercial links with Mesopotamia, as a cylinder-seal has been found in Mohenjo Daro and some Indus pottery in Mesopotamia. They signed their clay documents in much the same way as the Mesopotamians did, using seals (**8.3**) which were flat and rectangular in shape, about half the size of a matchbox, and finely engraved to represent animals (which seem to have had more than ordinary significance for them). Clay was the universal medium, just as it was in Mesopotamia. Cotton was first cultivated here.

It seems that the Indus civilisation was very highly organised. The earliest cities were well laid out on symmetrical and regular plans of broad streets with efficient systems of covered brick drains (**8.1**) and of rubbish disposal. The sumps in the drains have yielded many archaeological treasures. It was also a conservative and peaceful civilisation, which was apparently undisturbed by foreign invasion until about 1500 BC, when it appears that the ancestors of the present inhabitants of India made a sudden and quick conquest from the north, massacring the people and laying the cities waste. The Rigveda, an ancient sacred book of the Hindu Indians, tells of how their Aryan forbears destroyed the forts of an earlier civilisation — a possible reference to the Indus civilisation.

Architecture

The extensive ruins of Harappa and Mohenjo Daro are built of baked clay bricks set in mud mortar. The builders did not, however, use the true arch, but made *corbelled arches* over openings (**8.2**).

The purposes of the various buildings that have been found are not very clear, but houses apparently had brick first storeys and wooden second storeys, and were plastered inside with mud. All contained lavatories, and chutes to discharge refuse into pits in the street. Bathing seems to have been important, probably in connection with religion as it is to Hindus today; in Mohenjo Daro a large brick-paved bath-house has been found. However, nothing has yet been found which can definitely be described as a temple.

Other arts

No *painting* has yet been found and the only *sculpture* consists of some small figurines and stone figures of seated bearded men. The figurines show keen realism and a sense of humour (**8.4, 8.5**).

The most outstanding examples of Indus art are the seals, which are beautifully carved.

Jewellery seems to have been the main article of clothing, particularly among women, and some beads made of clay, faïence, jadeite and gold have been found, together with terracotta buttons. Bronze needles and utensils used in manicure and for applying cosmetics; stone weights; and clay marbles, dice, gamesmen and a checker-board for use in a game like chess have also been discovered.

Wheel-thrown *pottery* with clean lines and stylised painted decoration has also been found (**8.6**).

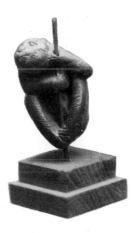

8.5 A beautifully observed and modelled monkey of fired clay. Found at Mohenjo Daro. Height 6 cm. National Museum, Delhi

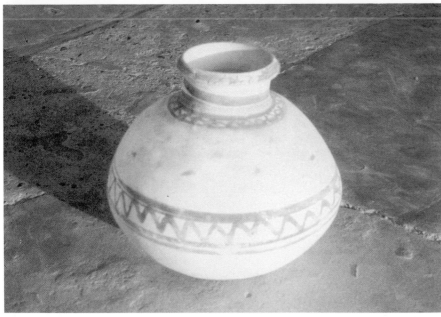

8.6 (top left) 3000-year-old pots found at Harappa: National Museum, Delhi; and (bottom) a pot used by a modern water-seller in a village near Harappa. The continuity of the tradition is obvious.

Things to do

1 Make some figurines from rolls of clay in the manner of the Indus sculptors.

2 Make some ceramic jewellery using a plaster press-mould carved in relief like the Indus seals.

3 Incise a block of wood, plaster or stone with a design so that it will make a pattern when pressed onto soft clay.

9 India and Hinduism

As we discovered in section 8, the Indus civilisation in India probably dates back as far as those in Egypt and Mesopotamia, but was completely destroyed about 1500 BC. About this time a race known as the *Aryans*, who had inhabited the area around the Caucasus Mountains since very ancient times, began to migrate into neighbouring lands, in each of which they initiated very influential civilisations. Some Aryans moved south into what we now know as Greece and Iran, and the great Greek

9.1 (right) Kandarya Mahadeva temple, Khajuraho, India. Stone. c. AD 1000. The shrine is under the tallest spire and the dance-floor just inside the entrance at the top of the steps at the right. An excellent example of the north-Indian temple.

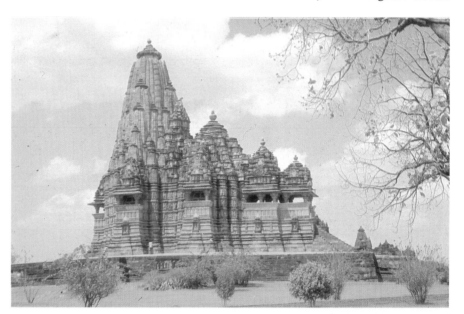

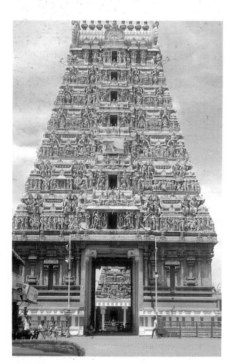

9.2 One of the gateways (gopuras) to the Mylapore Temple, Madras, south India.

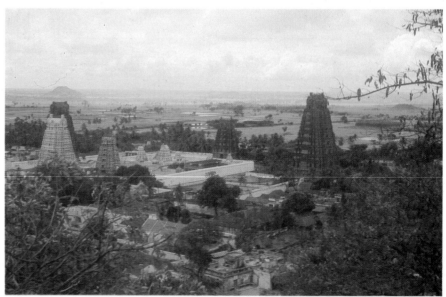

9.3 (right) A typical south-Indian temple-complex.

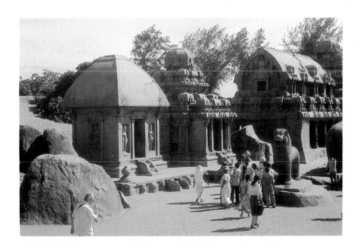

and Persian civilisations resulted; others moved west and are the forbears of modern Europeans.

The division of the Aryans we now call the *Hindus* invaded the north of India, apparently destroying the Indus civilisation and initiating modern Indian culture. It seems that the leaders of these ancient Aryans established the *caste system* to preserve their dominance over their own subjects and the people they had conquered, and it is still a strong force in India today. The priest, ruler and warrior castes are regarded as superior to traders, artisans and labourers; and the lowest in the social scale have no caste at all.

Hinduism

Hinduism, the religion of the Hindus, commands our respect because it is the world's oldest surviving major religion, and also because a very large number of people who live in the Asian countries nearest to Australia adhere to it. Hindu influence spread to countries such as Kampuchea (the Khmer period of the ninth to fifteenth centuries AD), Thailand and Indonesia, where its influence on life and art is still felt today.

9.4 (top left) The Raths at Mahabalipuram, south India. This series of small shrines and large animal sculptures was carved out of the solid rock in the early seventh century AD. Although carved out of stone they are models of various styles of temple of the period, the one on the left obviously representing a thatched roof. The lion is a symbol of royalty.

9.5 (top right) A performance of a shadowplay (*wayang kulit*) in Java, Indonesia. The characters and story are from the Hindu epic story, the *Ramayana*, and Mt Meru is represented at the left. Hinduism and Buddhism spread to Indonesia in the early centuries AD.

9.6 (lower left) Prambanam, Java, built in the ninth century AD when Hinduism was strong in Java. The cosmic-mountain form seems almost real in this photograph.

9.7 (lower right) A series of shrines in Katmandu, Nepal, dedicated to Brahma (the bull) and Shiva (the trident and lingam)

9.8 (left) The *lingam*-and-*yoni* symbol, representing the male and female principles, associated with Shiva worship.

9.9 (right) The cosmic mountain represented in palm-leaves — part of a banner made for a religious procession in Bali. Bali is the only Indonesian island where a form of Hinduism has survived until today.

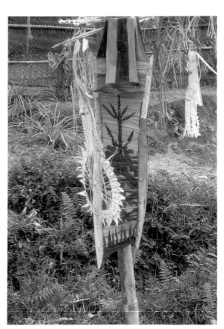

9.10 Sculpture on the outer wall of the Kandarya Mahadeva temple (**9.1**) — in typical sensuous, curvilinear style heavenly beings are represented giving praise to the gods. The loving couples are part of the sexual symbolism which is an important part of Hinduism and related to Shiva worship.

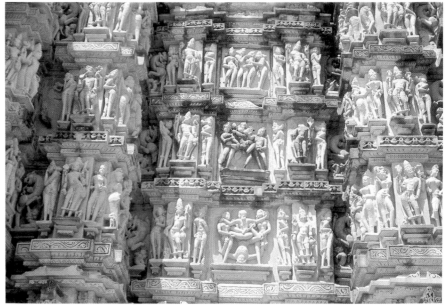

In Hinduism god has many forms, the chief of which are *the trimurti*: Brahma (the Creator), Vishnu (the Preserver), and Shiva (the Destroyer; **9.11**). Hindus believe in living in peace and not taking life in any form (except as part of ritual sacrifice). Consequently, they are vegetarians; the highly spiced food of India, such as curries, is perhaps a result of this.

Hinduism holds that people's souls survive death and are *reincarnated* in other lives (human or animal), that this process has gone on from the beginning of time, and that it continues for each soul at its own pace until it reunites with the divine universal, *Brahman*. Through successive reincarnations of leading a good life and practising spiritual discipline through such activities as daily ritual (*puja*) and meditation (*yoga*) in each incarnation, a soul migrates upwards through the case system to the very highest spiritual level and is never again reborn into the world.

The doctrine of reincarnation is also known as *transmigration of the soul*.

Other religions

We should note that, although Hinduism is the most important, there are other religions in India. Christianity is by no means absent and, from the ninth century AD, Islam spread eastwards from Arabia, the home of Mohammed, into India. There followed centuries of strife between the Moslems and Hindus until the situation was partly resolved when the Moslem states of Pakistan and Bangladesh were formed in 1947 and 1971, respectively. Moslem (Islamic) art is discussed in section 11.

Buddhism flourished as a reaction to Hinduism for many centuries but is now practically non-existent in India (see section 10).

Religion and art in India

Because religious belief and practice so dominate Indian life, there is no important Indian art which is not religious art. All religious art may only be created according to established rules, traditions and canons. There is therefore no room for the individual creativeness or interpretation which are so much a feature of modern Western art. This means that Indian art is more accurately described as *craft*, in the sense that we distinguished between the two in section 1.

Architecture

The temple is the centre of all Hindu life and culture — not only of religious observance. In past ages it was the court of the ruler as well as a meeting place for scholars and teachers, which it still is today. The creation of a temple and the sculpture which is an integral part of it may only be done by men who have been born into a certain caste and whose lives are as devout and controlled as those of the priests. Artists usually follow their fathers and undergo intensive training in the established rules, traditions and canons. Their works must please god — not man — and excellence is measured by closeness to model examples from the past. Consequently, there has been little change in style over the centuries and the names of individual artists and craftsmen is never recorded. Architects, builders and sculptors may only work after profound meditation and purification.

The general shape of the temple is that of the sacred cosmic mountain range which is believed to be at the centre of the spiritual universe; it is called either Mount Meru or Kailasa. This symbolism is most evident in the north-Indian type of temple (**9.1**), which is a massive solid-looking structure (*sikkhara*) covered with sculptures of the gods. South-Indian Hindu temples are large, walled quadrangles containing various shrines (**9.3**); but the many-storeyed gateways (*gopuras*) in the walls have the typical mountain form (**9.2**).

In Hinduism all the arts are integrated — for example temples have dance-floors on which musicians and dancers perform as a regular part of religious observance, and the themes are common to the music, the dance and the sculpture on the walls. One aspect of Shiva (*Shiva Nataraja*: **9.11**) is Lord of the Dance and some dances in Hindu ritual symbolise the 'cosmic dance' of destruction and re-creation.

Sculpture

Indian sculpture has sensuous, rhythmic lines and curved forms. Stone and bronze are the chief materials used because permanence is important. In some examples there is little sense of design or restraint, and the colour may be garish, but the best sculpture is stylised and graceful.

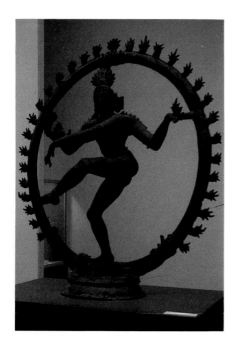

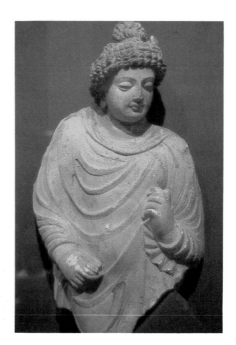

9.11 (left) Shiva Nataraja. Cast copper. Height approximately 1 m. Eleventh century AD. Shiva is here represented as Lord of the Dance, symbolising his life-giving aspect and triumphing over evil (the figure under his feet). The Cleveland Museum of Art; purchased from the J.H. Wade Fund.

9.12 (centre) Dancing *apsara* (heavenly being), from one of the temples in Khajuraho, India, representing a being who inhabits the slopes of the cosmic mountain. Stone, c. 1000 AD.

9.13 (right) After Alexander the Great conquered the lands to the northwest of India (fourth century BC), Greek styles influenced Indian art, as is shown in this stucco sculpture of the Buddha from Afghanistan (cf. **15.12**). The style is known as Gandhara or Hadda. The National Gallery of Victoria: Felton Bequest

Painting and crafts

In Indian painting perspective and foreshortening are regarded as secondary to pattern, colour and design. Hence, Indian pictures often seem to lack realism to Western eyes. However, once one learns to appreciate Indian painting in terms of pattern and colour, a world of beauty and sensuousness is revealed to the discerning viewer.

For centuries, Indian craftsmen working in family shops have produced delicate works of furniture, jewellery and textiles in a range of rich materials. These have always been decorated profusely in much the same way as Indian pictures are, although sometimes with less taste.

Things to do

1 Discover in which countries Hinduism, Buddhism and Islam are practised today.
2 Find examples of Indian art not mentioned in this section such as the temples at Ellora.
3 Study the various schools of Indian painting and learn to identify their characteristics.
4 Make a banner or picture from leaves and branches, like **9.9**.

10 Buddhism

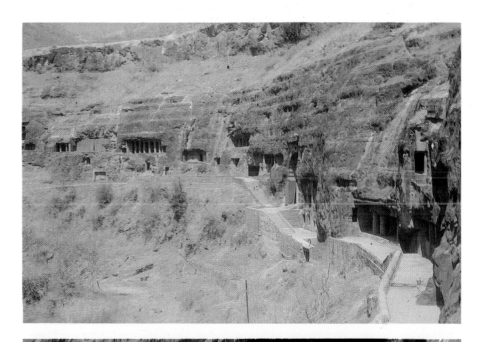

10.1 The Ajanta Caves, India. These are not natural caves: Buddhist monks carved them from the cliff-face between the first century BC and the ninth century AD, creating a cool, quiet environment for meditation.

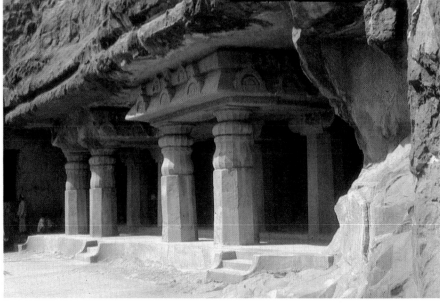

10.2 Entrance to Cave No. 7, Ajanta. A *vihara* (monks' dwelling), showing the restraint of Buddhist architecture (cf. **9.1**)

The Buddhist faith developed in India in reaction to Hinduism as long ago as the sixth century BC. At that time, Prince Gautama renounced his wealth and position and led a life devoted to unselfishness and meditation. He had reached, through the process of transmigration of souls which was described in section 9, the state of Nirvana, or that of being a

10.3 An unfinished man-made cave in south India gives some indication of the method used to carve the solid rock.

buddha. In that state one is not conscious of having an identity separate from that of the Creator.

There have been other buddhas, but Gautama became known as Lord Buddha, and his teachings developed into a new religion based on meditation to attain Nirvana. In Buddhism any individual may reach Nirvana — not only those of high caste. Thus it became a very popular faith, and missionaries went from India to Sri Lanka and Indonesia in the south; to Nepal, Tibet, China, Korea and Japan in the north; and to Burma, Kampuchea and Vietnam in the east. In most of these countries Buddhism is still the major religion today, and in some strong Hindu aspects of the faith survive in the ceremonies.

Buddhists believe that some holy people who could have entered Nirvana decided to remain on Earth to assist others to Nirvana. These are the *boddhisatvas*. The Goddess of Mercy (Kuan Yiu in China and Kannon in Japan is a boddhisatva (see **12.17**).

Just as Buddhism is a derivation of Hinduism, so too is Buddhist art a derivation of Hindu art, but the architecture is less ornamented and the sculpture and painting more expressive of peace and calm.

Because Buddhists care little for personal material things, the main structures to endure have been religious buildings. Even the palaces of rulers were built of wood and therefore few have survived (see **10.4**).

Architecture

The *stupa* is a large, solid mound of masonry, usually rounded in shape, erected over a sacred place or relics of a holy person. Although there are usually altars (**10.16**) and statues of the Buddha (**10.15**) associated with a stupa they are not places of ritual and worship in the same way that Christian churches are. They are intended to provide an atmosphere conducive to meditation and personal prayer, and some of this is done during *circumambulation* (walking) around the terraces provided for this purpose. Most of the stupas are of bold, simple and dignified design; *Borobudur* in Java, however, is an exception and is covered with sculptures (**10.12**).

In a country in which the sun's heat can be extreme and for a religion which emphasises peace and meditation it is logical that *rock-cut*

10.4 The ancient city of Pagan, Burma. Most of the dwellings have disappeared leaving only an enormous number of pagodas (stupas) as a reminder of how great and devout this city once was. Pagan was deserted after it was overrun by Kublai Khan's Mongols in 1287.

10.5 (left) Bodnath *stupa*, Nepal. A golden royal umbrella crowns the stupa, which is surrounded by terraces for circumambulation. The eyes represent the spiritual person of the Buddha and the flags and banners are symbols of devotion. The niches in the base contain prayer-wheels (see **10.8**).

10.6 (right) Nyatapola Pagoda, Bhadgaon, Nepal. The royal umbrella form in **10.5** has become the whole building.

architecture (**10.1–10.3**) should develop. In the *Ajanta Caves*, India, a series of dwellings for monks (*viharas*) and meeting halls (*chaityas*) were cut in a vertical rock cliff-face, mainly during the fifth and sixth centuries AD. It is typical of Buddhism that the craftsmen who hollowed out these artificial caves from the solid rock cared little for the enormous and long labour it took.

Painting and sculpture

Buddhist sculpture is much less agitated, detailed and decorated than Hindu sculpture, and stone is used more often than bronze. Reliefs illustrate scenes from the various incarnations of the Buddha (the *Jataka* stories) and sculptures in the round show the Buddha in a range of symbolical attitudes (*mudras*, or gestures of the hands, and *asanas*, or placements of the legs: **10.8, 10.13, 10.15, 10.18**). All are designed and executed with calm dignity and grace.

Buddhist painting is similarly dignified, calm and graceful, although little has remained to the present day. Perhaps the most famous is that on the walls of the caves at Ajanta and Tan-Huang (China).

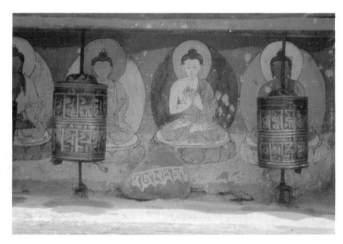

10.7 (top left) Detail of a moonstone (the semi-circular bottom step of a stupa-entrance) representing animals important in the lives of the Buddha. Sri Lanka.

10.8 (top right) Prayer-wheels and paintings of the Buddha in the mudra of teaching. Bodnath, Nepal (see **10.5**).

10.9 The Swe Dagon Pagoda, Rangoon. A magnificent large central stupa (covered with gold) surrounded by many smaller stupas (called *pagodas* in Burma). An atmosphere of utter calm and peace pervades Swe Dagon.

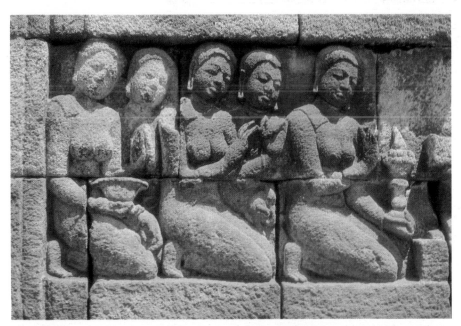

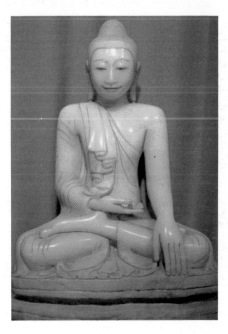

10.10 (top left) Two *apsaras* painted on a cave wall in Sigiriya, Sri Lanka. Fifth century AD.

10.11 (top right) A Buddhist painting from the early mediaeval period. From a ruined monastery in Sri Lanka.

10.12 (centre left) *Women Making Offerings*. Stone relief from the stupa of Borobudur, Java, showing the calm dignity of Buddhist sculpture (compare **9.11**).

10.13 (centre right) A Buddha in the 'earth-touching' mudra (calling the Earth to witness his triumph over evil). Nineteenth century, Burmese. Alabaster with traces of paint. City of Hamilton Art Gallery, gift of Mr and Mrs Rex Taplin.

10.14 (left) Detail of the roof of Wat Pho temple, Bangkok, showing mosaic decoration based on the *naga* (water-snake).

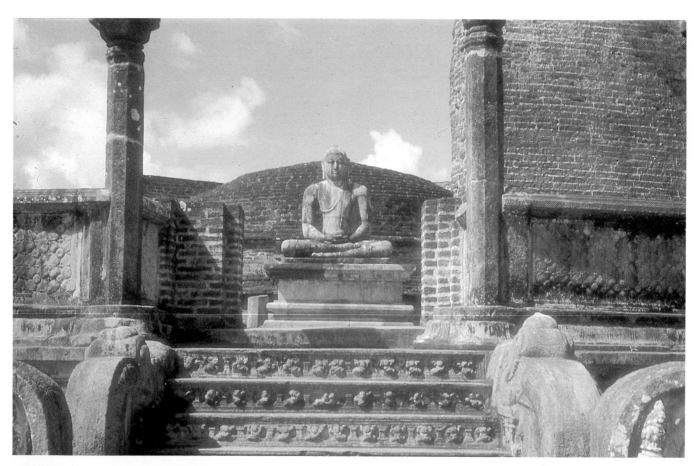

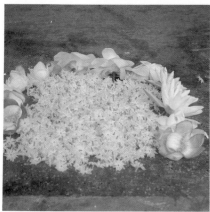

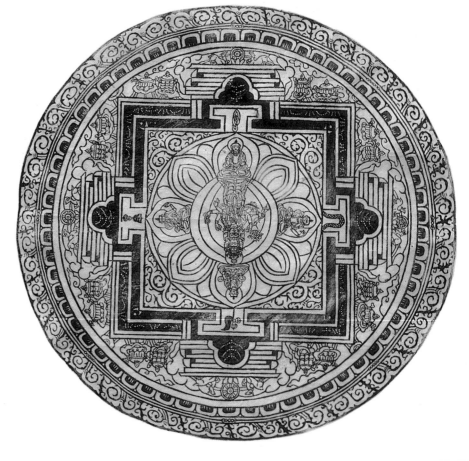

10.15 (top) The Vatadage Dagoba, Sri Lanka. A ruined stupa (called *dagoba* in Sri Lanka) with a sculpture of the Buddha in the *mudra* of meditation (the 'lotus position') in front.

10.16 (above) Typical lotus and frangipani ('temple-flower') offerings on an altar at a *stupa* in Sri Lanka.

10.17 (right) A *mandala* from Nepal — A Hindu-Buddhist symbol for the harmony of the cosmic unity combining the square and the circle with deities and sacred symbols. In China there is a saying, 'The earth is square and the sky is round'. Woodcut print on paper.

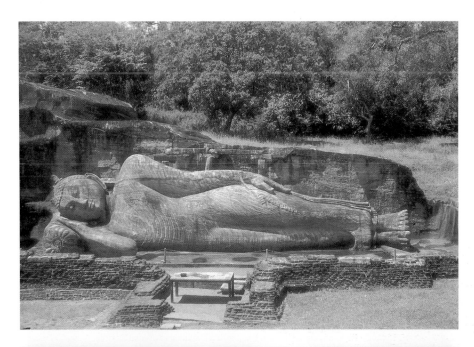

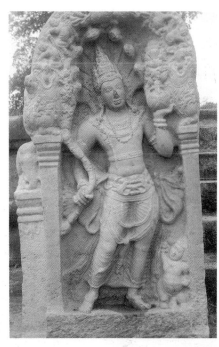

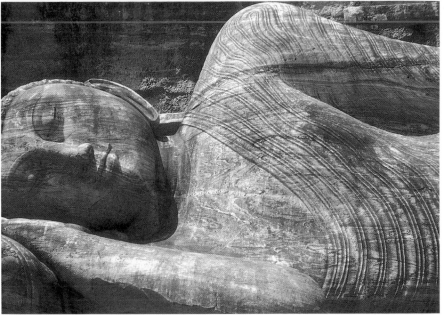

10.18 (top left) *The Dying Buddha*. This huge sculpture (about 15 metres from head to toe) represents Lord Buddha entering Nirvana for the final time. One of several images of the Buddha carved from the solid rock at the Gal Vihara, Sri Lanka (all that remains of an ancient monastery). Twelfth century AD.

10.19 (left) Detail of **10.18**. A head of enormous calm and peace. (Reproduced in colour on front cover)

10.20 (above) A *Nagaraja* (serpent-king) guarding a sacred site in Sri Lanka. The number of cobra heads around the king's head indicates his status and power. Nine is the highest number. Stone. About 1 metre high.

Things to do

1 Read about the lives of Lord Buddha and find other illustrations of Buddhist art in books.

2 List as many *mudras* and *asanas*, with their symbolical meanings, as you can.

3 Seek out a follower of Buddhism, or one who has read something about the religion, and discuss its main tenets.

4 Model or carve a figure in a restrained and dignified style similar to that used by Buddhist artists.

11 Islam

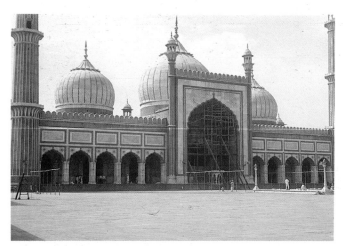

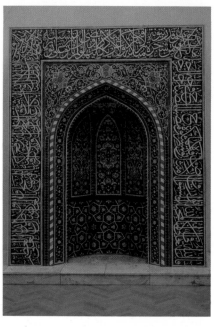

11.1 (top left) The Jama Masjid (mosque), Delhi. The *mihrab* is under the central dome within the arch. Bases of *minarets* can be seen at the extreme edges of the picture.

11.2 (top right) The Golden Mosque, Lahore, Pakistan. Ritual cleansing at the pool before entering the mosque proper for prayer.

11.3 (lower left) Two minarets of the Wazir Khan Mosque, Lahore, Pakistan, almost hidden among market buildings. The loudspeakers fixed to the balconies make the muezzin's task easier.

11.4 (lower right) Mihrab. Glazed tile mosaic. Height approximately 3 metres. Four cleverly superimposed inscriptions form the frame. Cleveland Museum of Art: gift of Katherine Holden Thayer

The prophet Mohammed was born in Mecca, Arabia (now called Saudi Arabia) in AD 570. He preached his doctrine, which is an extension of the Jewish and Christian religions, to the Arabs. During his lifetime and in the years after his death, the Arabs built a religious empire as great as the Roman empire. At its height, Islam (a term which describes all the people who follow the prophet wherever they live, just as Christendom means all Christians) stretched from Spain to Pakistan, across Sicily, North Africa and the Middle East. The Moslems have since been driven

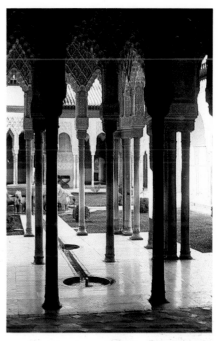

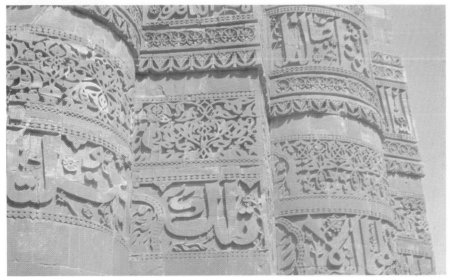

11.5 (top left) The Rambagh Palace Hotel, Jaipur, India. Now a hotel, this former palace is typical of the beautiful homes of the Moslem rulers of India. Note the multifoil arches. Air-conditioners have been installed on the top floor for the comfort of Western tourists, replacing screens like those in **11.11**.

11.6 (centre) Qtab Minar, Delhi, a huge monument decorated with flowing arabesques and script, relief-carved in the stone. Known as the 'Waves of God'.

11.7 (top right) The Court of Lions, Alhambra Palace, Granada. This is one of the most beautiful buildings in the world. Fourteenth century AD.

11.8 (bottom left) Detail of a damascened door. Geometric arabesque.

11.9 (bottom right) Detail of a carved wooden door.

horseshoe ogee trefoil mutifoil

11.10 Islamic arch forms

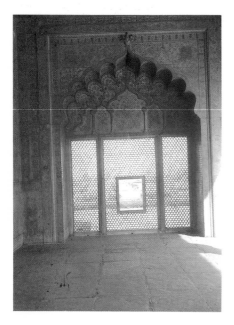

11.11 Typical palace window looking out to a river, from which breezes cool the shady interior. It is difficult to believe that the screen is actually a sheet of marble which has been pierced and carved in this mesh pattern. The whole room is covered with the delicate and graceful carved and painted decoration seen here. Rang Mahal, Delhi, India

11.12 (right) The Khademain Mosque, Baghdad

out of Spain (where they were known as the Moors) and Sicily, but they left behind them a wonderful cultural legacy. Islamic art is also called Mohammedan art or Moslem (Muslim) art.

The Christian Crusades of the eleventh, twelfth and thirteenth centuries were made against the Moslems who, in their centuries of conquest, had overrun the Holy Land and were refusing Christians permission to enter the country. It is important to realise that at that time Europe had just emerged from a period of barbarism known as the Dark Ages. The Moslems, who had preserved much of the knowledge of the ancient Greeks and Romans all this time, were far more cultured than the Europeans. For example, the Arab universities at Damascus and Baghdad were the first to be established after the Christian Emperor Justinian had closed the schools of Athens in AD 529. In these universities, and in others at places such as Toledo and Alexandria, the Arabs preserved the writings of ancient philosophers (Aristotle, Galen, Euclid, etc.) and passed this knowledge on to the medieval Europeans, thus kindling the spark that eventually became the flame of the Renaissance.

Arab scholars made significant advances in anatomy and medicine, agricultural science, astronomy and astrology, navigation, metallurgy (especially steel-making) and mathematics. Today, although we use Roman letters, we use numerals which the Arabs derived from India, adding for themselves the important concept of zero. One branch of mathematics — algebra — still bears its Arabic name. Arab traders acquired the art of paper-making in China and brought it, along with

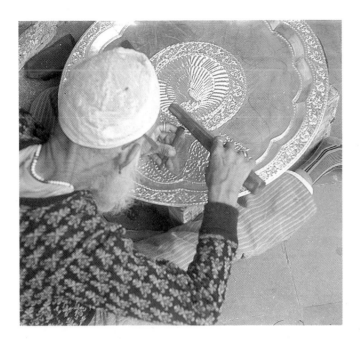

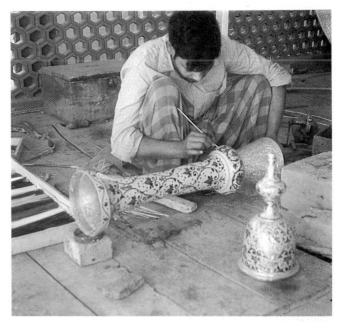

articles made by their own craftsmen — Persian rugs, damask and decorative metalwork — to the West.

The Moslems believe in one god, whom they call Allah, and recognise Christ as one of the prophets. They stop work at five set times during each day, wherever they may be, and kneel on prayer mats to pray. They also believe in fasting, giving alms, and making pilgrimages to their holy cities Mecca and Medina before they die, if possible. These beliefs are the 'Five Pillars of the Faith'.

11.13 (left) A craftsman chasing a pattern on a brass plate prior to applying enamel. (right) Sticks of enamel are softened over heat and applied in the grooves. Indian enamelled brassware may be bought in shops in Australia.

Architecture

Originally the Arabs were nomads, having no architecture of their own. When they began to conquer more settled communities (e.g. Mesopotamia), they took over the styles of building they found there and simply adapted them to suit their own purposes. Consequently the *mosque*, the place of worship, varies in design from place to place; but all mosques have certain common features. There is a courtyard with a fountain for ablutions before worship and a niche (*mihrab*) in the wall nearest Mecca to which worshippers can turn when praying (**11.1, 11.4**). There are usually four *minarets* or towers from which the *muezzin* (priest) calls the faithful to prayer five times a day. If the mosque is also the tomb of a holy person, it is domed. The famous Taj Mahal in Agra, India, which was built by the Mogul Shah Jahan in 1632–53 as a tomb for his consort Mumtaz Mahal, is a tomb-mosque.

Another typical feature of Islamic architecture is the shape of the *domes* and *arches*. They can be pointed, horseshoe, or ogee, and arches are often cusped into trefoil, quatrefoil or multifoil designs; while domes are decorated inside with brickwork and tiles forming *stalactite vaulting*.

Houses and palaces, although usually plain outside, are often richly decorated inside. The windows are small and covered by delicately carved screens (in place of glass: **11.11**); both features protect the interior of the building from the heat of the sun. The Alcazar in Seville, and the Alhambra in Granada (**11.7**), both in Spain, are examples of Moorish architecture at its best.

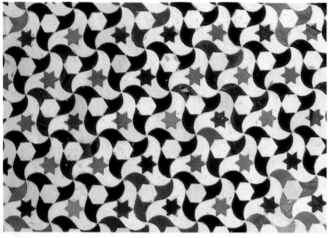

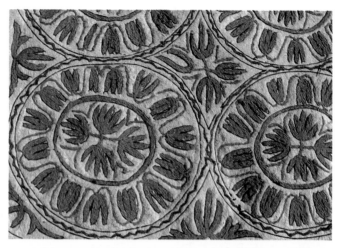

11.14 (top left) Mosaic-tile decoration in the Alhambra, Granada. The pattern of curved triangles and stars is subtly based on the geometry of the hexagon. Of art like this, Jacob Bronowski (in *The Ascent of Man*, British Broadcasting Corporation, 1973) says, 'The artist and the mathematician...have become one...These patterns represent a high point of the Arab exploration of the subtleties and symmetries of space...'

11.15 (top right) A *numdah* mat, made in Kashmir but available in shops in Australia, shows typical patterns and colour combinations. Embroidered felted wool.

11.16 (lower left) Lahore taxis display the same love of ornament and colour that is evident in traditional Islamic art.

11.17 (lower right) An eighteenth century Persian ceramic plate. Museum of Applied Arts and Sciences, Sydney

Other arts

Emphasis on decorative ornamentation is characteristic of all Islamic art, and rich colours are used in combinations often unfamiliar to us. The Koran (the holy book of Islam) forbids Moslem artists from copying anything 'in the heavens above or the earth beneath or the water under the earth'. Although this commandment is not always strictly observed, Islam has no tradition of realistic sculpture and painting such as that of Christendom, and Moslem sculpture in the round is rare. Islamic artists have developed an intricate abstract decoration, the *arabesque*, which is used universally in one or other of its two versions — flowing and geometric (**11.6, 11.8**).

Calligraphy is regarded, as it once was in the West, as a fine art. Prayers and texts from the Koran are used very successfully as decorative elements on architecture, pottery and metalwork (**11.4**). Arabic script, of which there are two kinds (*Kufic* and *Neskhi*) is written sinistrad (from right to left). Manuscript volumes of the Koran and the works of the poets are richly illuminated and bound, each volume being the work of a series of fine specialist craftsmen. They are greatly treasured and contain the best examples of Islamic *painting* style, in which pattern and harmony are more important than naturalism. For this reason, pictures are comparatively weak in perspective, but well composed, rich and harmonious.

11.18 (above) *A Rajput Nobleman with Ladies on a Palace Terrace*. A watercolour by an unknown artist of the middle eighteenth century showing typical attention to pattern and colour rather than realism and perspective. Victoria and Albert Museum, London

11.19 (top left) Decorative brick paving, Jehangir's Tomb, Lahore, Pakistan.

11.20 (left) Watercolour painted in the seventeenth century by unknown artist of the Isfahan School. The perspective used in this picture is not consistent and is still subordinate to the pattern. Photograph: the High Commissioner for Pakistan in Australia

The rich and intricate style of pattern-weaving known as *damask* was developed in Damascus, and many parts of Islam are noted for beautiful woven rugs. Portable articles, especially fabrics, are the chief items of luxury for people whose homes are impermanent, as are those of many Moslems.

The *ceramic arts* of pottery and tile-making, and ornamental metalwork (*damascene*, from Damascus: **11.8**) are highly developed. In all these arts the characteristic colours and patterns are employed.

Things to do

1 Study some examples of Islamic art in books on countries of the Middle East and North Africa.

2 Paint a picture using an Islamic colour-scheme and an abstract design similar to the arabesque.

3 Copy a poem you know using Roman lettering but illuminating the page in the manner of the Islamic artists. (If you are using them, gold paint shines better if you give it a yellow or red undercoat, and silver if you give it a blue undercoat.)

4 Read more about the relationship betwen Arab mathematics and art in Jacob Bronowski's *The Ascent of Man* (BBC, London, 1973), pages 172–73.

12 China

12.1 Yin and Yang — the Taoist symbol for the two eternally opposite yet joined principles of the cosmos whose interactions produced all creation. When they balance, this is Tao (the way of nature, or harmony). Yin is dark, negative, earthly and female; yang is bright, positive, heavenly and male.

12.2 Chinese calligraphy.
The development of a character: (left) a writing brush; (centre) the character for 'writing brush' as it was written c. 1000 BC; (right) the modern character.

wood wooden bed

wooden frame forest

China has been civilised more or less continuously for over 4000 years and for most of this time it has been ruled by dynasties of emperors, such as the Shang, Han, T'ang, Sung, Yuan and Ming. Western civilisation is older, of course, but periods of barbarism have broken its continuity. China was unified politically by the Emperor of Ch'in (Qin) in the third century BC (the name China comes from Ch'in), and he built the Great Wall to keep out invaders from the north. Chinese art is usually dated by dynasty rather than year — we speak of Han bronzes or Ming painting.

Until the twentieth century, Chinese culture had changed little in 4000 years. This was mainly because the family was the basis of society. The Chinese revered their ancestors (but they did not worship them), and this made them dislike social change. Traditions began to break down when China ceased to be ruled by emperors; it became a People's Republic in 1949. However, traditional Chinese culture is still an important study, particularly because of its fine art, which is very different in style from Western art.

The traditional Chinese concept of time differs from ours in that there is little emphasis on the division between past, present and future. They believed that, because spiritual life continues after death, their ancestors were always with them.

In the sixth century BC, the principles of the traditional Chinese way of life were enshrined in *Confucianism* and *Taoism*. When Buddhism was introduced from India in the fourth century AD, it was found to be compatible with Confucianism and Taoism, and the three religions were able to exist side by side. The coming of Buddhism gave rise to a period of great artistic activity.

Confucius was a philosopher who formulated a social and ethical system which guaranteed wise and reasonable living ('the Middle Way').

Taoism is a religion which preaches that there is nothing in nature (*Tao*) that does not have a spirit. This has influenced Chinese artists and craftsmen in that they believe materials should not be mishandled. A stone carving should retain the feeling of stone and not imitate bronze, for example. Lao-tzu, the founder of Taoism, was a philosopher who was deified after his death.

The Chinese have made many contributions to civilisation. In the first century AD they made the first true paper. In the third century they were using maps, including relief-maps, made to scale. They invented gunpowder and the cannon, and used rockets in warfare against the Mongols in AD 1040. They also invented the crossbow, paper money, the kite (the first flying apparatus), lacquer, and printing. They were the first to weave silk and may also have invented the principle of the modern loom. They may have had the mariner's compass as early as 1000 BC. All of these things were introduced to the West at a much later date by Arab traders bringing silks to the West via the 'Silk Road' and travellers such as Marco Polo.

Architecture

Taoism dictates that a building must look natural in its surroundings. Chinese buildings consist of a wooden framework with roofs, and sometimes walls, covered with glazed tiles. They are constructed on the tree or umbrella principle, whereby the roof is supported not by the external walls, but by pillars within the building. Walls are therefore little more than screens. The wooden parts are often carved (**12.3**).

Chinese roofs are curved. We can speculate that this may be because the earliest buildings were roofed with lengths of bamboo, split in halves lengthwise and laid across the beams: in time the bamboo would have sagged. This theory is supported by the half-cylinder shape of the clay tiles that are used for roofing today, and the method of laying them.

The *pagoda* (t'a) is a tall, tower-like structure of many storeys (usually an odd number), each marked by a roof with upswept eaves. Pagodas are not temples for use in worship but are regarded as monuments to faith and are sometimes used as repositories for sacred writings, images and relics. There is a staircase to the top storey. The form of the pagoda probably derives from the multiple umbrella (a sign of royalty) which tops the Buddhist stupa (see **10.5** and **10.6**).

The *p'ai-lou* is a monumental wooden gateway built as a memorial.

Painting

The links between painting and writing in China are many. The same materials are used: water-colours and inks made in cakes from secret formulae, and silk or paper made from bamboo, rice straw and other fibres. Pointed brushes are held vertical in the hand, the paper or silk rests on a horizontal surface, and the painter or calligrapher sits or kneels before the work. Both painter and calligrapher sign their work with the impression of a seal dipped in vermilion paint (see **12.19**).

Often a painter is also a poet and usually a poem is written on a picture. Both are executed with the same care and skill, and both painting and calligraphy are regarded as fine arts by the Chinese. A 'master of three excellencies' is a poet, painter and calligrapher. In Chinese writing, the way a character is written has a bearing on its meaning. Earlier Chinese *pictographs* (writing characters) were more easily recognisable as pictures than are the modern characters (see **12.2**).

Chinese *water-colour* style is different from the Western style. Chinese artists do not necessarily aim at literal truth to nature, or at beauty. They wish rather to express the lifeforce of nature, and landscapes with figures are usually chosen as subject-matter because they can best express the basic unity of man and nature. Pictures are usually painted from memory and only after considerable meditation ('cleansing') on the part of the artist. This means that subjects are idealised and are not pictures of particular things at particular times. The actual painting is often executed quite quickly; indeed skill and economy are highly valued (see **12.18**).

Some pictures consist of washes of colour without outline ('*boneless*' *style*), while others have heavy outlines ('*paintings with bone*'), and yet others are done in black only. There is a canon of conventions for brush-strokes with each stroke expressive of some character or texture in nature.

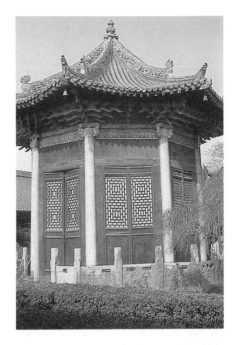

12.3 This small shrine in Sian Province illustrates the main characteristics of Chinese architecture — curved, upswept eaves, supported on pillars topped by a complicated system of brackets, tiled roof, and complex fretwork screens.

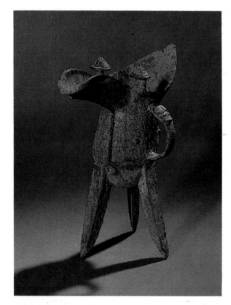

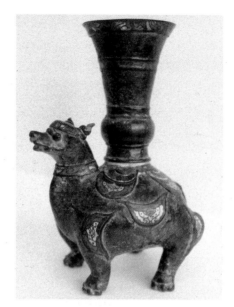

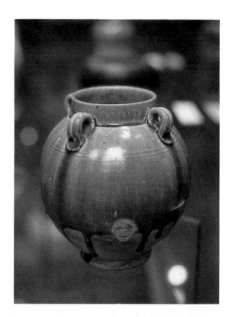

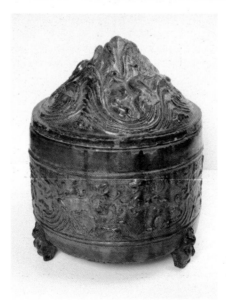

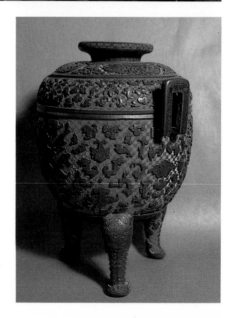

12.4 (top left) Bronze wine-vessel (*chüeh*) for ritual use. Height about 20 cm. Shang Dynasty (1766–1122 BC). National Gallery of Victoria, Kent Collection

12.5 (top, centre) Incense burner. Bronze with cloisonné enamel decoration. Han Dynasty (206 BC–AD 220). City of Hamilton Art Gallery: Shaw Bequest

12.6 (top right) Stoneware jar of the Sui to early T'ang Dynasties (6th to early 7th centuries AD) showing a typical emphasis on proportion and simplicity of form, together with an appreciation of how a glaze adheres and runs to form a pattern naturally. National Gallery of Victoria, Felton Bequest

12.7 (centre) The Hall of Annual Prayer for Grain, part of the Temple of Heaven, Peking. Built in the fifteenth century AD mainly of wood, this magnificent pagoda has been rebuilt more recently.

12.8 (bottom left) Hill-jar, earthenware. Han Dynasty (206 BC–AD 220). Height approximately 25 cm. Although the use of hill-jars is unknown, they are obviously a Chinese equivalent of the cosmic-mountain of the Hindu-Buddhist culture. City of Hamilton Art Gallery: Shaw Bequest

12.9 (bottom right) Carved lacquer incense-burner. Nineteenth century AD. Height 40 cm. The Art Gallery of South Australia

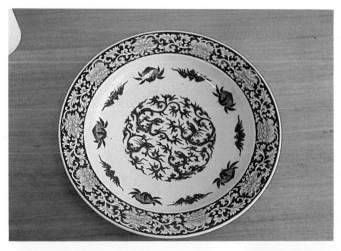

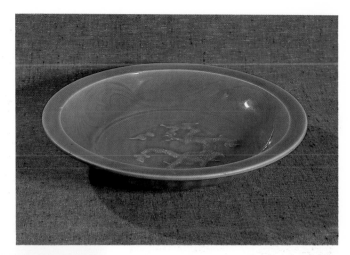

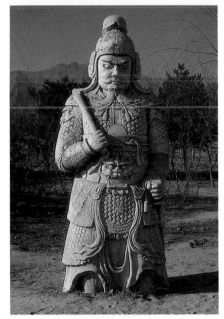

12.10 (top left) Porcelain dish with blue painted decoration — of the kind known as 'Ming blue'. Ming Dynasty, reign of Emperor Wan-li (AD 1513–1619). Approximately 45 cm wide. City of Hamilton Art Gallery: Shaw Bequest

12.11 (above) Stoneware dish, celadonware, made in the late Yuan or early Ming Dynasty (late fourteenth century AD). Celadon ceramic was made in imitation of jade (because it was much cheaper) and believed to share some of the magical qualities of that stone — such as revealing poisoned food if placed in a vessel. The National Gallery of Victoria

12.12 (middle left) Guardian, Ming Tombs. Stone. Although partly buried, this massive figure gives a good idea of Chinese sculpture style. Ming Dynasty (AD 1368–1644).

12.13 (middle right) Jade sculpture. Height approximately 17.5 cm. The Art Gallery of South Australia

12.14 (bottom left) Monkey on horse — sculpture in white or 'mutton-fat' jade (nephrite). Ming Dynasty (AD 1368–1644). In Taoism the horse is an important symbol and the monkey has magical powers of longevity and transformation. City of Hamilton Art Gallery: Shaw Bequest

12.15 (bottom right) Dog guardian outside the Joss-house, Darwin. Stone.

Sculpture

Like most Asian sculpture, Chinese sculpture is curvilinear and graceful. However, it is more restrained and stylised than Hindu sculpture. Bronze and jade are used in sculpture and for making grave furniture and ritual objects.

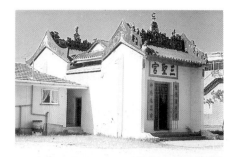

12.16 The Joss-house (*Miu*), Breakfast Creek, Brisbane. Mius were built in many large Australian cities to serve the religious needs of their Chinese populations.

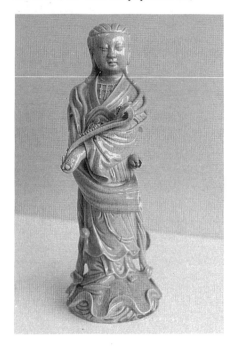

12.17 The Goddesss of Mercy (Kuan Yin). Earthenware with 'crackle' glaze. Ch'ing Dynasty (AD 1644–1912). City of Hamilton Art Gallery: Shaw Bequest

12.18 (right) The top half of a watercolour on silk by Wen Pan Sin. It shows the traditional format of Chinese hanging scrolls, with man-made elements at the bottom (just entering our photograph) and paths and streams leading up through forests, crags and mists to mountains. It also shows the way Chinese artists represent space and distance and the different brush-strokes used to represent trees, rocks, mist, etc. The poem at the top was probably written by the artist and his name appears in a red seal impression. Age has caused some of the colours to fade. This landscape was probably painted in the eighteenth century, but the style used has changed little for at least the last 1000 years.

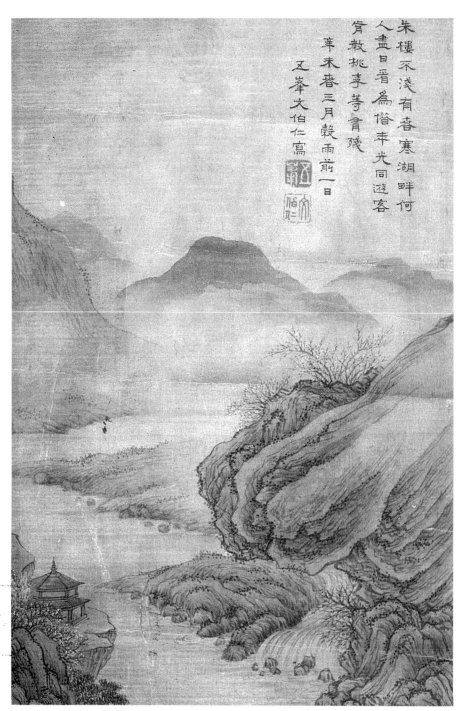

Jade, a stone usually greenish in colour, is thought to embody the vital energy of the *yang* and, therefore, to promote long life. It is so hard that steel tools will not cut it; it is worked by a slow process of abrasion with quartz sand. The jade carver commences work only after having considered carefully what shape in his subject would best suit the colour, shape, size and texture of the stone. His Taoist beliefs dictate that this decision is an extremely grave one, and it has been said it sometimes takes years to make. The skill of the jade carver is indicated by the results: for instance some ritual blades made of jade are up to 70 cm long and 15 cm broad, but less than 1 cm thick.

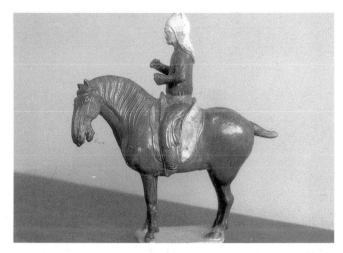

Pottery and lacquer

Chinese pottery has long been recognised as some of the best in the world. This is because of the simple beauty of the shapes, the quality of the clay (*kaolin*), and the restraint with which decoration and glaze are applied.

When the first Chinese porcelain was brought into Europe by travellers such as Marco Polo it made such an impression that Western potters tried to emulate it. Thus 'china' came to mean 'fine pottery'.

In the eighteenth and nineteenth centuries, European taste was for more highly ornamented pottery, hence the porcelain made for export to Europe was often over-decorated. Although blue-on-white decoration is typical of some kinds of Chinese pottery, the famous 'willow pattern' was probably first made in Europe in imitation of genuine Chinese ware and became so popular that Chinese potters then made it, but purely for export.

Today, throughout the world, synthetic lacquers are used for painting furniture, automobiles, and other articles. They dry with a hard, shiny, coloured surface and are comparatively recent inventions. But the Chinese have had such a medium for over 2000 years. It is true lacquer, a natural plastic made from the sap of the lac tree. The Chinese have used it to provide a decorative and protective surface on wooden bowls, furniture and coffins, and the traditional leather armour. Its remarkable resistance to water is shown by the fact that wooden coffins have been found undamaged in tombs that have been damp for centuries. Lacquer objects are decorated with painted, carved or inlaid patterns, or by incising through an outer coat to an under layer of a contrasting colour (see **12.9**).

12.19 (left) Chinese writing and painting implements (from bottom): painting brushes, stone ink-palette with stick of black ink, container of red pigment with artist's name-seal inked ready for use, and small brush for writing. Ink is made just before use by grinding the stick of ink in water on the palette.

12.20 (right) Horse and rider, part of a group of tomb-figures, and an excellent example of T'ang Dynasty (AD 618–906) ceramic figurines. The horse's head is particularly noble. Height approximately 25 cm. City of Hamilton Art Gallery: Shaw Bequest

Things to do

1 Find more details about Chinese painting and pottery, such as the canons of brush-stroke.
2 Paint a water-colour using the Chinese method and style.
3 Emulate Chinese potters by making a piece of pottery which has austerely beautiful lines and plain yet rich glaze.
4 Make a list of buildings in your district that look natural in their surroundings.

13 Japan

13.1 Torii at Itsukushima Shinto shrine, marking approach from the water. Wood. Height approximately 10 metres.

13.2 A Japanese garden set up in the Museum of Fine Art, Boston.

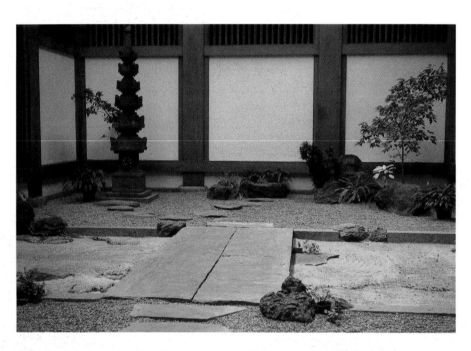

Although it has certain distinguishing features, Japanese culture, particularly in past centuries, has had a good deal in common with traditional Chinese culture — religion, philosophy, art and calligraphy. This is not surprising since Japanese culture as we know it was first inspired by Chinese Buddhist missionaries who arrived in Japan via Korea in the sixth century AD, adding their values to those of the indigenous Shintoist culture. However, by the ninth or tenth century, a truly Japanese character had begun to develop and, in the nineteenth century, when Japan began to have contact with the West, Japanese art began to influence Western art, particularly painting and architecture (see section 24).

Since the Second World War, Japan has undergone much westernisation, but the Japanese, though fierce in war, have traditionally practised a high level of culture in peacetime. The great emphasis on purity of thought, nobility of feeling and good taste is best exemplified in the stylised ritual and finely made utensils of the tea ceremony (*chanoyu*).

A reverent mental attitude (*michi*, or *do*, cf. *tao* — see **12.1**), which brings about harmony between man, heaven and nature, is cultivated by such practices as *judo* and makes the Japanese consider everything they do and their whole environment as works of art. Balance and harmony are desired everywhere, and this is achieved through giving attention not only to objects themselves but equally to the spacing and relationship (*ma*) between each object. The fact that an empty space is not regarded as something negative but as a positive and constructive part of an arrangement, is well shown in Japanese paintings and prints (see **13.3**, **13.7**).

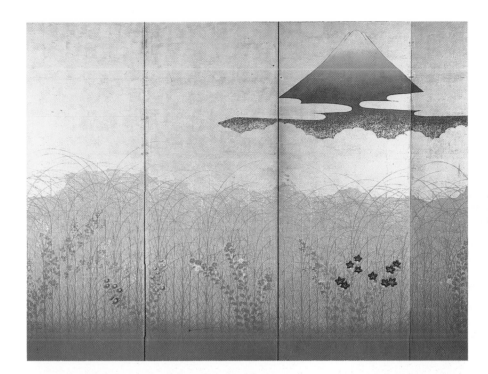

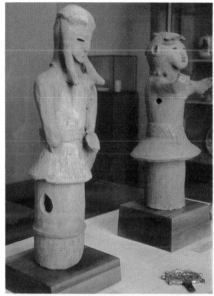

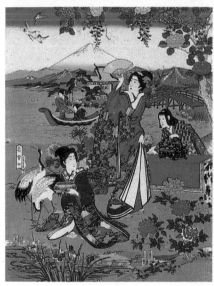

13.3 (top left) Left-hand half of one of a pair of sixfold Japanese screens in the Art Gallery of South Australia, representing the sacred mountain, Fuji. Gold leaf and watercolour on paper stretched on wooden frames. Edo period (1615–1867) Height 170 cm. Gift of Mitsubishi in Australia, 1981.

13.4 (top right) Haniwa. Ceramic. Height approximately 45 cm. Fifth to sixth centuries BC. Museum of Fine Art, Boston

13.5 (lower left) Kiyoshi Saito, *Flower and Girl*, 5. Woodcut, 38 x 52 cm. 1971. This is in the continuing tradition of Japanese printing. The wood-grain has been enhanced before printing.

13.6 (lower right) A *ukioy-e* woodcut which was owned by Vincent van Gogh (see **1.16**). Courtauld Institute of Art, London

Architecture

Sacred architecture is much like that of the Chinese. However, domestic architecture has a number of distinguishing features which influenced Frank Lloyd Wright and other American architects earlier in this century. Timber framework, open plan, and moveable lacquered-paper *shōji* (screens) in place of fixed walls make houses strong yet flexible enough to withstand earthquakes, and adaptable to changes of season. The furniture is sparse, but it is sensitively placed and there is an overall simplicity and grace, good proportion, and tasteful use of colours, textures and decoration.

13.7 Utagawa Toyohiro (1735–1814), *Courtesan*. Watercolour on silk (*ukiyo-e* school). Height of figure approximately 1.5 metres. Freer Gallery of Art, Washington

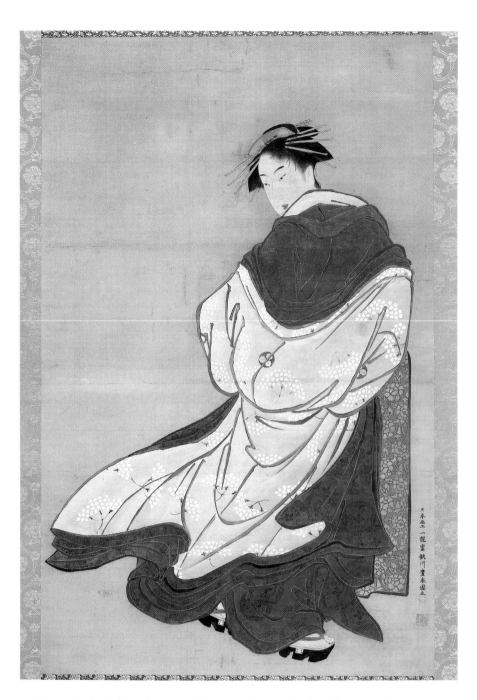

That the building is part of nature is emphasised by unpainted woodwork, indoor *ikebana* (floral arrangements) and *bonsai* (potted dwarf trees), and a garden scarcely separated from the building. A garden may consist entirely of large stones tastefully placed among areas of gravel raked into patterns, and small pools. All this illustrates the Japanese characteristic of restraint and their spontaneous feeling for the appropriate use of different materials to reveal the inherent qualities of each.

The *torii*, a development of the Chinese p'ai-lou, is a large wooden archway erected as a memorial.

Painting

From about the tenth century AD the typical Japanese style of painting (*yamato-e*) developed. Although the style is similar to the Chinese (the

same canons of brush-strokes are used, for example), Japanese pictures often show wonderful characterisation, and even caricature, which can by very humorous. The scroll-forms, *kakemono* (hanging scrolls) and *emakimono* (horizontal scrolls designed to be unrolled gradually and 'read' from one end to the other), are typically Japanese. An emakimono may be several metres in length.

Perhaps the most famous Japanese pictorial art is *ukiyo-e*: wood-block prints and water-colours of actors and courtesans which were a popular art of the eighteenth and nineteenth centuries. Ukiyo-e means 'the transient scene'. Examples of ukiyo-e appeared in Europe during the nineteenth century and influenced the Impressionist and Post-Impressionist painters with their striking *asymmetrical* (or *occult*) *balance* and bold, flat shapes. (In one of his self-portraits, shown in **1.16**, van Gogh has shown the print **13.6**, which he owned, hanging on his wall.) As a result of close collaboration between painter-designer and various printing craftsmen, the prints were made in hundreds from wood-blocks inked with pigment ground in rice-paste and applied with a brush, sometimes (as for a sky) in graded tones.

Sculpture and pottery

The curvilinear style of most Japanese sculpture is similar to other Asian styles. Wood, lacquer and bronze are the most common materials. *Hani-wa* figures, made of clay, are found guarding ancient tombs — although they look curiously modern (**13.4**).

Pottery is extremely refined, revealing knowledge of clay form and sensibility to nuances of colour, glaze and texture in both the potters and their patrons.

Raku is pottery made for immediate use and then discarded. The green-clay pot is placed in a red-hot kiln, removed when it is red-hot it-self, and plunged into a box of sawdust. This violent process brings about the rugged, highly textured, and often warped appearance of raku ware, and further shows the Japanese taste for 'natural' things — even if it is sometimes contrived.

Things to do

1 Find in reference books examples of all the kinds of art mentioned.
2 Make a block-print from linoleum or wood.
3 Make a ground-plan of a garden using the elements in the same way as the Japanese do.

14 The ancient Aegean civilisation

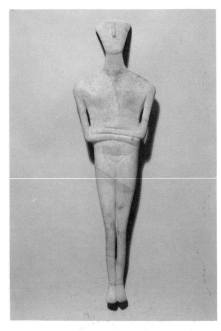

14.1 (above) *Female figurine*, 2500–2000 BC. Marble. Height 62.2 cm. Cycladic period. Art Gallery of NSW: gift of the Art Gallery Society of NSW

14.2 (right) *Woman and Child*. 1300–1400 BC. Terracotta. Height about 25 cm. From Cyprus. Palais de Tokyo, Paris

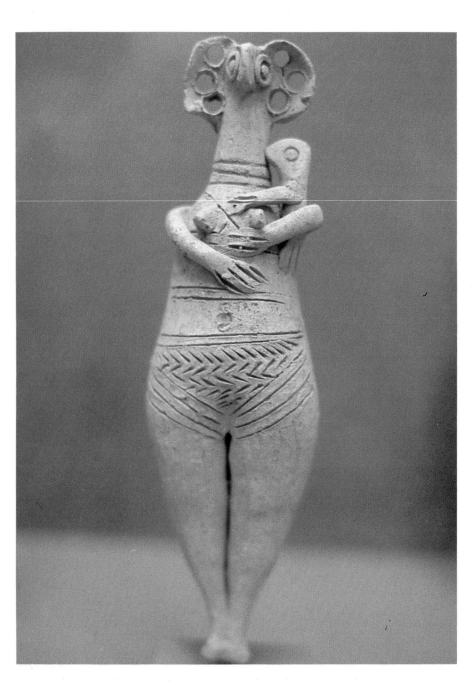

The term 'Aegean' covers the civilisations of the Aegean area which preceded that of the ancient Greeks. They developed along the shores and on the islands of the Aegean Sea as early as 3000 BC, reaching a peak of achievement about 1500 BC.

The early mainland culture we call *Mycenaean*, after its chief city, Mycenae; the island culture we call *Cretan* or *Minoan*, after the island of Crete and its legendary King Minos. Although the ancient Greek civilisa-

tion probably developed from these earlier cultures, they were completely destroyed in about 1100 BC — and probably the Greeks were responsible

The Minoan culture

The island of Crete probably controlled the trade of the entire Aegean area and became very wealthy. Surrounded by water, and presumably protected by her fleets, she must have felt secure; for her cities were not fortified.

Wall paintings of processions, dances and sports depict a carefree people of slender build. The Minoans had a system of writing which has not yet been completely deciphered, thus limiting our knowledge of their way of life.

Architecture

The 'Palace of Minos' (there is no actual evidence that Minos ever lived there) at Knossos is the chief example of Minoan architecture. It is a large, rambling structure, built on a hillside and in places several storeys high. It contains many passages and staircases, fresco-decorated apartments and storerooms, and there were once drainage systems, lavatories and light-wells to illuminate internal rooms.

Other examples of the Cretan palace were found at Phaistos and Mallia. At Phaistos, concrete paving was also found. The *Minoan column*, which was made of wood, is wider at the top than at the bottom and has a cushion (or rounded) capital.

Decorative mural paintings in fresco depict scenes from Cretan life, and birds, flowers, animals and fish. Some are realistic in treatment, but others are conventionalised. With human figures, treatment of shoulders and eyes is similar to that found in Egypt (see **7.12**), but the Cretan style expresses movement better. The double-headed axe is a characteristic motif.

Pottery

Minoan pottery, which foreshadows the later Greek work, is painted with animal and vegetable motifs. In the famous eggshell-thin *Kamares ware*, designs are painted on a black background.

Sculpture

The only sculpture yet discovered is a number of small, delicately wrought, stylised figures in ivory with additional gold details (*chryselephantine*: **14.6**).

The Mycenaean culture

The mainland cities of Mycenae, Tiryns and Pylos were protected by thick walls because of the constant threat of attack from migrating warriors from the north. Their inhabitants themselves were warlike and fought at the siege of Troy. They dominated Crete in the later years of the Minoan culture, and may have destroyed that civilisation.

Architecture

The characteristic feature of Mycenaean architecture is the type of wall, which was made of large, roughly hewn and irregularly shaped blocks of

14.3 Column from the 'Palace of Minos', Knossos, Crete. These columns, made of wood, have the thinner end at the bottom (cf. Greek and Roman columns).

14.4 Double-headed axe motif

14.5 Cretan pattern

14.6 *The Snake Goddess*, c. 1600 BC. Chryselephantine. This small Minoan sculpture is more naturalistic than those in **14.1** and **14.2** which were done about the same time. Museum of Fine Art, Boston: gift of Mrs W. Scott Fitzgerald

stone which were cut to fit each other (*polygonal masonry*). Such walls are called Cyclopean walls after the mythical giants, the Cyclopes, who once were thought to have built them.

Mycenaean architecture combines the post-and-lintel principle with corbelled arches. Palaces with impressive halls of state (*megarons*) and beehive tombs (*tholoses*) have been excavated, like the enormous 'Treasury of Atreus' (Atreus was a king of Mycenae, but to call this tomb a treasury is incorrect).

Sculpture

Little sculpture has been found at Mycenae. However, the gateway to the city (the *Lion Gateway*) is a fine monumental work depicting a pair of lions whose front paws rest on the base of a Minoan column — an indication that this architectural feature had some extra significance. The lions have no heads, but there are indications that the original heads may have been made of some precious material.

Pottery

In both shape and decoration, the Mycenean pottery is more primitive than that found in Crete. Decoration consists of bands of geometricised figures (see **15.17**).

Things to do

1 Read some passages in *The Iliad* and *The Odyssey* by Homer. These will give you a good idea of the way of life in these places in ancient times.

2 Make a wood-carving and add to it pieces of shaped metal and other materials in the manner of chryselephantine sculpture.

3 Look back through the earlier sections of this book and find another culture which built walls similar to those of the Mycenaeans. What geological features do the two countries have in common?

15 Ancient Greece

The culture of the Minoans spread to the mainland of Greece, and to Asia Minor, through contact with the cities of Mycenae, Tiryns and Pylos. Later, these cities were subjugated by a branch of the Aryans who came from the north and settled in an area extending from Greece and Asia Minor to Persia and India (see page 48). The invaders called themselves the Hellenes, or the Achaeans, and their land (what we now call Greece) Hellas. The northern and eastern Hellenes were known also as the *Ionians*, and the southern Hellenes as the *Dorians*. This period is known as the *Heroic Age* and probably lasted from the fifteenth century to the eleventh century BC. The exploits of heroes like the Argonauts and the men who fought at the siege of Troy (Ilium) have come down to us as legends in the *Iliad* and *Odyssey* of Homer.

During the *Golden Age* (the fifth century BC), Greece was at her height, and most of the great names come from this period: Pericles, the ruler of Athens; the philosophers Socrates and Plato; the artists Phidias, Polyclitus and Ictinus; and the writers Euripides, Sophocles and Aristophanes. During the fourth century BC, Philip, king of Macedonia, and after him his son Alexander ('Alexander the Great'), built an empire which stretched from the Indus River to Egypt. By this means, and through trade and immigration, Greek culture was disseminated over a wide area.

At first the ancient Greeks were ruled by kings and tyrants but later they developed a democratic system of government. Greek democracy did not, however, extend to the thousands of slaves on whom the high standard of their economy and art depended.

Athletic and other contests of skill seem to have originated in Greece where they were connected with religion. The Greeks believed that humans should achieve perfection not only in physical skills but in the arts as well. Consequently their games (e.g. the Olympic Games) included singing and playing the lyre as well as athletics, and the champion had to excel in all things. The Greeks had many gods (Zeus, Apollo, Athena, Aphrodite and many others) and sculptures of them were made in the likeness of perfect humans. The ancient Greeks believed that what was beautiful must also be good.

To the ancient Greeks we owe the origin of many of the things we value today — our language and literature (especially drama), our science, mathematics and philosophy, and much of our art — which were passed on through the Renaissance of the fourteenth century AD. Also, the Athenians set up the Areopagus, the world's first court of criminal law, and developed a democratic form of government.

Hellas was not united politically. Nearly every large city was a state in itself (*city state*, or *polis*) and maintained its own army and had its own typical culture pattern. There was much rivalry, and even war, between them. The citizens of Sparta were Dorians. They led a hardy open-air

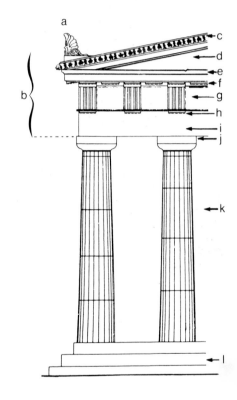

15.1 The Doric order: (**a**) acroterion; (**b**) entablature; (**c**) raking cornice; (**d**) pediment; (**e**) horizontal cornice; (**f**) mutules; (**g**) frieze (triglyphs and metopes); (**h**) guttae; (**i**) architrave; (**j**) capital: (top) abacus (bottom) echinus; (**k**) drums of column; (**l**) stylobate

15.2 Temple of Aphaia, Aegina (model in the Glyptothek, Munich). A typical Doric temple as it would have looked when new (c. 490 BC). The various members named in **15.1** can be identified, also the sculpture in the pediment. The peristyle (row of columns around it) makes this a peripteral temple.

15.3 (top right) Temple of Aphaia, cut-away model revealing the structure of a typical Doric temple. The Parthenon has a similar structure.

15.4 (right) Temple of Aphaia, Aegina (model in the Glyptothek, Munich), showing how Greek temples were set in a dominating position.

life and were the finest soldiers in Greece, but they had little art. The Ionians (in Asia Minor) were more cultured than the Dorians and their art had more grace. Athens eventually became the centre of Greek culture and combined the best of both the Dorian and Ionian cultures. The Athenians were highly civilised and valued quality in all things, an admirable characteristic.

Ideal form and fine proportions are the most striking features of Greek art, which was the first to express a belief in rational human values. Greece also developed naturalistic sculpture and painting to a high degree.

Greek civilisation had lasted only a few hundred years when it was eclipsed by the expansion of Rome in the second century BC, but Greek culture has influenced European life to the present day. The fair-skinned Hellenes were gradually replaced by the olive-skinned people whose descendants now inhabit the Mediterranean area.

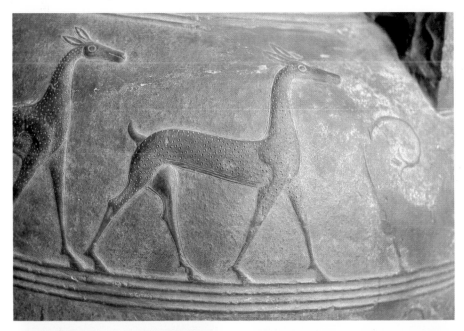

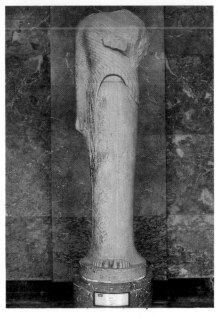

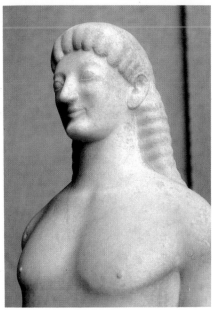

15.5 (left) A beautifully modelled relief from a seventh century BC pot made in Boeotia. Louvre, Paris.

abacus

echinus

15.6 The structure of a Doric column, showing how the drums are secured together with bronze tenons (dowels) fitted into mortises (sockets).

abacus

echinus

15.7 The structure of an Ionic column showing how volutes were carved on the four corners of the capital.

15.8 (lower left) The *Hera* found on the island of Samos, c. 560 BC. Marble. About 200 cm high. Typically frontal early Greek sculpture. Louvre, Paris

15.9 (lower right) *Kouros from Tenea*, c. 570 BC. Marble. About 170 cm high. Note the 'archaic smile'. Glyptothek, Munich

Architecture

The earliest buildings were probably made of wood on the post-and-lintel principle, because the later marble buildings which survive have the appearance of wooden buildings: they are rectangular with gabled roofs. Their general form resembles that of the modern timber bungalow. Fine marble is plentiful in Greece, and the building blocks were laid without mortar and held together with metal dowels and clamps.

The Doric order

There were three *orders* of Greek architecture, that is, three systems of proportion and styles of ornamentation. Bold design, noble proportions and restrained ornamentation were the characteristics of the Doric order. The Doric column was fluted and stood six times as high as its diameter. Its capital was not ornamented and it had no base-moulding (**15.6**). The

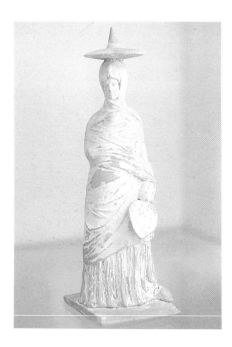

15.10 One of the Tanagra figurines. Terracotta. Third century BC. Height about 25 cm. British Museum, London

15.11 (right) In the archaic period even dying warriors wear the 'archaic smile'. Figure from the west pediment of the Temple of Aphaia (the other end to that shown in **15.2**). Marble, life size

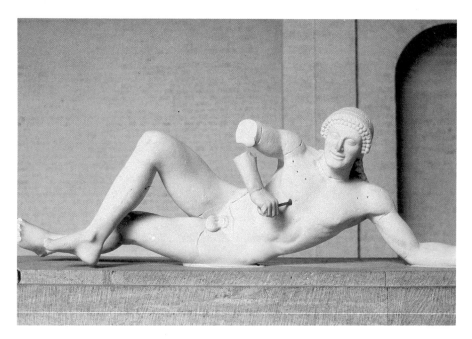

Parthenon, on the Acropolis in Athens, is the finest example of a Doric building.

The Ionic order

The Ionic order was more ornamented and decorative than the Doric. By comparison with the Doric column, the Ionic was taller and more slender (it stood eight diameters high). Its square capital was carved with volutes at the corners, and it stood on a moulded base (**15.7**). Sometimes *caryatids* were used (columns carved to represent human figures), as in the Erechtheum on the Acropolis.

The Corinthian order

The Corinthian order was the most ornate and splendid of all and was much admired by the Romans. The Corinthian column stood ten or twelve diameters high and had a moulded base. The capital was decorated with an acanthus leaf motif (see **16.2, 16.12**).

The Parthenon

This is usually considered to be the world's most beautifully proportioned building. It was designed by architects Ictinus and Kallikrates, under the direction of the great sculptor Phidias, to house Athena Parthenos (a huge chryselephantine statue of 'the virgin goddess', patroness of Athens) which Phidias made. It was built in the Doric order and originally the pediments were filled with sculpture, those in the eastern pediment depicting the birth of Athena and those in the western pediment depicting the legendary dispute between Athena and Poseidon (god of the sea) for possession of Athens. Many of the sculptures, including much of the famous Panathenaic Frieze, are preserved as the 'Elgin Marbles' in the British Museum (**15.12, 15.13**). The Parthenon was made into a Christian church in the sixth century AD and into a mosque by the Turks in 1456. It was ruined by an explosion during a war between the Turks and the Venetians in 1687.

The architects of the Parthenon included incredible refinements in the

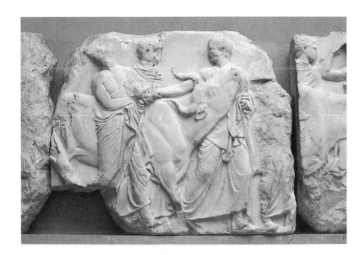

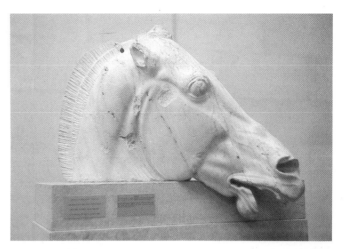

design. Although the naked eye cannot detect it, there is scarcely a straight line in the building. The sides of the columns swell outwards very faintly about half-way up (*entasis*) and all the horizontals curve upwards slightly in the middle. Although these refinements are called *optical corrections*, we are not really sure why they were made. The Parthenon is a temple of the *peripteral* type, i.e. a *colonnade* (or *peristyle*) (see **15.3**) runs around all sides. Like the Egyptian temple, the Greek temple was never entered by large numbers of people but, because of the importance of religion in Greek life, care was taken to site it in a dominating position in the city. The Parthenon, along with other Athenian temples, is situated on the Acropolis, a hill which dominates Athens. No Greek domestic architecture survives.

The Temple of Aphaia at Aegina is another famous Doric temple (**15.2 – 15.4**).

Sculpture

Idealised human figures representing gods or heroes were the chief subjects of Greek sculpture, and marble, bronze and chryselephantine were the chief materials used. Friezes and stelae were carved in the finest relief. Originally the marble sculptures were painted in conventionalised colours.

The earliest Greek sculpture (that of the *Archaic Period* of the sixth century BC) was frontal and stylised, yet monumental and good stone form. The *kouroi* (male deities) and *korai* (female deities) of this period are reminiscent of Egyptian sculpture. They wear the typical 'archaic smile', details of anatomy are indicated by incised lines rather than modelling, and hair and beards are represented in stylised ringlets. The *Hera of Samos*, the *Calf-bearer*, and the *Horseman* from the Athenian Acropolis, and many *Apollo* figures are the chief examples (**15.8, 15.9, 15.11**).

A quickening of spirit and a confidence in Greek values followed the defeat of the Persians in 480 BC. This is reflected in the sculpture of the fifth century (the *Classical Period*). Anatomy is better and the figures have more action and a life-like torsion. Sculpture reached the peak of idealisation in this period. The figures were represented in positions of rest, but they imply latent movement. The *Discus thrower* (*Discobolus*) by Myron; the sculpture of Athena and other sculptures from the Parthenon by Phidias and his followers; the *Charioteer of Delphi*; the pointing figure of Apollo from the pediment of the temple of Zeus at Olympia; and sculptures by Polyclitus are some examples.

15.12 (left) Detail of the Panathenaic Frieze of the Parthenon, showing cattle being led to sacrifice. In sculpture like this, Greek art reached the pinnacle of realism and grace. Late fifth century BC. British Museum, London.

15.13 (right) Head of a horse from the pediment of the Parthenon, late fifth century BC. Marble. British Museum, London.

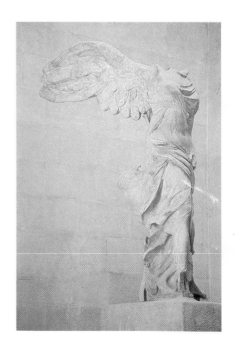

15.14 *The Winged Victory* (or *Nike*) *of Samothrace*, c. 190 BC (Hellenistic Period). Marble. About 240 cm high. This sculpture originally stood on the prow of a monumental stone ship in the harbour of Samothrace. Louvre, Paris

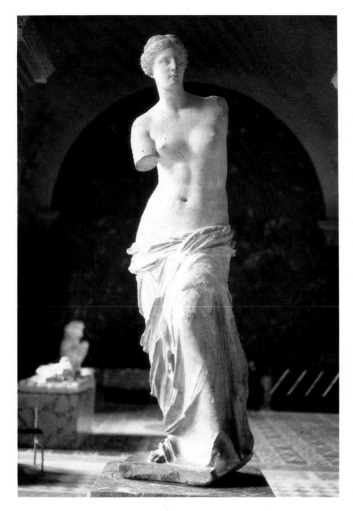

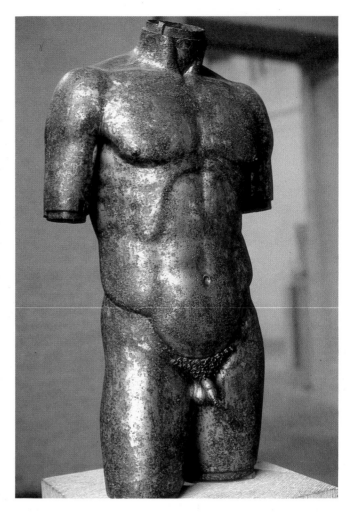

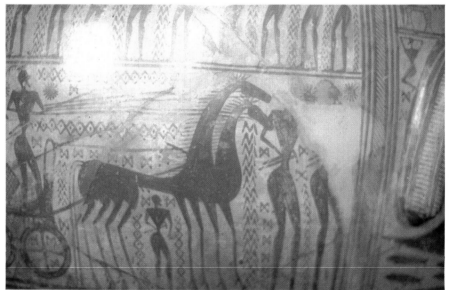

15.15 *The Aphrodite of Melos* (or *Venus de Milo*). Roman copy of Greek original of c. 150–100 BC. Marble. Approximately 205 cm high. Like **15.8** and **15.14**, this sculpture was named after the place where it was found (in 1920). The sculpture originally carried a large mirror into which Venus gazed at her own reflection, but the arms broke off and the mirror was lost. Napoleon brought the sculpture from the Villa Borghese, Rome (see **26.14**), to where it now rests — the Louvre, Paris.

15.16 *Male torso*, c. 50 BC. Gilded bronze. About 100 cm high. An excellent example of the best in Hellenistic art. Glyptothek, Munich

15.17 Detail of the decoration on a Geometric Period vase. The vase originally contained the remains of a warrior, and the picture represents the funeral procession. The mourners are, apparently, naked — an interesting observation on burial rites of the time. Louvre, Paris.

From the fourth century BC Greek sculpture began to decline (the *Hellenic* and *Hellenistic Periods*). An increase in naturalism was accompanied by greater sentimentality and less idealism. The *Aphrodite of Melos (Venus de Milo)* (**15.15**) the *Winged Victory of Samothrace* (**15.14**), *Laocoön* (**16.18**), and sculptures by Praxiteles and Lysippus are examples.

15.18 (left) Amphora from Rhodes. Seventh century BC. Height about 200 cm. Typical of the many huge ceramic jars used in the ancient world to transport and store wheat, wine and oil. British Museum, London

15.19 (centre) Red-figure crater. About 450 BC. Height 40.6 cm. The Art Gallery of South Australia

15.20 (right) 'Horsehead' amphora. Black-figure ware, from about 600–470 BC. Nicholson Museum, University of Sydney

Pottery and painting

In the ancient world, large pottery vessels were used as containers for the goods of trade and for storage (**15.18**). For this reason ancient Greek pottery is sometimes found in other lands. There were many standardised shapes, among them the amphora (storage jar), kylix (drinking cup), hydria (water jar), lekythos (oil flask) and crater (mixing bowl). In the Archaic period pottery was decorated with *geometrical* figures and patterns (**15.17**) (*dipylon* ware). Later pottery had realistic painted decoration, mainly illustrating the legends and life of the Greeks. There were three main styles: *black-figure*, in which the decoration was painted in black on the natural reddish clay base; *red-figure*, in which the design was left unpainted but the background was painted black (**15.19**); and *polychrome*, in which both methods were combined and other colours and also white were added.

The only examples of Greek painting which survive are the painted decorations on pottery. However, we know from written records that a fine school of painters existed in Athens from the fifth century BC onwards. As with the sculpture of the period, this painting was realistic.

Things to do

1 Find some local buildings where Greek orders have been used.
2 In a reference book find the meanings of the following terms:
Helladic
Orientalising
Cycladic.
3 In a reference book study the mouldings and other architectural decorations used by the Greeks. How many occur on buildings in your own district?
4 Look up the derivations of the following words in a good dictionary:

ceramic	aesthetic
ethic	monochrome
politic, policy	style
democratic	amazon
crater	poet

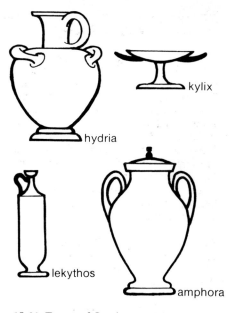

15.21 Forms of Greek pottery

15.22 The 'Greek Key', 'Greek Fret', or 'meander' motif

16 Ancient Rome

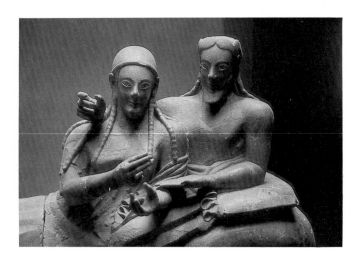

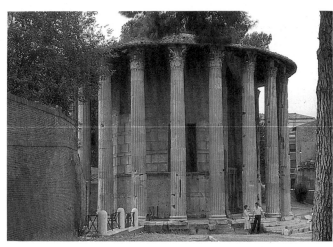

16.1 (left) Detail of lid of *Sarcophagus of the Married Couple*, sixth century BC Life-sized figures. The Etruscans buried their dead in terracotta sarcophagi, like this one designed for a husband and wife, which often carry remarkable sculptures of those they contained. Villa Giulia, Rome

16.2 (right) The Temple of Vesta, Rome. Corinthian Order.

16.3 A Composite Order capital — on top of the acanthus leaves of the Corinthian Order the volutes of the Ionic Order.

The Greeks established colonies, mainly for trade and to relieve over-population in various places along the coast of North Africa (e.g. Alexandria), on the Riviera (e.g. Marseilles — Masilia to the Greeks) and in Italy.

At this time Italy was not known by this name. It was a collection of independent settlements, the most important of which, besides the Greek trading colonies, were the young city of *Rome* and the district of *Etruria* to the north of Rome. These emerged about the time the Greek civilisation was at its height (fourth and fifth centuries BC).

The inhabitants of Etruria (the Etruscans) were similar to the Greeks in many ways; eventually they were conquered, along with the rest of Italy, by the Romans (refer to **23.8**).

By the time of Christ, the Romans had built up a great empire which encompassed the whole of the Mediterranean basin (including Greece and Egypt) and western Europe. Julius Caesar, who conquered Britain in 55 BC, was one of the great Roman soldiers who helped in these conquests. Under the emperors, Rome maintained peace (the *Pax Romana*) in Europe for centuries, but eventually the Romans grew irresponsible and corrupt and the empire became too unwieldly for centralised government.

The Germanic people at that time were very warlike tribes who were not united into one nation and had never been conquered by the Roman legions. They gradually infiltrated Roman Europe, and by AD 500 they, in turn, dominated the scene. The successful conquests of the barbaric Germanic tribes brought about the almost complete destruction of the civilised way of life the Greeks and Romans had developed — buildings and works of art fell into neglect or were destroyed, and the *Dark Ages* and *Middle Ages* followed (in art, these were the Romanesque and Gothic periods, which we shall study in the next section).

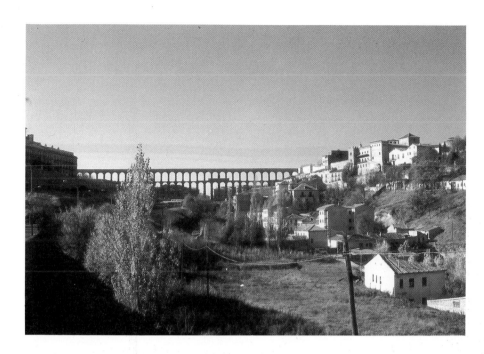

16.4 A view of the town of Segovia, Spain, which was part of the Roman Empire. The aqueduct which brought drinking water from the mountains and across the valleys in a steady fall-line still stands. During the Middle Ages such structures were associated with paganism and acquired names like 'The Devil's Bridge'.

The Romans were great planners, soldiers, administrators and engineers, and they are remembered for these qualities rather than for their art. They loved Greek art, particularly the more naturalistic later styles of sculpture and the Corinthian order of architecture. When they conquered the Greek world, the Romans plundered its art, transporting many originals to Rome and copying others they were unable to move. The famous sculptures *Venus de Milo* (**15.15**) *Apollo Belvedere* (**16.19**) and *The Discus Thrower* are copies of Greek originals, now lost.

The Romans established a rational system of laws on which ours is largely based (e.g. trial by jury). Our writing, too, has developed from Roman letters with very little change.

Engineering

Civil engineering was a feature of the Roman civilisation. Roman engineers built excellent roads which radiated from the city of Rome, linking it with the outposts of the empire. They also built public baths; theatres; amphitheatres (e.g. the Colosseum in Rome, **16.5** and **16.10**); viaducts and aqueducts (e.g. the Bridge over the Gard River in southern France, the Pont du Gard; see **16.4**). Some of these, especially the roads, are still in use today.

Architecture

Roman architects combined the Greek post-and-lintel (or *trabeated*) system with the arch (or *arcuated*) system that the Etruscans had used. They found that, using *arch*, *vault* and *dome*, they could span larger spaces than had ever been possible before (see page 11). This opened up a new concept of architecture in which the interior was as important as the exterior. The Romans loved splendour and they found large buildings essential.

The semi-circular arch was the basis for the vault (*barrel* and *groin*, or *intersecting*), the dome and the arcade, which is a series of arches placed end to end (see **1.14**).

The Greek orders were used, especially the Corinthian, and the Romans themselves developed the *Composite order* (**16.3**) by combining the

16.5 A view in Rome, showing the Colosseum on the left, the Triumphal Arch of Constantine (AD 312–315), and the Palatine Hill, on which the emperors built their palaces, on the right

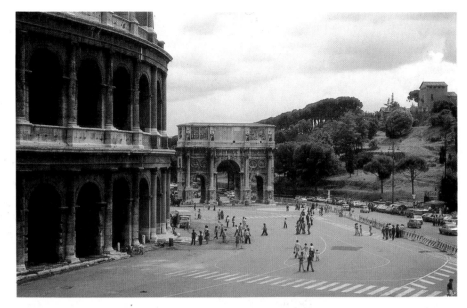

16.6 The Roman Amphitheatre, Arles, south of France. Arles was part of the Roman Empire's Province (now called Provence) and the amphitheatre built there is still used for sporting events.

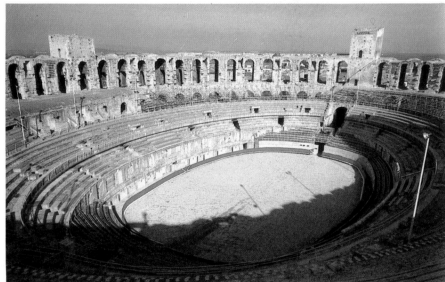

16.7 (below, left) The inside of the dome of the Pantheon, Rome, showing how light enters through the oculus.

16.8 (below, right) Inside the Pantheon showing the coffered dome, arched and pedimented windows, and coloured-marble panels which cover the concrete structure.

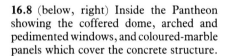

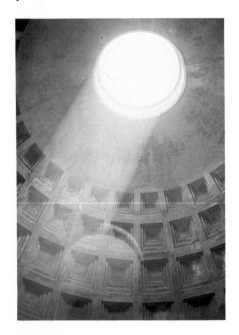

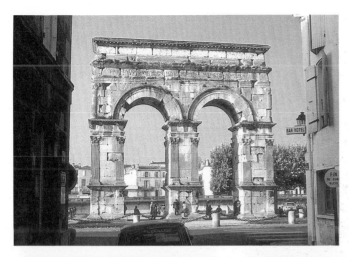

16.9 (top left) Triumphal arch at Saintes, southwest France, which was also part of the Roman Province. The shape of the stones which make up the arches themselves can be seen.

16.10 (above) Arch made of the typical long, flat Roman bricks. In the Colosseum, Rome.

16.11 (far left) Carved acanthus decoration on the Ara Pacis (Altar of Peace) which Emperor Augustus erected in Rome in 13 BC to commemorate his victories in Spain and Gaul. The moulding along the top is a Greek key.

16.12 (left) The acanthus plant

Ionic and Corinthian orders. They also used the *Tuscan order*, an austere style like the Doric, which they copied from the Etruscans.

The Romans developed concrete. There are in parts of Italy deposits of lava-dust which, when moistened, has exceptional binding qualities and sets into a very strong 'natural concrete'. They faced their concrete buildings with slabs of carved and coloured stone.

Many round buildings, such as the Pantheon in Rome (**16.8**) were roofed with domes. The dome of the Pantheon is cast in concrete in a single piece, and has a large hole (*oculus*) in the centre for lighting (**16.7**). It spans nearly 52 metres and is thus larger than the dome Michelangelo built on St Peter's Cathedral, Rome (the largest Christian church in the world), 1500 years later.

The Romans loved lavish ornament. Carved acanthus foliage, quartered marble panels, murals, and mosaics decorated every building. Sometimes, however, this decoration was over-done and seems distasteful to modern people.

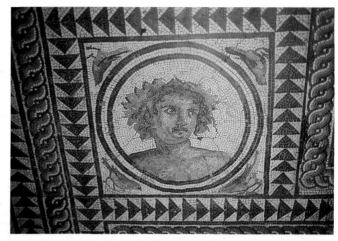

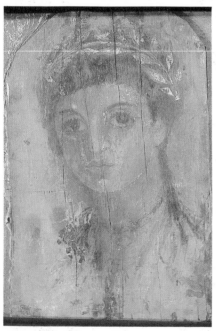

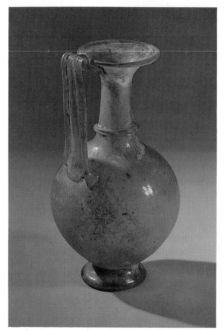

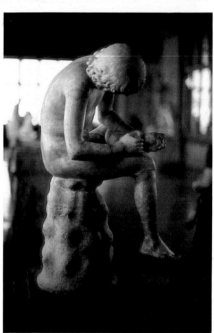

16.13 (top left) Anthemion and palmette decoration. Ara Pacis, Rome

16.14 (top right) Bacchus (god of wine and revelry). Second century BC Roman floor mosaic (the picture has been reversed). British Museum, London

16.15 (lower left) Portrait on a wooden mummy-case, painted in encaustic (colours mixed in hot wax) about the time of Christ. National Gallery, London

16.16 (centre) Roman glass. Third century AD. National Gallery of Victoria

16.17 (lower right) The *Spinario* (boy taking a thorn from his foot). Marble. Height about 100 cm. Sculpture on sentimental themes was popular in Rome. Uffizi, Florence

Sculpture and painting

Much of the ancient sculpture found in Italy today consists of Greek spoils or copies of Greek masterpieces. However, Roman sculptors made excellent portrait heads and busts in marble or clay (**16.20**). Wealthy Romans, proud of their family traditions, collected sculptured portraits of their ancestors and in the Imperial Period there was a great demand for sculptures of the emperor. Generally the portraits were strongly realistic and excellent expressions of character.

The relief-carved *triumphal arches* (**16.5, 16.9**) and *Trajan's column*, and the bronze equestrian statue of emperor *Marcus Aurelius* stood in Rome throughout the Middle Ages and remain there today. They greatly influenced Renaissance artists in the thirteenth to fifteenth centuries AD.

The interior walls of Roman houses were painted with very realistic *murals* in *fresco* (see page 8). Some of these paintings represent views onto gardens and neighbouring buildings and they give striking illusions of reality even today.

Painting was also done in *encaustic* (colours ground in wax and fixed to

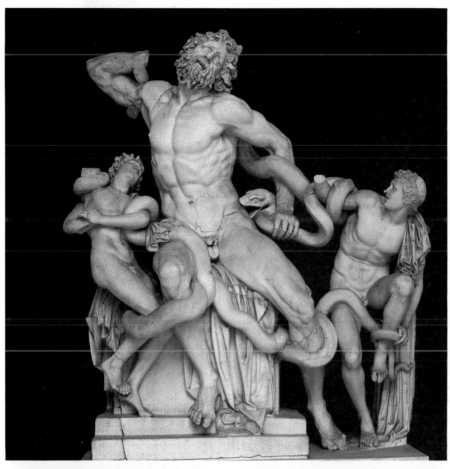

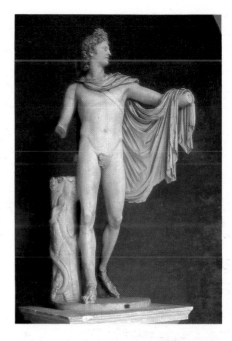

16.18 (left) *Laocoön*, first century AD marble sculpture of the Trojan priest who, with his two sons, was killed by serpents. Height 215 cm. Vatican Museum

16.19 (above) *Apollo Belvedere*. A Roman marble copy of a Greek original which had a good deal of influence on sculptors like Canova (**26.14**). Height 220 cm. Vatican Museum

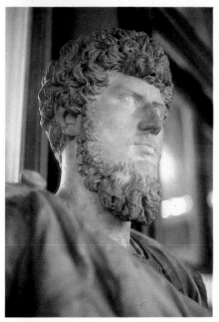

the surface by heating — see **16.15**). Floors and walls were often decorated with pictures in *mosaic* (i.e. small pieces or *tesserae* of coloured glass, stone or potterry set in mortar). Many examples of Roman painting and mosaic have been unearthed by archaeologists working in the ruins of Herculaneum and Pompeii (**16.14**).

16.20 Three life-size Roman marble portraits. Graphic realism which reminds us of twentieth-century people. The one on the right is in the Glyptothek, Munich, and the others in the Uffizi, Florence.

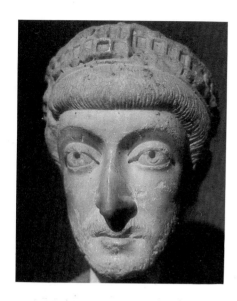

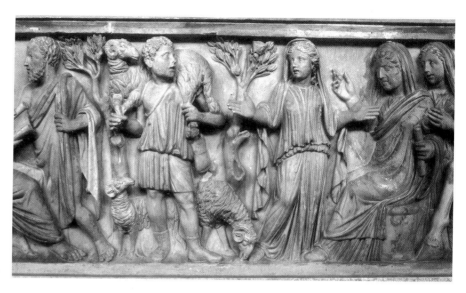

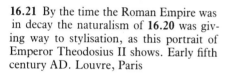

16.21 By the time the Roman Empire was in decay the naturalism of **16.20** was giving way to stylisation, as this portrait of Emperor Theodosius II shows. Early fifth century AD. Louvre, Paris

16.22 (right) Relief from a sarcophagus of third century AD showing Christ as the Good Shepherd in a style that foreshadows that of the Middle Ages. Vatican Museum

Things to do

1 Make a picture in mosaic. Perhaps the simplest way is to glue paper tesserae onto a sheet of card.

2 Find good examples of Roman lettering and numerals and make careful copies of them.

3 Find out more about the art and life of the Etruscans.

4 Ask an experienced person to show you how to make a sculpture in concrete.

5 Find the meanings of the following terms:

voussoir	thermae	stucco	villa
coffer	forum	pilaster	

17 The Middle Ages

In general, the history of the Middle Ages (or Mediaeval Period) describes the breakdown of the Roman empire and civilisation in the fifth and sixth centuries AD, followed by a long and gradual return to a civilised way of life in the Renaissance.

Two events — the beginning of Christianity and the barbarian invasions of Roman Europe — set the scene for mediaeval art.

Several incidents in Christ's life remind us that he was born into the Roman world, and the existence of the Roman empire facilitated the spread of the Gospel. St Peter and St Paul probably visited the city of Rome. At first Christians were persecuted (especially between AD 285 and 305 under Emperor Diocletian). They were forced to meet for worship in the catacombs (underground tunnels which were used as burial chambers) and in their homes because they were forbidden to build churches. However, in AD 313, Emperor Constantine ('The Great'), who had become a Christian, issued the Edict of Milan which gave Christians religious freedom throughout the empire.

Early in the Christian era the Roman empire began to suffer attacks from barbaric Germanic tribes living north of the Alps and east of the Rhine. These people had never been subdued by the Roman legions and were, themselves, under pressure from further east because of the formation of the deserts in central Asia. By AD 500, they had infiltrated most of the western part of the empire. Their attacks on the city of Rome caused the withdrawal of the Roman garrisons from Britain and other provinces of the empire, and the removal of the capital to the wealthy Greek city of Byzantium, safely to the east. Constantine renamed Byzantium 'Constantinople' and it became the capital of Christian Rome. In 1453 Constantinople was captured by the Moslem Turks who changed its name to Istanbul ('The City'), the name by which it is known today.

Gradually the Roman empire split into eastern and western sections with rival capitals at Constantinople and Rome. The eastern Romans (those living in the area covered by modern Greece, Russia, Asia Minor and the Balkans) were conservative and their art developed little as the centuries passed. It is known as *Byzantine* art (see **17.3, 17.7**). Western Europe, on the other hand, was strongly affected by the barbarians, and its art (known first as *Early Christian* art) developed through the Romanesque, Gothic and Renaissance periods to become the art of today. But, until about AD 1000, eastern and western styles had more in common than not.

During this time individual tribes conquered different parts of the Roman empire, setting the scene for the formation of the modern European states and bequeathing them their names. Thus the Franks conquered the Romans' Gaul, which became known as France; the Angles (with others) conquered the part of Britain which became known as England (Angleland); and the Helvetii conquered Switzerland (Helvetia to the

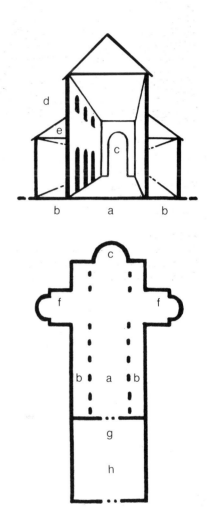

17.1 Section and plan of a basilican church; (**a**) nave; (**b**) aisle; (**c**) apse; (**d**) clearstory; (**e**) triforium; (**f**) transept; (**g**) narthex; (**h**) atrium

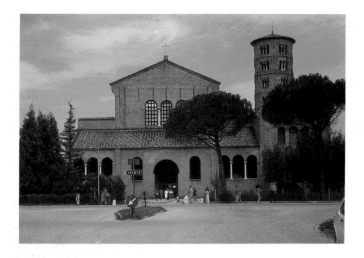

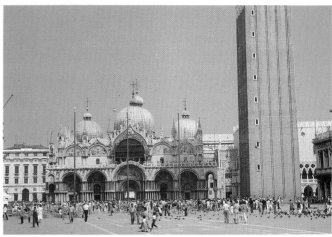

17.2 Sant' Apollinare in Classe, Ravenna — basilican church of the Early Christian period seen from the entrance: atrium and narthex in front, the nave the highest part of the main building, the roofs of the aisles just visible on each side, and the bell-tower on the right. Early sixth century AD.

17.3 (right) Sant' Appollinare in Classe, — interior view, showing semicircular apse at far end of nave, the aisles on each side, the clearstory letting light in to the nave, and the wooden roof. The church is decorated opulently in the Roman tradition, with marble columns and mosaics. The mosaic on the apse half-dome represents Christ as the Good Shepherd.

17.4 (top right) St Mark's, Venice: a central church, built on Greek-cross plan with main central dome and smaller domes over each arm of the cross. The brick bell-tower is so large that the picture could not include it all. The pictures in the semi-circular arches are mosaics.

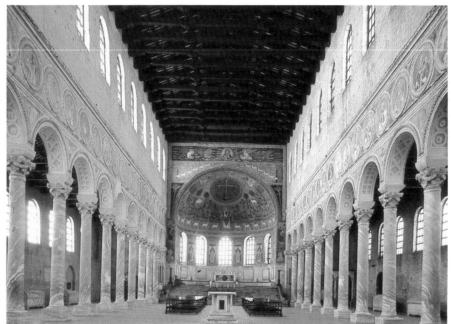

17.5 The Greek Cross (left) and the Latin Cross (right)

Swiss themselves). The Frankish kingdom in Gaul became a highly organised centre of culture at an early date and, under Charlemagne (Carolus Magnus; 768–814), reached great heights (the 'Carolingian Renaissance' of the ninth century).

During the Dark Ages (AD 500–1000), a period of extreme anarchy and disorganisation, the light of civilisation was almost extinguished, but the monks of the Benedictine order succeeded in converting the barbarians to Christianity. With the beginning of the Dark Ages, the Pax Romana was no more and small land-holders, who were unable to defend themselves, gave their land to more powerful men in exchange for the protection of their armies (the Feudal or Manorial System). These small land-holders eventually became serfs.

There were few towns. The feudal baron built a castle on his manor and maintained a retinue of armour-clad knights, at first brutal warriors, but later dedicated to Christian chivalry. The architecture of the time (tenth to twelfth centuries) is known as *Romanesque* because, though many changes were made, the Roman arch was still used.

During the later Middle Ages the number of towns increased in

northern Europe. In the towns, craftsmen organised themselves into guilds and people were relatively free of the political domination of the Church and the feudal lords. This was a period of intense piety and many churches were built in the architectural style of the time — *Gothic* (mid-twelfth to fifteenth centuries).

Towards the end of the Middle Ages people began to see again the worth of Roman and Greek works of art that had been thrown down by the barbarians but were being rediscovered in Italy. Also, people changed from the old ways of superstition and dogma and read the works of the classical writers. In short, there was a rebirth of the civilised and rational way of life of the Greeks and Romans — the *Renaissance*. Naturally, the rebirth of art occurred first in Italy, because this was the land of the ancient Romans. From there, it spread throughout Europe, eventually affecting England in the sixteenth century AD.

Early Christian and Byzantine architecture

The early Christian and Byzantine styles were both based on the Roman style and had much in common with each other. Buildings were massive, walls being up to 7 metres thick. The structural principle was the semicircular arch, and the main material was concrete. Decoration consisted of quartered marble panels, mosaics, frescoes and carved reliefs. Sometimes architects adapted a pagan Roman building or plundered members from Roman ruins. The Pantheon itself became the Church of St Mary of the Martyrs in AD 609. When a Roman column was too short it was propped up with an *impost block* or *dosseret*, which was placed on top of the Roman capital and decorated so that it fitted in more or less with the general design (though it was often in a different style; see **17.7**).

Basilican churches

The first Christian churches were made from Roman basilicas (law-courts and public halls), and later churches were built on the same plan. The throne of the judge in the *apse* became the bishop's *cathedra* (hence *cathedral*), an *altar* was added and the mosaic of the glory of the emperor (on the apse half-dome) was converted into one showing Christ in His majesty (**17.3**). Some basilican churches had transepts which made the plan cross-shaped, or *cruciform* (**17.1, 17.23**). The basilican plan persisted in the west into the Romanesque and Gothic periods.

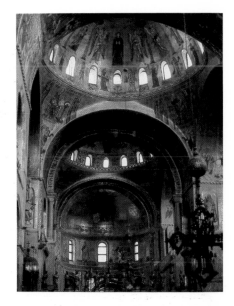

17.6 St Mark's, Venice — interior, showing the main dome (top), one of the smaller domes and the apse with its half-dome. It is a very dark interior with the main light entering from the clearstory windows. It is richly decorated with mosaics, the main colour being gold.

17.7 (left) Sant' Apollinare Nuovo, Ravenna — the arcade between the nave and an aisle of this Early Christian basilican church, showing a mosaic procession of saints under the clearstory windows and Roman-style capitals topped by impost-blocks decorated with crosses. The small round pictures were painted much later — in the Renaissance.

17.8 (right) St Front, Périgueux (SW France) — a central church in the Romanesque style. Note the lack of decoration. This picture shows two of the pendentives which carry the dome.

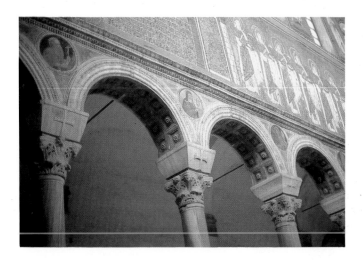

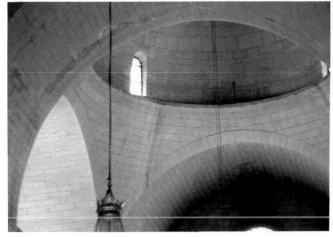

17.9 (left) St Peter's Cathedral, Worms (Rhine Valley, West Germany) — Romanesque building, consecrated in AD 1018. This picture shows the twin towers of the east end and the small dome over the crossing of the transepts. A typical Romanesque building with round arches, few windows and simple decoration. It also illustrates how the mediaeval cathedral nestled among the buildings of the town.

17.10 (right) Mosaics decorating barrel-vault of tomb of Galla Placidia in Ravenna. Gold mosaic tesserae are made by coating the back of pieces of glass with gold leaf. The effect is like small pieces of gold mirror. The glass protects the gold and the colour still glows today as if it were new.

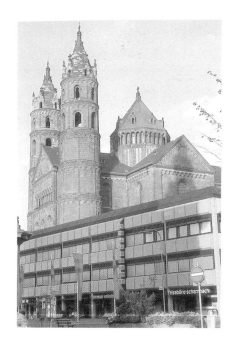

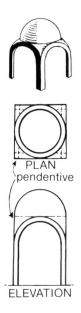

17.11 The principle of the dome on pendentives

Central churches

In the eastern empire churches were built on the equal-armed Greek-cross plan. A *dome* built on *pendentives* (**17.8**, **17.11**) covered the crossing of the arms. Examples of this type of church are Santa Sophia (Hagia Sophia), Istanbul, and St Mark's in Venice (**17.4**, **17.6**).

Romanesque architecture

After the breakdown of the Roman empire the only important buildings to be erected were churches and castles (**17.15**, **17.16**). Houses were usually humble structures with wattle-and-daub walls and thatched roofs.

The same massive style, based on the Roman arch, was still used but by now the fine skills of the Roman builders had been lost and the ornamentation of Romanesque buildings was simple and austere. The Roman method of making concrete had also been forgotten and all large buildings were made entirely of stone (**17.9**).

The Romanesque style developed first in France and northern Italy and was taken to England by the Normans when they conquered the

17.12 (left) Romanesque capital (from St Pierre, Moissac, SW France). The motif of leaves and vines derives from the Corinthian order, but the naturalism of the acanthus leaves has been replaced by simplicity and ruthless stylisation. Compare **16.2**, **16.11**, **16.12**.

17.13 (right) Romanesque carving of a lion from Worms cathedral. Note the strength and simplicity of the form.

Christian symbols

Symbol of Christ

Derivation (ichthus is Greek for fish):

Greek letter I = Roman J (Jesus)
Greek letter X = Roman Ch (Christ)
Greek letter Θ = Roman Th (theos is Greek for god)
Greek letter Υ = Roman U (son)
Greek letter Σ = Roman S (Saviour)

The Labarum

Interpretation: The Greek letter X (chi) = the Roman Ch and the Cross;
the Greek letter ρ (rho) = the Roman R and the Crook;
the Greek letter Α (alpha) = the beginning;
the Greek letter ω (omega) = the end;
i.e. 'Christ, the beginning and the end'.

Interpretation: Christ and the four Evangelists

17.14 Part of a mosaic floor found by ANZAC soldiers near Gaza in 1917. Sixth century AD. Australian War Memorial, Canberra. The peacock was the early Christian symbol for the Resurrection.

country in 1066. Consequently the style is sometimes also called *Norman* (**17.17**).

Early Christian basilican churches had wooden or barrel-vaulted roofs. As the former were not fireproof and the latter were subject to cracking, Romanesque and, later, Gothic architects divided their stone vaults into *bays* of *groin vaulting* with thicker *cross-ribs*. The arches forming the ribs converged to form *clustered columns* or *piers* on the inside of the wall (the word *column* usually refers to a free-standing support of circular section, whereas the word *pier* can refer to a support of square section). The thrust was taken by *buttresses* placed flat against the outside of the wall (see **17.19, 17.22**). This was a far more rational and economical technique than the Roman method.

A *campanile* (bell tower), built somewhat apart from the church itself, was added during the Romanesque period. The most famous example is the *Leaning Tower of Pisa* (see **17.2, 17.4**).

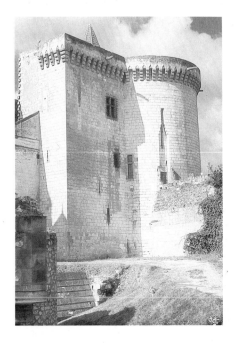

17.15 (left) Keep (main part) of the castle at Loches (central France). Defenders could pour flaming materials on attackers through the slits in the parapet (machicolation) and the few windows are narrow to prevent arrows entering.

17.16 (right) Doorway into castle at Loches. Originally an iron grille (portcullis) slid up and down in the groove.

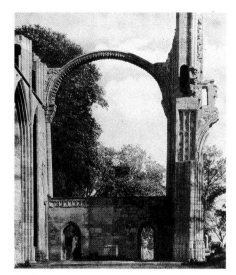

17.17 A Norman arch still stands in the ruins of Crowland Abbey, Lincolnshire, England — a testimony to the stability of the arch form. Reproduced from *Beautiful Britain Calendar*, Royle Publications Ltd, London. Photograph: E.S.B. Elcome.

17.18 (right) St Trophime, Arles (southern France) — the tympanum over the entrance, showing typically recessed arches and relief carvings of the twelve apostles (on the lintel) being blessed by Christ. The figure of Christ is surrounded by the symbols for the four evangelists: the angel (St Matthew), the eagle (St John), the ox (St Luke) and the lion (St Mark).

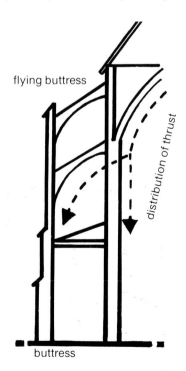

17.19 The principle of Gothic construction

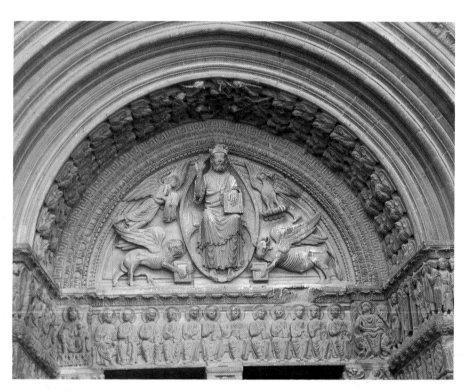

Gothic architecture

During this period ordinary houses were made of wattle-and-daub or *half-timbering* (**17.31**) but, owing to the more peaceful conditions, few castles were built. However, many of Europe's finest cathedrals were built at this time: for example, the cathedrals of Notre Dame in Paris, Rheims (**1.4**) and Chartres, and Salisbury cathedral in England (**17.23**). The religious enthusiasm of the period was such that the whole population of the town worked on the building of the cathedral.

However, the old belief that mediaeval artists worked anonymously to the glory of God is not true. Quite a few names have come down to us — the sculptors Gislebertus and Giovanni de' Grassi, and William of Sens, architect of Canterbury cathedral, for example.

Gothic church architects strove more and more for height in their buildings in an effort to express the triumph of Christianity, and the cathedral now dominated the town. The effect of height was gained through taller and more slender columns and *pointed arches* and vaulting. As a consequence of this added height, higher and more complex buttresses (e.g. *flying buttresses*: **17.19, 17.26, 17.32**) were needed to carry the thrust. However, these tall structures do not appear massive because they were built with extreme economy. The Romanesque vault, column and buttress system developed into the most efficient method of building ever conceived, apart from twentieth century methods.

The walls between the columns were no longer load-bearing and were often wholly taken up with large *stained-glass* windows set in *tracery*. Campaniles were replaced by towers capped with spires which were built into the church itself over the crossing of the nave and transept (**17.23**) or over the façade (**17.20**).

Gothic architecture began in France about 1150. As the period continued, emphasis on height and vertical lines increased and decoration became more and more pointed. By the thirteenth century the *Early English* style had developed. By the fourteenth century — the *Decorated*

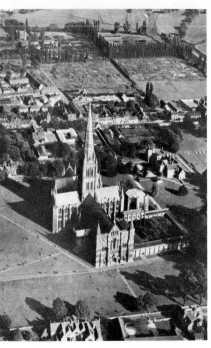

17.20 (top left) Notre Dame cathedral, Paris. Typical Gothic cathedral showing the vertical division of the facade into nave and two aisles (each with its own doorway) and large wheel-window. Built 1163–1235.

17.21 (top right) The Palace of the Doges, Venice. Venetian Gothic architecture featuring simple, pointed arches on the ground floor and more elaborate arches and quatrefoils on the next; also decorative brickwork in the wall and a sculpture of the lion of St Mark (the patron saint of Venice).

17.22 (lower left) Early Gothic buttresses, St Pierre, Moissac (SW France)

17.23 (lower right) Aerial view of Salisbury, England. The addition of transepts makes the plan of the cathedral into a Latin cross. The spire of this Gothic cathedral is located over the crossing of the transepts with the nave. The picture also shows how the mediaeval town nestles about the cathedral, which is by far the tallest building. Salisbury's spire (119 m) is the tallest in the world. Reproduced from *Beautiful Britain* Calendar, published by Royle Publications Ltd, London.

Period — there was, as the name suggests, an increase in ornamentation, especially magnificent window-tracery and more elaborate vaulting. The English *Perpendicular Period* (Tudor period — fifteenth century) was characterised by an accent on vertical lines, flattened arches (see **27.11**, **17.30**), and the culmination of vaulting development in *fan vaulting* (**17.30**). In Europe, the influence of English Decorated style resulted in the *Flamboyant Period* of the fifteenth century, which was characterised by curved, flame-like decoration (**17.26**).

The name *Gothic* was given to this style by Renaissance people, who considered it as inelegant and as barbaric as the Goths, although the Goths themselves had nothing to do with it. During the Middle Ages, a church took so long to build that often it was started in an earlier style and finished in a later one (**17.7**, **17.25**, **17.26**, **17.28**).

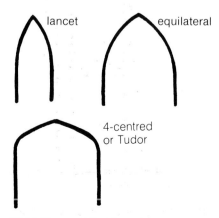

17.24 Types of Gothic arch

17.25 This view of Worms cathedral shows how church building has continued, sometimes through hundreds of years. Worms (see **17.9**) was a Roman outpost in the second century AD and there has been a church there since then. Most of the present cathedral was built in the Romanesque period, as seen in this picture. However, Gothic windows, which were added in the fourteenth century, can be seen to the left, and in one of these is stained-glass which was made only a few years ago, as were the lamp-standards.

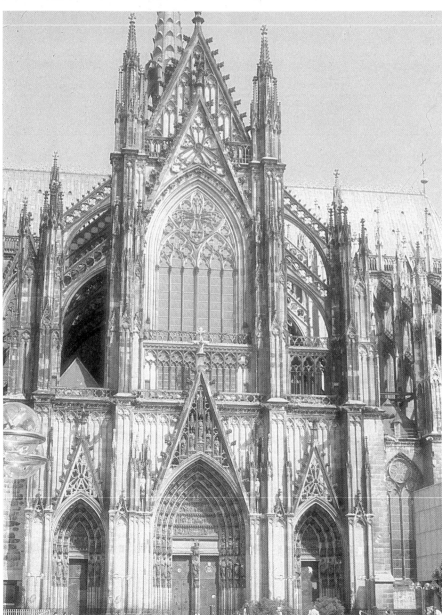

17.26 Cologne cathedral. This cathedral was started in the Gothic period but not completed until the nineteenth century (the Gothic Revival: see page 131). It is difficult to see which part of the building is which as, unlike Worms, the style is unified. Note the flying buttresses and the lavish decoration, which indicates that it is late Gothic. Compare with plates **17.2**, **17.8** and **17.9**.

17.27 The town of Assisi, Italy. Mediaeval towns were often built on hilltops so that their inhabitants could better defend themselves in this time of unrest. The church of St Francis (Assisi was the saint's home) is nearest the camera and its bell-tower dominates the valley.

Stained glass

This is perhaps the most famous Gothic pictorial art. Coloured pieces of glass, set in lead strips, covered the windows of churches, illustrating sacred stories in a style which used only colour and line, without light-and-shade, to achieve its glorious effect (see **17.33–35**).

Sculpture

A good deal of Hellenistic naturalism survived into the Early Christian period (see **16.22**), and Carolingian sculpture was strongly influenced by the Roman. However, throughout most of the Middle Ages, sculpture hardly existed apart from carved ivory reliefs and architectural ornamentation. The column-like figures flanking the portals of Rheims and Chartres cathedrals (**17.37**) and many relief-carved *tympana* (**17.18**) are examples.

However, as with painting, some very naturalistic work was being produced in northern Europe just prior to the Renaissance by such artists as Peter Parler, Tilman Reimenschneider (**17.39**) and Veit Stoss, whose work foreshadowed things to come.

The early Christians developed a system of symbols, at first secret, many of which have become embodied in Christian tradition. Trefoils symbolising the Trinity, quatrefoils (**17.21**) symbolising Christ and the four Evangelists, the peacock symbolising the Resurrection, and the lamb symbolising Christ (**16.22**) are examples. The Labarum (or Christogram), the device of Constantine the Great, is a Roman military banner to which Christian meaning has been given — a fitting emblem for the first Christian emperor (page 97).

17.28 Cologne cathedral, the right-hand door in **17.26**, further indicating the continuous tradition of church building. This door was made in the last few years by the modern German sculptor Ewald Mataré. The hand of God is at the top and the fishing-net symbolises the role of Christ and the Apostles.

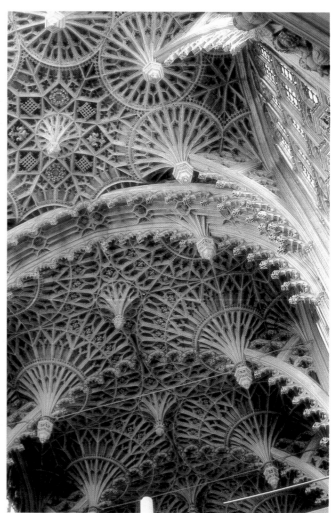

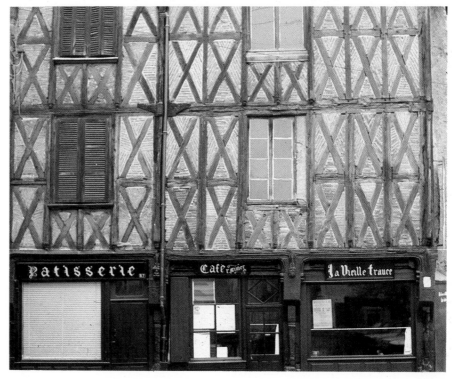

17.29 Vaulting in the nave of Westminster Abbey. Despite its great height and delicacy, this is entirely built of stone and shows the marvellous development of the arch principle by the Gothic builders. The whole weight of the roof is carried by the ribs which gather together to form the slender clustered columns, permitting the builders to make large windows. The light coming in through the clearstory can be seen. The bosses have been painted gold. cf. **17.3** and **17.8**.

17.30 Vaulting in the Henry VII Chapel in Westminster Abbey. One of the last buildings to be made in the Gothic style (built 1503–19), it represents the heights of Tudor Gothic building. Again, it is entirely built of stone, each lacy pendant being carved so that it keys in to its neighbour and they support each other. The arches are of the 4-centred or Tudor type.

17.31 Mediaeval half-timbered building, Montrichard, France. The wooden members form the main structure and the brickwork is just infill. Often this infill was white-washed.

17.32 A striking shot from the tower of Notre Dame, Paris, showing (foreground) a view through the water channel of a gargoyle and the flying buttresses carrying the weight of the nave roof over the aisle. These buttresses, too, have water channels to carry rain water from the nave roof and out through the gargoyles to the right of the picture.

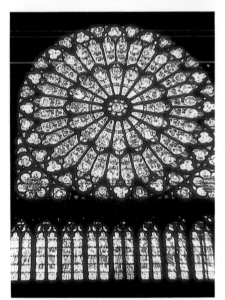
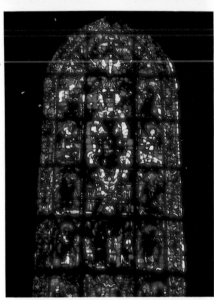

17.33 The rose-window (top) and lancets (lower) in the northern transept of Chartres cathedral.

17.34 Notre Dame de la Belle Verrière — early thirteenth century stained glass in the north aisle of Chartres cathedral — a piece so famous it has been given the name 'Our Lady of the Beautiful Stained Glass'.

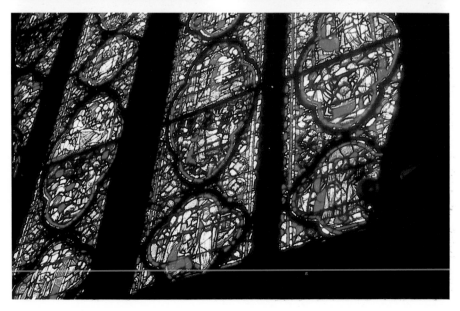

17.35 Stained glass in Sainte-Chapelle, Paris, which was the royal chapel for centuries and one of the first ever Gothic buildings (built 1241-8).

17.36 One of the grotesques which decorate the parapet at the base of the towers of Notre Dame cathedral, Paris (**17.20**). This is actually a reproduction of the thirteenth century original carving: the way the old stone is crumbling away, owing to industrial pollution of the air, can be seen in the stone in the lower right.

17.37 Stone figures on the western portal of Notre Dame cathedral, Rheims, showing how the figures are elongated to fit in with the design of columns, yet have a graceful naturalism. On the left, one of the *Smiling Angels of Rheims*, and on the right a female saint (see **1.4**).

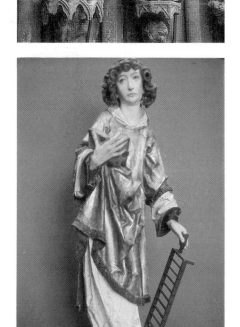

17.38 *St Barbara*. Oak. Late French Gothic. Height approximately 1 metre. National Gallery of Victoria: Felton bequest

17.39 *St Stephen*, by Tilman Reimenschneider (German sculptor c. 1460–1531). Late Gothic sculpture in linden wood, painted. Museum of Art, Cleveland; Leonard C. Hanna Jr Bequest

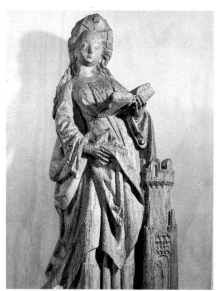

17.40 Gothic stained glass. Method of securing panes with lead strips (cames).

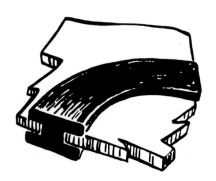

Things to do

1 Look up the following architectural terms and relate them to this section:

open and blind arcades	corbel	embrasure	mouldings
crenellated battlements	chevron	portcullis	pinnacle
machicolation	gargoyle	string-course	cloisters
clerestory (clearstory)	boss	narthex	mullion

2 Look up any of the terms mentioned in this section which were not fully explained and find out more about them.

3 In a book on the history of architecture, find out more about the following larger topics which have been only briefly mentioned in this section: Gothic vaulting; types of Gothic arch; the development of buttresses in the Middle Ages; English wooden church roofs; the development of the mediaeval church plan.

4 Design a stained-glass window.

5 Devise a set of secret symbols relating to your own life or interests.

6 Design a coat of arms for your family or town.

18 The Renaissance

Gothic art was largely a north European phenomenon. The Italian city of Milan has a fine Gothic cathedral, but then Milan is a north Italian city. Farther south, as might be expected, the links with ancient Rome remained quite strong throughout the Middle Ages. Roman buildings, like the Pantheon (**16.7, 16.8**) and the Colosseum (**16.5**), the ruins of the forum, the triumphal arches (**16.9**), ancient Roman vases and sarcophagi, and sculptures like the equestrian figure of Marcus Aurelius, stood in Rome throughout the Middle Ages and were continual reminders to the Italians of their once-great past and of the art of the ancients. Throughout the Middle Ages many Italians had wished for a resurgence of Italy's political strength but this was not to happen. Instead the resurgence was cultural — the Renaissance — the rebirth of interest in Greek and Roman ideals and values; the beginning of modern times, in fact.

While northern Europe was developing Gothic art, the Romanesque style continued in Italy, especially in Tuscany, where artists more and more took surviving Roman works as their models. This period (the twelfth and thirteenth centuries) we now call the *Tuscan Proto-Renaissance*. The tendency to look back to Rome and Greece may have been encouraged by repeated migrations of scholars and artists from the eastern empire, which was under attack from the Moslems at this time (in 1453 Constantinople itself was conquered by the Turks).

Throughout much of the Middle Ages life was insecure and uncomfortable. The teachings of the Church encouraged people to care more for happiness in the hereafter than for comfort and riches on earth, and few questioned this. Renaissance people, on the other hand, were reluctant to accept anything that could not be proved, as was the case in classical times. Consequently the influence of the Church gradually decreased and men again came to value rational and free enquiry. This is not to say that religion died away, but from the books of the classical scholars, which had been preserved throughout the Middle Ages in Christian monasteries and by Moslem scholars, came a resurgence of the optimistic Greek belief in the worth of individual humans (*Humanism*). This led, for one thing, to a demand for painted portraits and for pictures illustrating the classical myths. From these books, too, came renewed interest in classical science, mathematics, philosophy and literature.

The period we know as the Renaissance, however, was neither isolated nor sudden in appearance. Throughout the Middle Ages, in several parts of Europe, there had been intermittent attempts to 'humanise' life, most notably perhaps the Carolingian Renaissance of the ninth century, and there had always been free-thinking individuals who had shocked their contemporaries with their heretical or pagan ideas, even during the greatest period of acceptance of the Christian faith.

In the Renaissance, all the arts thrived. Accompanying the changed intellectual climate was a renewed interest in the naturalistic painting and sculpture, and the architectural styles of the ancient Romans.

There was always considerable contact between Italy and the north. Architects and craftsmen migrated from town to town where the great cathedrals were being built. This meant much interchange of ideas. The naturalism of the late Gothic sculpture and painting influenced the development of Italian Renaissance sculpture and painting, but the north remained Gothic until the fifteenth century, whereas the new style began in Italy as early as the thirteenth and fourteenth centuries. However, once fully identified, the spirit of the Renaissance spread throughout Europe and little remained anywhere of the mediaeval way of life by the seventeenth century.

The period from about the thirteenth century until the sixteenth century was one of ferment and change. It was a period of geographical and scientific discovery. Gunpowder was introduced from China, making the castles and armour of mediaeval warfare obsolete. The development of printing, another introduction from China, made book production cheaper, and the consequent wider reading of the Bible, by now translated from the Latin into German, French and English, and works of the ancient scholars, aided the Protestant Reformation, which also belongs to this period. The voyages of da Gama, Columbus, Magellan and others were facilitated by the introduction of the mariner's compass and in turn facilitated trade and the development of a wealthy middle class — the first capitalists, many of whom became great patrons of the arts. The world was no longer believed to be flat, and European nations were soon to found colonies in the New World, Africa and the Orient. New national styles developed in literature as well as in the visual arts, and great national poets such as Dante Alighieri (1265–1321), Francesco Petrarch (1304–74), and William Shakespeare (1564–1616) emerged.

Many towns on the trade and pilgrimage routes between Europe and the Orient had developed into city-states similar to those of ancient Greece. They became wealthy by taxing the travellers and traders who passed through them and the powers of the Church and the feudal lord were gradually assumed by the civic authorities. Civic pride and rivalry caused much money to be spent on patronage of the arts — for example on fine civic buildings such as the Doge's Palace in Venice (**17.21**).

The Italian city states most prominent in the history of art were Florence, Venice, Siena and Rome. Florence has been called 'The Athens of the Renaissance' because it was a great centre of culture under the wealthy and famous banking and trading family, the Medici. By the sixteenth century, the modern European states were emerging from the Holy Roman Empire of the Middle Ages, and scientists such as Galileo, Bacon, Harvey, Newton and Copernicus, working on the basis of ancient science and from their own observations, laid the foundations of modern physics, mathematics, astronomy and medicine. Their discoveries gave Europeans a first glimpse of the control they were to assume over nature in the succeeding centuries.

Renaissance art can be divided into four sub-periods. The *Proto-Renaissance* (thirteenth and fourteenth centuries), a period of transition from the Middle Ages, saw the establishment of the main centres — Siena, Florence and Venice. Unfortunately, the promise of this period was frustrated by the Black Death of 1348–50, which killed thousands and brought about a long period of pessimism.

By the fifteenth century (the *Early Renaissance*) there was a revival of

optimism and belief in the powers of man. The first generation of giants (Masaccio the painter; Donatello the sculptor; and Brunelleschi the architect) was followed by a number of men quite near them in stature (Piero della Francesca, Sandro Botticelli, Paolo Uccello, Fra Angelico, Fra Filippo Lippi, Luca Signorelli and Antonio Pollaiuolo). Later in the century man seemed less omnipotent, and this is reflected in the sadness and uncertainty of Leonardo da Vinci, one of the many artist-scientists of the period.

The *High Renaissance* (c. 1500–1520) saw the climax of Italian Renaissance art. It was centred in Rome and occurred through Church patronage of artists, most of whom were Florentine (e.g. Michelangelo and Raphael). By then the technique of rendering nature was well known and the masters of the period synthesised the painterly Venetian style with the linear Florentine style and were able to express with classical grace and restraint the higher spiritual ideals.

The fourth sub-period, in the later sixteenth century, was the *Mannerist* period, so named because the impact of Leonardo, Michelangelo and Raphael was such that those who followed could do little but imitate their styles (manners). Mannerism's exaggerated, extravagant forms, dynamic compositions and wildly gesticulating figures were a reaction to High Renaissance classicism. Mannerist tendencies intensified in the *Baroque* and *Rococo* periods (seventeenth and eighteenth centuries), but by then great Renaissance artists were emerging north of the Alps (see section 20).

Things to do

1 Look up the meanings of the Italian terms *dugento, trecento, quatrocento, cinquecento* and *siecento* in a dictionary of art.

2 Read further in an encyclopaedia or history book (use the index) on Humanism, the Renaissance, the Medici family, printing, the Reformation, Renaissance science, and other topics mentioned in this section.

3 To gain more knowledge of the background to Renaissance art read from the following books by Italian Renaissance authors:

The Divine Comedy, by Dante Alighieri;

The Decameron, by Giovanni Boccaccio;

the poems of Francesco Petrarch;

The Lives of the Most Famous Architects, Painters and Sculptors, by Giorgio Vasari (1515–74);

The Book of the Art of Cennino Cennini (c. 1390); and the autobiography of Benvenuto Cellini (1550–1571)

19 Renaissance painting in Italy

In Italy, where Renaissance art first flowered, different and distinctive styles of painting developed in each of the main city states. A group of artists who work in a similar style is often described as a *school*, and the three main schools of Italian Renaissance painting are usually considered to have been the Sienese, Florentine and Venetian schools. This situation was due partly to their geographical isolation from each other, partly to parochialism, and also to the *bottega* system. Under this system, a master-painter would train apprentices in his workshop until they reached the status of journeymen. They would then be free to leave, some eventually becoming masters themselves and setting up their own bottegas.

Artists were responsible to their patrons for the production of architectural designs, sculpture and incidentals such as jewellery, and decor for pageants — as well as for paintings. Renaissance artists had to be 'masters of all trades', but they had always been regarded as little better intellectually than artisans. Largely because men like Leonardo da Vinci had distinguished themselves in science, philosophy, letters and other learned subjects as well as art, the status of artists rose during the Renaissance.

The development of *perspective* — the ability to represent space and volume in a convincing way in a picture — is one of the key achievements of Renaissance art. However, it is also an indication that Renaissance people were able to look at the world with a new, scientific detachment and objectivity, which is a characteristic of modern society.

The Sienese school

In the early fourteenth century Siena was a very progressive community but a series of misfortunes, including the plague (the Black Death) of 1348–50 and military defeat by Florence, generated pessimism and fear of change. Siena was one of the first Italian cities to embark on a civic and religious building program, but all work stopped in 1348.

Sienese painters of this time were closer to the naturalism of the Florentine pioneer Giotto (see **19.1**), but the changed cultural climate resulted in the copying of fourteenth century models with little change thereafter. Consequently, Sienese painting reminds us more of Mediaeval than of Renaissance art. Pictures are usually small and painted in tempera on wooden panels. Subjects are almost exclusively religious and figures are stiff symbols painted without light-and-shade on a gold-leaf ground.

Duccio di Buoninsegna (1260?–1319?), the earliest and most typical Sienese painter, is known for his *Madonna in Majesty* (*Maestà*), a stained-glass window, and *The Marys at the Tomb*, all in Siena cathedral. The influence of French Gothic naturalism is stronger in the work of Duccio's pupils: Simone Martini (c. 1285–1344) — for example *The Annunciation* of 1333 in the Uffizi, Florence; and Stefano di Giovanni, called Sassetta (1392?–1450) — for example *The Journey of the Magi*, private col-

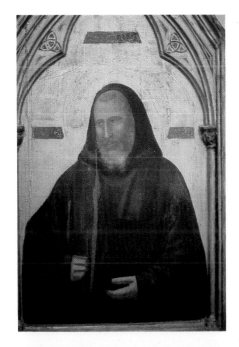

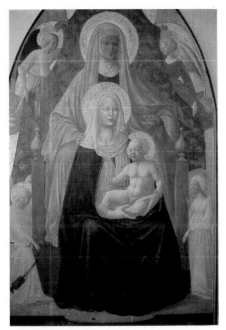

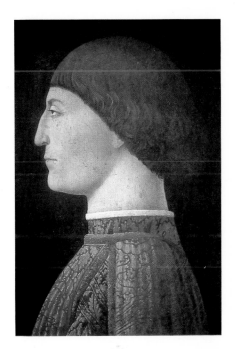

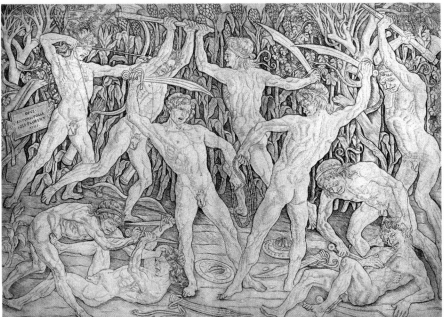

19.1 Giotto, *St Benedict*, one of the panels formerly on the high altar of the Badia, Florence, and now in the Museo di Santa Croce. Although painted at the end of the thirteenth century, and in a Gothic frame with gold-leaf background, this picture exhibits Renaissance humanism typical of Giotto. The elongated eyes are also typical of Giotto.

19.2 *The Virgin and Child with St Anne* (about 1425), painted in tempera on a wooden panel by Masaccio with the assistance of Masolino (c. 1383–1447?). The natural poses, the animation in the faces and the colour and modelling of the three main figures mark this as an early Renaissance painting. Uffizi, Florence

19.3 Piero della Francesca (1410/20–98), portrait of *Sigismondo Malatesta*. A typical Florentine-school portrait with its emphasis on line and form rather than colour. c. 50 cm × 38 cm. Louvre, Paris

19.4 Antonio Pollaiuolo (c. 1432–98), *Battle of the Nudes*. This engraving, inspired by Roman sculptures like **16.18**, gave Pollaiuolo an opportunity to exhibit his knowledge of human anatomy. Florentine school. National Gallery of Victoria: Felton Bequest

lection, New York. The brothers Ambrogio and Pietro Lorenzetti, who worked from about 1319 until 1347, were closer in style to the great Florentine innovator, Giotto.

The Florentine school

Florentine art has a similar background to Sienese art, but the Florentines were progressive and believed that art should evolve. They allowed Roman and Gothic sculpture to influence them in the direction of naturalism, and they observed nature and studied human anatomy, movement and facial expression to achieve this more effectively. There are many large Florentine murals in fresco; smaller pictures were painted in tempera and, later, oils.

Florentine artists concentrated on drawing, that is, the use of light-and-shade (*chiaroscuro*) and *perspective*, to give an illusion of space and solidity in their pictures — in fact, this is the keynote of their school. Although most works had Christian subject matter, for the first time since the pagan era classical mythological subjects were also important. The human body, including the nude, was frequently represented, and portraiture was developed.

Giotto

Ambrogiotto di Bondone, called Giotto (1266?–1337), the first great Florentine painter, was a remarkable genius well ahead of his time, who already showed some of these tendencies. In his frescoes in the Arena Chapel, Padua, the figures have movement and marked three-dimensional quality, and very convincingly express emotions such as grief or fear. His backgrounds suggest space and represent landscapes realistically, but his faces lack individuality, the eyes being particularly unvaried and even frontal. However, he was the great innovator of Renaissance painting and has been called 'the father of modern art'.

Giotto executed major fresco cycles (series of pictures) in the churches of San Francesco, Assisi (where he first worked as apprentice to the almost legendary Cimabue, *c.* 1240–1302?) and Santa Croce, Florence, as well as the Arena Chapel, Padua. He was the architect of the campanile of the cathedral of Florence (the Duomo) and carved some of the sculptures which decorate it (see **21.1**).

Masaccio

It was a century later — the century of great progress in Siena — that Giotto's successor, Masaccio (1401–28), appeared. Together with his associates Brunelleschi the architect, and Donatello the sculptor, he perfected naturalism — light-and-shade, foreshortening and perspective. His famous frescoes, *The Tribute Money* and *The Expulsion of Adam and Eve*, parts of a series in the Carmine church, Florence, are the first great fully realistic pictures (see **19.2**).

Leonardo da Vinci

Leonardo da Vinci (1452–1519) is the finest example of the Renaissance 'universal genius'. Although a great painter, he depended more upon other accomplishments to earn his living. For nearly 20 years he was in the employ of Duke Ludovico Sforza of Milan, and for much of this time he was engaged in engineering work, building fortifications, and designing machines and weapons. He invented the principles of the machine-gun, the military tank, the submarine and the aeroplane, although none of these was built until centuries later. His plan to drain the marshes of Campagna was not completed until 1929. He had a passionate longing for knowledge of all kinds and achieved fame as a poet, musician, philosopher, scientist, architect and sculptor as well as painter; in fact his intellectual power greatly improved the status of the artist in society. His fine anatomical drawings were among the first modern scientific studies in medicine.

Leonardo's fame as a painter began when, as an apprentice of Verrocchio (c. 1435–88; see **26.4**), the angel he had painted in a corner of his master's *Baptism of Christ* far outshone the rest of the picture in naturalism and grace. In the famous portrait of a lady with an enigmatic smile, *Mona Lisa* (or *La Gioconda*) in the Louvre, Paris; the now sadly deteriorated *Last Supper* (a mural in the monastery of Santa Maria della Grazie,

Milan); and the two versions of *The Virgin of the Rocks* (Louvre, Paris, and National Gallery, London), he reached the heights of representation, noble beauty, spirituality and characterisation.

With his empirical mind Leonardo was the first artist really to understand nature and his 1473 drawing of the Arno Valley is the first pure landscape since Roman times. It shows his grasp of the unifying visual power of light and atmosphere, which he rendered by his *sfumato* (misty) technique.

Michelangelo

Michelangelo Buonarroti (1475–1564) thought of himself more as a sculptor than as a painter, yet he excelled in both arts, and in architecture as well. In fact, his genius and achievements were in many ways the ultimate in Renaissance art. To Michelangelo, the nude human body (not only the face), and especially the male nude, was the ideal medium for the expression of both human and divine spirituality, tragedy and pathos.

One of Michelangelo's earlier sculptures, the *Sleeping Cupid* (1495–96), had so much classical feeling that it was sold by a dealer as an antique (without Michelangelo's knowledge). His most famous early work, the *Pietà* (1498) in St Peter's cathedral, Rome, was produced when Michelangelo was under the influence of Leonardo, but the two were rivals in 1504–05 when it was proposed that each should paint a mural on the same wall in the Palazzo della Signoria, Florence. Neither picture progressed much past the *cartoon* stage, however. Michelangelo's marble sculpture *David*, called *The Giant* (1501–04; **26.7**), which is 5.5 metres high, became the symbol of the newly established Republic of Florence, because it symbolised the triumph of an ordinary man over a tyrant. It expresses strength and moral indignation, and was carved from a block of stone that had been rejected by more experienced sculptors because it had a crack in it. A replica of *David* still stands in the city square (Piazza dei Signori), while the original is in the Academy of Florence.

For 40 years, from 1505 to 1545, he worked on a monumental tomb for Pope Julius II, which includes the famous *Moses* (**26.8**) and seven *Slave* figures (see **1.3, 26.9**). From 1520 to 1534 he worked on the Medici chapel and tombs in San Lorenzo, Florence.

Michelangelo's crowning achievement as a painter is the fresco on the ceiling of the Sistine Chapel (1508–12) in the Vatican. The fresco covers 930 square metres, took four years to complete, and contains 343 figures, some of them 5.5 metres in length (**19.6**).

Michelangelo lived through the High Renaissance and into the Mannerist period. His last works (e.g. *The Last Judgement* which was painted on one wall of the Sistine Chapel in 1535–41; **19.7**) are in the restless Mannerist style.

Michelangelo also worked as an architect. Apart from designing the tombs mentioned above, he built the Laurenziana Library in San Lorenzo, Florence, and in 1546 he became architect of St Peter's cathedral, Rome. (Michelangelo's architecture is more fully covered in section 21.)

Raphael

Raphael Sanzio (Raffaelo Santi; 1483–1520) had the ability to learn from the great masters who had preceded him — his master Perugino (c. 1445–1523), who had planned the decorations of the Sistine Chapel which Michelangelo brought to completion; Leonardo da Vinci; and the Venetian Sebastiano del Piombo (c. 1485–1547). Thus Raphael's own style

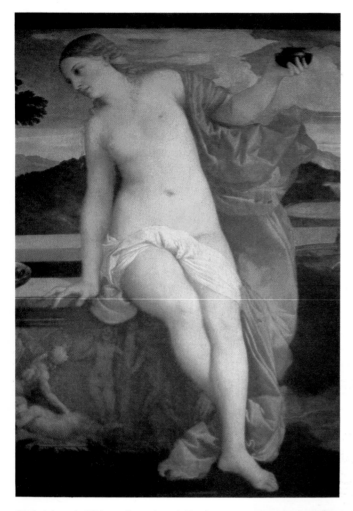

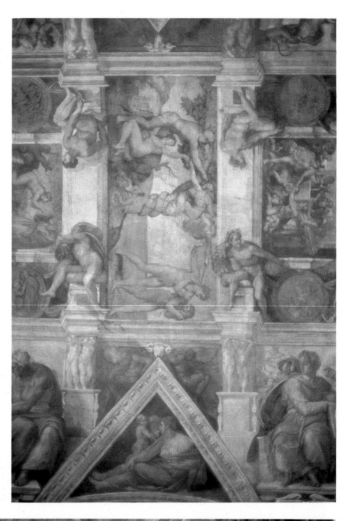

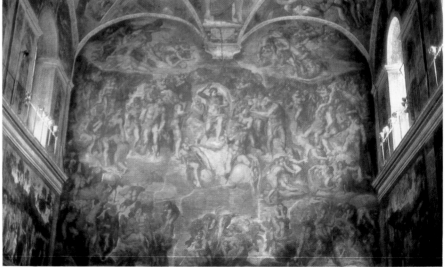

19.5 (above) Titian, *Sacred and Profane Love*, right-hand figure. The softness of this nude, its colour and the broken-colour technique mark this picture as one of the masterpieces of the Venetian school. c. 1516. Villa Borghese, Rome

19.6 (top right) Michelangelo, detail of Sistine Chapel ceiling (1508–12) depicting temptation of Eve and expulsion from the Garden of Eden. Fresco.

19.7 (right) Michelangelo, detail of end wall of Sistine Chapel, *The Last Judgement*, showing a nude Christ reigning over Heaven and Earth on the last day. This fresco, painted 30 years after the ceiling, has the agitated design of Mannerism.

was a unique fusion of the best in Florentine and Venetian art and he became a great master of serene, ideal painting and, as such, the best example of the *classicism* and restraint of the High Renaissance. All his life he painted pictures of the Madonna, and the succession of influences on his work can best be seen in these. His most famous work is probably the fresco decorations of three *Stanze* (stanza = room) in the Vatican (**19.8**).

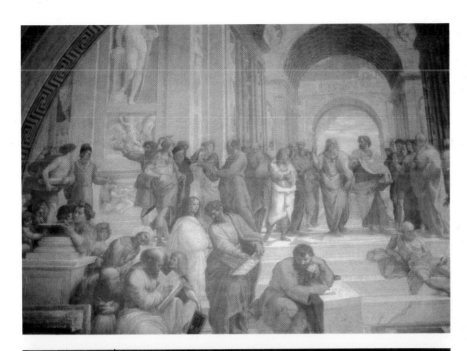

19.8 Raphael, detail of one of the frescoes in the Vatican *Stanze, the School of Athens* (1509–11), representing some of the ancient Greek philosophers whose works were again valued in the High Renaissance period

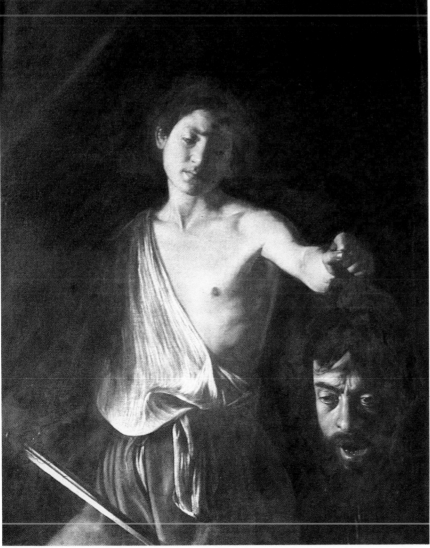

19.9 Caravaggio, *David* (c. 1605/6). Oil on canvas. The striking realism of this Baroque painter, with its strong reliance on chiaroscuro, influenced many later painters, including Velasquez, Rubens and Rembrandt. Villa Borghese, Rome

The Venetian school

This is the traditional name for the style of painting that developed in a number of north Italian towns during the Renaissance. It is not confined to the city of Venice but also includes the art of cities like Padua and Urbino. Although Venetian art has a similar background to that of Siena, the Venetians were as progressive as the Florentines, and Venetian artists aimed at naturalism also. Although their pictures were as well drawn as Florentine pictures, the Venetians placed more emphasis on rich and harmonious colour, as an integral part of the picture. They also used more expressive brushwork and more *painterly* texture (that is, the system of outlines filled in with colours, which the Florentines used, is replaced by an infinite number of short brush-strokes which allow the edges of forms to merge into the background — a more naturalistic style). Backgrounds, such as landscape, were more prominent in Venetian pictures, which were often painted 'for art's sake' (see **19.5**).

Early Venetians were Jacopo (c. 1411–64), Gentile (1426–1517) and Giovanni (1428–1516) Bellini; Antonella da Messina (1431–79); Vittore Carpaccio (1461–1522); and Andrea Mantegna (1431–1516). With Tiziano Vecellio (called Titian; 1477?–1576) and his short-lived contemporary Giorgione (1478–1511), however, we come to the full flower of Venetian painting. Giorgione's *Concert Champêtre* (Louvre, Paris) and *Sleeping Venus* (Art Gallery, Dresden) are truly great Venetian paintings. Many authorities believe Giorgione influenced Titian strongly and might have become the greatest Venetian painter had he lived longer. Titian was a master of asymmetrical compositions, lit from the front to allow full play of colour and a minimum of shadow. He used his main medium — oil — layer upon layer in impasto and glaze and this, together with a broken-colour technique (a foreshadowing of Impressionism: see section 23), gave his pictures great richness and luminosity expressive of Venetian worldliness and splendour. His best-known works are *Bacchus and Ariadne* (National Gallery, London) a *Venus* similar in conception to Giorgione's, and several portraits.

With Jacopo Robusti (more commonly called Tintoretto; 1518–94), we enter the *Mannerist* period. Tintoretto achieved his expressed aim of 'the drawing of Michelangelo and the colouring of Titian'. The dramatically mobile compositions of the Mannerist period are best illustrated by his *Last Supper* in S. Giorgio, Venice (its diagonal lines, deeply set focal-point and moving figures make a good comparison with Leonardo's static composition on the same subject), and *The Miracle of St Mark* (Academy, Venice).

Other Italian painters worthy of study are Antonio Allegri da Correggio (called Correggio; 1494–1534); Paolo Veronese (1528–88); Baroque painter Michelangelo Caravaggio (usually called Caravaggio to distinguish him from Michelangelo Buonarroti; 1573?–1610) (see **19.9**) and Francesco Guardi (1712–93), a Rococo painter (see **23.1**).

Things to do

1 Find reproductions of all the pictures mentioned in this section.
2 From library books and encyclopaedias, find out more about the most important painters mentioned in this section.
3 From library books or encyclopaedias, find details of the lives and work of the other artists whose names appear in this section.
4 Select one typical picture from each of the three schools. Describe them all, compare each with the others, and state your preference, giving reasons.
5 Find as many reproductions as you can of pictures by artists mentioned in this section.

20 Renaissance painting in the rest of Europe

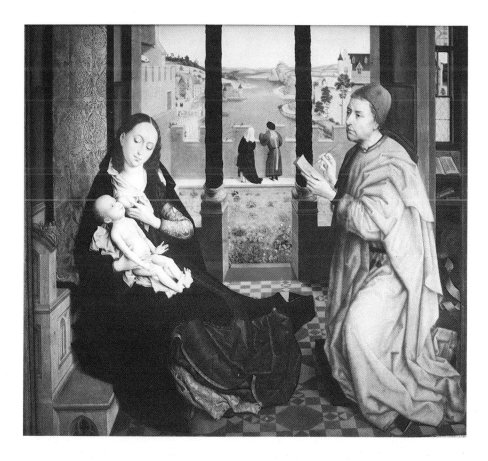

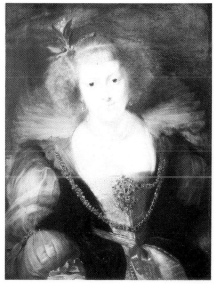

20.1 (left) Rogier van der Weyden, section of *St Luke Painting the Virgin*, in the Alte Pinakothek, Munich. (St Luke is the patron saint of artists.) While the figures and the clear, enamel-like colours relate to Gothic art, the human interest in the suckling Child and the perspective are quite Renaissance — and the expanse of landscape seen through the columns is Northern Renaissance.

20.2 (right) Sir Peter Paul Rubens' beautiful portrait of his second wife, *Helene Fourment* (1614–73) in her wedding dress, painted soon after their marriage in 1630. Oil on oak panel. 75 cm × 56 cm. Rijksmuseum, Amsterdam

We have seen that the naturalism of Gothic sculpture and painting influenced early Italian Renaissance painters such as Giotto. As the Renaissance gained momentum, princes, kings and bishops in northern Europe, who understood and believed in humanist principles, wished to build churches like Michelangelo's St Peter's, and to decorate their palaces with sculptures and paintings in the 'new' classical style. This renewed the movement of artists between Italy and the rest of Europe.

Leonardo da Vinci spent the last years of his life in the service of Francis I, who brought him to France (see **22.4**); and an associate (and rival) of Michelangelo, Pietro Torrigiano (1472–1528), who is famous in Italy chiefly because he broke the nose of the great sculptor in a student brawl, was imported to England by Henry VIII.

But the visits to Venice in 1494 and 1506 by the great German painter Albrecht Dürer show that it was a two-way movement. However, there was a time-lag, sometimes of one or two centuries, between the vogue of a style in Italy and its influence in other parts in Europe.

Naturalism is as old in northern Europe as in Italy (the van Eycks — see below — were contemporaries of Masaccio), but northern European

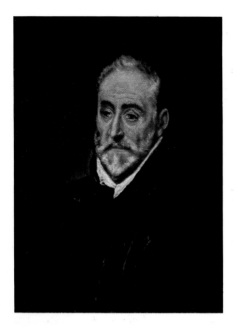

20.3 El Greco, *Portrait of A. Covarrubias.* Oil on canvas. Louvre, Paris

20.4 (right) Sir Peter Paul Rubens, *Hercules and Antaeus*, c 1625–30. Oil on panel. 65 × 50 cm. This subject from classical mythology is an excellent one for interpretation with Baroque energy. National Gallery of Victoria; Felton Bequest, 1946–47

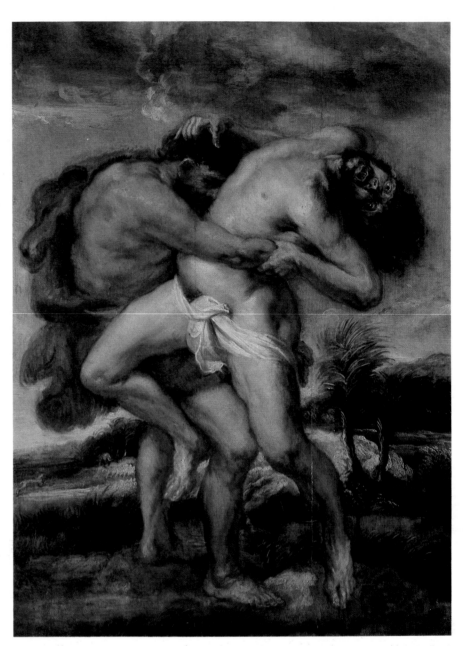

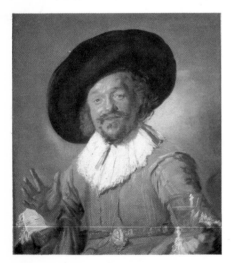

20.5 Frans Hals, *The Merry Toper* (1627). Oil on canvas. Rijksmuseum, Amsterdam. A typical example of the excellent characterisation of this Dutch artist, who is famous for his *Laughing Cavalier*, which resembles this picture.

painting has more literary content and is less idealised than Italian painting. Realism, rather than ideal beauty, is often the aim, and *genre* scenes (scenes taken from everyday life: **20.10**) are more popular than religious and classical figure compositions. This realism is achieved more by proliferation of detail than by the use of chiaroscuro, but there is a definite attempt to catch the effects of light, such as sunlight shining into a room. More local colour is used, giving pictures less over-all harmony and subtlety than Italian pictures. Northern pictures are often small panels or miniatures — there was no need for monumental painting when stained glass was so well developed. Because of the natural resources and climate of northern Europe water-colour and oil paint are the chief media: both linseed oil (the basis of oil paint) and canvas (for ground) are produced from flax, which is a common plant in northern Europe.

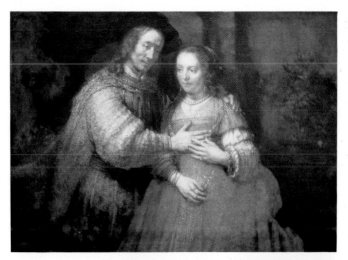

20.6 (top left) Rembrandt, *The Jewish Bride*. Oil on canvas. 122 cm × 141 cm. A representation of adult love by this master of portraiture. Rijksmuseum, Amsterdam

20.7 (above) Georges de la Tour, detail from *The Adoration of the Shepherds*, a large oil on canvas in The Louvre, Paris. French Baroque painters like de la Tour were influenced by Caravaggio (**19.9**). De la Tour executed strong light-and-shade effects brilliantly.

20.8 (far left) Albrecht Dürer, *Melencolia I*, 1514. Copper engraving (copy in The Art Gallery of South Australia). This picture probably represents Humanity, seated amidst the symbols of mathematics, technology, design and science, brooding on the futility of life. It thus illustrates German artists' expressionistic inward looking.

20.9 (left) Lucas Cranach, *Eve* (detail). Oil on canvas. Life-size. Uffizi, Florence. Compared with Titian's nude in **19.5**, this picture illustrates German art's 'linear' rather than 'painterly' style and interest in expressive realism rather than ideal beauty. Cranach, a devout Protestant, was a friend of Martin Luther and painted him many times.

The Flemish school

The brothers Hubert (1366?–1426) and Jan van Eyck (1385?–1441) may have been the first artists to use oil paint, although it is unlikely that they invented it, as some have thought. Their work is typically north European in its detail, colouring, realism and effect of light and, although landscape backgrounds are well developed, it still retains a good deal of Gothic stiffness in the figures. They collaborated on the *Ghent Altarpiece*, a typical example of the northern folding altarpiece or *triptych* (picture with three hinged panels, the central one larger than the others), and Jan also painted *Giovanni Arnolfini and His Wife* (National Gallery, London), in which the detail is so minute that four figures can be seen clearly in a mirror less than 4 cm across hanging on the back wall of the room. The *Ince Hall Madonna*, which is owned by the National Gallery of Victoria, is now thought to be an accurate copy of a lost original by Jan van Eyck, but it is still a worthy example of Flemish Renaissance art.

Jan became a confidant of Philip the Good, Duke of Burgundy, and was trusted with missions to Spain and Portugal by his master. He was the first Flemish artist to sign his work and he adopted a personal motto,

as though he were a noble, which he appended to his signature: 'Als Ich Chan', which means 'As Best I Can'. His pictures are full of symbolism, although they are completely naturalistic in style; for example, a burning candle indicates that God is watching the scene, and a dog indicates faith and faithfulness.

Other early Flemish artists include: Robert Campin (1378–1444); Rogier van der Weyden (c. 1400–64; **20.1**); Hans Memlinc (c. 1430–94); and Hieronymus Bosch (c. 1450–1516), who used an accomplished realism in puzzling, satirical visions of Hell, and other dream-like horrors.

Pieter Brueghel the Elder (1525–69) continued the Bosch tradition in some pictures but, in others like *The Wedding Dance* (Institute of Arts, Detroit), a cycle of pictures illustrating the changes in landscape and farming activities during the months of the year, and *Peasant Wedding*, Italian Mannerist influence is obvious (Brueghel visited Rome in 1553). His highly individual pictures are often humourous and, with Bosch, often foreshadow the surrealism of the twentieth century.

Sir Peter Paul Rubens (1577–1640) acted as ambassador for the Spanish governor of the Netherlands on several occasions. He visited England in 1629 and was knighted by Charles I. In 1635 he returned to paint the ceiling of the Banqueting Hall, Whitehall, which had been built by Inigo Jones, Britain's first Renaissance architect (**22.13**). Although Rubens was a fully-fledged *Baroque* painter (he travelled and worked in Italy 1600–08), his interest in detail and literary content was Flemish.

In Baroque painting, which originated in Italy, a painterly style derived from Venetian art is used. Compositions are exuberant and energetic (like Mannerist art) and flooded with light and colour. The rendering of nature has become so competent that very convincing illusions of space can be represented. This is largely achieved through strong chiaroscuro. An Italian Baroque artist is Caravaggio (see **19.9**).

Rubens became so popular that he had to employ a staff of assistants and apprentices who 'blew up' (enlarged to scale) his sketches onto canvases and roughed them in in paint to his design and instructions, leaving him only the master-touches to do. His chief assistant was the very skilful Sir Anthony van Dyck (Vandyke), who also worked in England and received a knighthood there. Rubens' best-known pictures are: the cycle of paintings idealising the life of Marie de' Medici, who married Henry IV of France and was the mother of Louis XIII, now in the Louvre, Paris (**20.4**); *The Judgement of Paris* (National Gallery, London); *The Kermesse* (Louvre, Paris); and *The Abduction of the Daughters of Leucippus* (Alte Pinakothek, Munich). There are paintings by Rubens and Van Dyck in the National Gallery of Victoria (see **20.4**).

The Dutch school

Holland achieved recognition as a state independent from the Spanish Netherlands after the Peace of Westphalia (1648) and a predominantly Protestant school of Baroque art developed there. Rembrandt Harmensz van Rijn (1606–69), a miller's son, was its greatest painter. Dutch patrons were traders who had little time for 'art for art's sake' and admired naturalistic portraits, *genre* scenes and landscapes above all else. At first Rembrandt filled this role with brilliance and distinction, his marvellous insight into character standing him in good stead (**20.6**). He became wealthy and famous. But later he became engrossed in more purely painterly values and produced wonderful compositions and portraits in oils, featuring dramatic lighting, such as a face or figure spotlighted in a dark

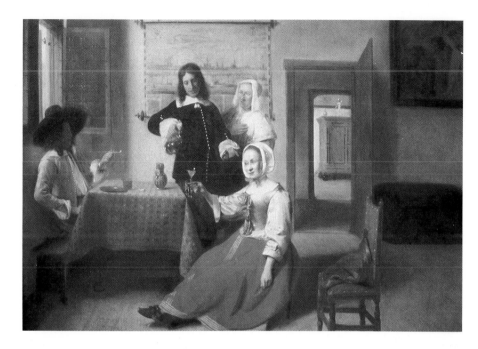

20.10 Pieter de Hooch, detail from *Young Woman Drinking*, 1658. Oil on canvas. Louvre, Paris. Dutch artists like de Hooch crammed a lot of accurate detail into small pictures showing people in scenes from everyday life.

composition. To him, beauty was secondary to the expression of character and humanity. He never flattered a sitter nor idealised a nude, and he had no time for Italian fashions. His last years were spent in unpopularity and poverty, going blind; yet many great pictures come from this period. His individualistic 'art for art's sake' attitude inspired nineteenth century painters.

Rembrandt's failing sight is sometimes said to have caused the darkness of his late pictures, but this would more likely have had the opposite effect. Apart from oil-paintings, Rembrandt made many fine etchings and drawings with quill and brush. His most important works are a series of self-portraits (which covers his lifetime), the group-portraits *The Syndics of the Clothmakers' Guild* (Rijksmuseum, Amsterdam), *The Anatomy Lesson* (Mauritshuis, The Hague), and *The Night Watch* or *Captain Banning Cocq's Company* (Rijksmuseum, Amsterdam).

Frans Hals (1580–1666), another great Dutch portrait painter, also had a period of success and prosperity and left a number of fine pictures, notably the well known *The Laughing Cavalier* (Wallace Collection, London) (see **20.5**). Contemporary with Rembrandt and Hals were a group of painters of *genre* scenes (the 'Little Dutchmen'): Jan Vermeer of Delft (1632–75), Pieter de Hooch (1629 to after 1684) (see **20.10**), and Jan Steen (1626–79); and the landscapists Jacob van Ruisdael (1628?–82) and Meindert Hobbema (1638–1709), who painted the famous *Avenue at Middelharnis* (National Gallery, London).

The German school

The subject matter of German art is typically inward-looking and it is painted, in a linear style, with an expressionistic immediacy — as well as having other characteristics common to all the northern schools. The character of German art was evident in one of its first Renaissance masterpieces, the *Isenheim Altarpiece* of Matthias Grünewald (1485–1530), in which a bleeding and distorted body of Christ hangs against a leaden sky, and also in the work of Lucas Cranach (1472–1553; **20.9**).

Albrecht Dürer (1471–1528), one of the first great German masters, was, like Leonardo da Vinci, a myriad-minded Renaissance man. The

20.11 Nicholas Poussin, *Diogenes Throwing Away his Bowl*, 1648. Oil on canvas. 160 cm × 220 cm. Poussin painted large, carefully-composed pictures of subjects taken from classical stories. However, the landscape setting of these pictures usually dominates and they are, thus, forerunners of the landscape art of the nineteenth century. Louvre, Paris

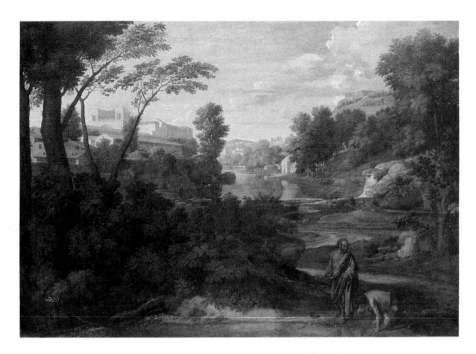

pictures he painted after visiting Italy, where he met Giovanni Bellini, show some Italian influences such as the use of chiaroscuro, which he grafted onto his former, more Germanic style. This can be seen in pictures such as *Self-Portrait as a Young Man* (Prado, Madrid).

From the late fifteenth century, printing was increasingly used in Germany, and Dürer worked on intricately wrought copper engravings and wood-cuts (**20.8**).

Hans Holbein the Younger (1497–1543) was a great portrait painter. His highly-finished style featured strong linearity, flat enamel-like colour and little light-and-shade, yet he represented space and form well. This is a tribute to his mastery of draughtsmanship, and many of his drawings are finished works in themselves. His objective brand of realism is almost devoid of typical Germanic expressionism.

For many years Holbein was court painter to Henry VIII of England, painting the king himself, Ann of Cleves, Catherine Howard, the Prince of Wales (later Edward VI) and many of the English nobility. His portraits of the *Duchess of Milan* (1538; National Gallery, London), *Erasmus of Rotterdam* (Louvre, Paris), and *George Gisze* (Berlin Museum) are among the greatest.

The Spanish school

In Spain, painting as a fine art did not exist until the Baroque style was introduced from Italy and Flanders in the sixteenth century.

The first great Spanish painter of the Renaissance was not native-born, but a Cretan — Domenico Theotokopoulos (1541?–1614), whose name the Spaniards found so difficult that they called him simply El Greco (the Greek). El Greco's early life is shadowy, but he would have known Byzantine art, and his figures have a Byzantine elongation, with his pictures often divided into zones, like icons. He must also have spent some time in Venice where he became familiar with Mannerist art. Pictures such as *The Burial of Count Orgaz* (Santo Tome, Toledo), *The Assumption of the Virgin* (Art Institute, Chicago), and *Pentecost* (Prado, Madrid) express intense religious emotion and, with their flame-like forms, a move-

ment towards heaven. *View of Toledo* (Metropolitan Museum, New York), a landscape, is flooded with an unearthly, threatening light which is fascinating (**20.3**).

Diego Velasquez (1599–1660), as a young prodigy in the court of Philip IV, received instruction from Rubens. He studied in Italy and adopted the Baroque manner, but his genius for realistic drawing and individualism kept him above most of his contemporaries. In his great portraits of Philip IV, his son Prince Balthasar Carlos, and his daughter the Infanta Margarita, particularly in the large group picture *The Maids of Honour* or *Las Meniñas* (Prado, Madrid), he allowed himself little personal expression or comment and concentrated on skilful, objective realism. His broken-colour technique influenced later painters.

The English school

Throughout the Gothic period Britain was renowned through Europe for its fine illumination, but this art failed to survive the iconoclasm of the Reformation. A fine school of portrait miniaturists flourished in the Elizabethan period (e.g. Nicholas Hillyarde, c. 1547–1619), but the demand for miniatures declined with the Restoration of 1660. Under the restored monarchs, whose tastes were European, artists were imported from the continent to execute works in the Renaissance style, which was new to England. Since that time, British patrons have had little confidence in British artists, except during the eighteenth century.

The French school

French artists generally handle paint with authority, and French pictures are graceful, well proportioned and are neither too literary nor too detailed. There is also an interest in space and light. These charactersitics can be seen in the work of the first French painter to be influenced by the Italian Renaissance style — Jean Fouquet (1415–81).

French painting in the sixteenth and seventeenth centuries passed through an Italianate Baroque phase represented by the Le Nain brothers, Antoine (1588–1648), Louis (1593–1648) and Mathieu (1607–77), and Georges de la Tour (1593–1652; **20.7**).

The two great French painters of the seventeenth century are Nicholas Poussin (1594–1665; **20.11**) and Claude Lorrain (or Gellée; 1600–82), both of whom spent more of their painting lives in Italy than in France. Although they were Baroque painters, their work shows a good deal of Raphael's influence and is therefore more calm and classical than most Baroque art. They are often called the *French Classical School*. Both chose to illustrate subjects from ancient mythology, though Claude's pictures come very close to romantic landscapes in which small figures act out the story. But French painting did not reach its greatest heights until the eighteenth and (especially) nineteenth centuries.

Things to do

1 Find reproductions of all the pictures mentioned in this section.
2 Find out from reference books more about the most important painters mentioned.
3 Find out more about the lives and work of the other painters mentioned in this section.

21 Renaissance architecture in Italy

One feature of the later Middle Ages was the growth of towns. The entire countryside of Europe was economically under the feudal system, and land-owning barons controlled not only agricultural production but also the lives of the tenants and serfs on their land. The other main force was the spiritual sway of the Church.

By the early Renaissance some of the towns, especially in northern Italy, had developed into city-states, and their merchant-class inhabitants gradually became independent of both the barons and the Church. The city-states vied with each other in making civic improvements, such as building a grander *palazzo pubblico* (town hall) and other public buildings, and a rational town plan. People were still generally devout Christians, but the decline in the Church's power over their lives and the increase in power of civic authorities was symbolised by the height of the tower of the palazzo pubblico gradually approaching that of the church. (This trend has continued — in modern cities everywhere, civic and commercial buildings are usually much taller than churches.)

Gothic v. Roman

The Treatise on Architecture by Vitruvius, an ancient Roman architectural theorist, had been preserved in manuscript form, and it was published in printed and illustrated editions from 1486 onwards. It was widely read and very influential. The time was ripe for architects in Italy to be influenced by Roman work, as painters and sculptors had been for some generations.

The dynamic but haphazard style we now call Gothic became unpopular (see page 105) and it was replaced by a rational system, outlined by Vitruvius, which was based on the *module* of the diameter of the column to be used — i.e. all measurements were multiples of this basic unit. This created a regular, stable system of proportion, rule and order, in which the 'revealed structure' of Gothic building gave way to a compact, usually regular, overall shape dominated by a dome or some other clear focal-point (cf. **17.9** and **21.7**). The Byzantine central type of church plan regained favour in the west, replacing the old nave-and-aisle basilican plan with a building planned about a vertical axis and capped with a dome (cf. **17.4, 17.1, 21.4**).

Renaissance architects studied the remains of the ancient forum in Rome and imitated buildings such as the Pantheon (which, of course, was still there but had become a Christian church). They replaced pointed Gothic arches with the round Roman arch and the Greek system of orders and trabeated (post-and-lintel) building. However, as the Roman art of making concrete was still lost, they followed the mediaeval system of building, using square-hewn stones (*ashlars*). Because this system meant a return to the massive Roman style, stained-glass decoration gave way to murals once more, as we have seen in the section on Italian Renaissance painting (section 19).

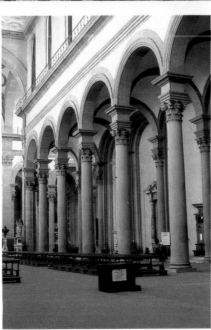

21.1 Santa Maria del Fiore (the Cathedral of Florence), seen over the roof-tops of the city. On the left, the campanile, designed by Giotto and, on the right, the dome, built by Brunelleschi from c. 1417 until his death. This dome fixed the form of the church in all Europe for four centuries.

21.2 (left) Filippo Brunelleschi, model of dome of Santa Maria del Fiore. Since the technology of Roman concrete construction had long been lost, Brunelleschi brilliantly adapted Gothic construction to achieve a 'Roman' effect. Museo del Duomo, Florence

21.3 Filippo Brunelleschi, Santo Spirito, Florence. Designed in 1434 but still not completed at Brunelleschi's death. A truly Renaissance concept — semi-circular arches, Composite capitals and a calm dignity, assisted by the quiet colour of the stone (cf. **17.20**, **17.26**).

The architect

Because a building's final appearance was decided before construction began, the role of the architect-designer became more important. Additions in a later style, common in the Middle Ages, became rare. Renaissance architects tended to conceive their buildings with emphasis on the external view, a more sculptural approach than the architectural approach of Gothic designers (who thought of buildings as enclosed spaces).

The first manifestation of the new style occurred in the Florence *duomo* (cathedral of Santa Maria del Fiore). The duomo is a Gothic building commenced in 1294 and, although Giotto was appointed chief architect in 1334, building continued largely in the Gothic style until

21.4 Filippo Brunelleschi, interior of the dome of Santo Spirito. It is built on pendentives (see **17.8**, **17.11**). The altar is under the dome — not in the apse, as it would have been in a Gothic church.

Filippo Brunelleschi (1377–1446), a friend of the painter Masaccio, and Ghiberti (see **26.1**) were appointed architects in 1417. Brunelleschi planned a magnificent dome, the first large dome to be built in Italy since ancient Rome (**21.2**). The shape and size of the dome (it spans 50 metres — only two less than the Pantheon), its dominant position, and the height height of the lantern on top, create a strong focal-point and make the duomo the first building to have this purely Renaissance character. Florence eventually acknowledged her gratitude to Brunelleschi by affording his body a resting-place in the duomo.

Other buildings designed by Brunelleschi, which are also early examples of Renaissance architecture, are the Foundling Hospital (1419–24); the Pazzi Chapel (c. 1430), which was the first completely Renaissance-style building; and Santo Spirito (**21.3**, **21.4**); all of which buildings are in Florence.

Donato Bramante (1444–1514) was a Florentine disciple of Brunelleschi, and probably a relative of Raphael. He worked in Milan while Leonardo was there but from 1499 was mainly in Rome, where he built the very classical Tempietto (in the courtyard of San Pietro in Montorio). The Tempietto is a small, completely circular building topped by a dome and surrounded by a Doric colonnade for which the columns (but not the capitals) were actually taken from a ruined Roman building.

In 1506 Bramante was commissioned to rebuild the crumbling, 1176-year-old St Peter's Basilican Church in Rome. His plan reverted to the central (or Greek-cross) type and called for a domed roof. The building was unfinished at the time of his death, and nine other architects, including Raphael, Michelangelo and Bernini, worked on St Peter's before it was completed more than 100 years later.

At the age of 70, Michelangelo, the dominant personality of High Renaissance art, took over the building of St Peter's. He improved Bramante's plan, making it more massive and grand, and redesigned the dome, raising it on a *drum* for added magnificence (**21.6**). However, Michelangelo died before it was completed and the dome was actually built by his successor, Giacomo della Porta (c. 1537–1602), somewhat differently from Michelangelo's design. Michelangelo also designed and sculptured tombs for the Medici family and Pope Julius II, and the Laurenziana Library, in Florence (1524–26). By this time, Michelangelo had achieved such mastery of Renaissance form that he transcended the accepted rules of the style and created a completely original variation, the first example of Mannerist architecture.

The Baroque

Two suggested derivations of the word *Baroque* indicate the character of the style of seventeenth century architecture: *barocco* is Portuguese for a rough, irregular pearl; and the Greek word *baros* means heavy. Baroque architecture is exuberant and grandiloquent, with great movement in space, massive forms and heavy decoration. Technical virtuosity is evident in the profusion of gilded sculpture and illusionistic painting, especially on the inside of domes. Buildings were conceived for their overall effect and there was little regard to the natural limitations of materials.

This was the period of the Counter-Reformation and the Church adopted the Baroque style as symbolic of its own spiritual splendour. Through the Church it spread to France, Spain, Central and South America, and England (see **21.5**, **22.16**). Gianlorenzo Bernini (1598–1680) was the greatest Baroque architect. He added a magnificent colonnaded *piazza* to Michelangelo's St Peter's (**21.8**, **21.10**).

Italian Palazzi

The word *palazzo* means town house, not palace as it is sometimes translated. The great business families in Florence and other Italian cities built massive homes and business premises combined. The style developed first in Florence, but there are also good examples in Rome and Urbino. Venice developed a somewhat different type.

The typical Florentine palazzo was rectangular in silhouette and built around a square *cortile* (courtyard), the centre of life in the building, which was thus cut off from the street and the rest of the city. The building was, in fact, used as a refuge in times of strife and, for this reason, the walls of the ground floor were thicker and finished in *rusticated* masonry (massive roughly-cut blocks). The building was usually three or four storeys high. The ground floor consisted of open arcades and was the business section, with shops, warehouses and workshops. One of the arched openings gave entry to the cortile. The next floor (the *piano nobile*, or best floor) was the residence of the family, and included the main public rooms. The upper floors were for the servants. The most typical example of the Florentine palazzo is the Palazzo Medici-Riccardi, which was built by Michelozzo Michelozzi (1396–1472) in 1444–64.

Venetian palazzi, like most buildings in the city, were built on piles. A cortile was not required because defence of the occupants was not an important factor in Venice. In style, they are often less rigorously Renaissance than their Florentine counterparts. A staircase leads directly to the piano nobile, and the *gran salone* (large room) on this floor has larger windows and receives special treatment.

21.5 The Baroque interior of the cathedral of Cordoba, Spain. Sixteenth century

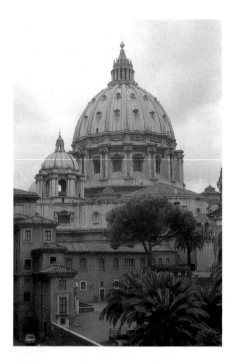

21.6 Perhaps the best view of the dome of St Peter's — from the Vatican. It shows clearly the effect of raising it on a drum.

21.7 St Peter's Cathedral, Rome. The basic Greek-cross plan of Bramante was completed by Michelangelo and della Porta, after which the nave was elongated (by Carlo Maderno, in 1607–15). However, the concept of a great domed church is credited to Michelangelo.

Things to do

1 Find pictures in library books of all the buildings mentioned in this section.
2 From library books or encyclopaedias, find out more about the architects mentioned in this section.
3 In books on architecture, find other examples of the architectural styles mentioned here.
4 In a reference book, find the meanings of the following terms:

balustrade	rustication	cornice
lantern	portico	voussoir
colonnade	attic	plinth

21.8 St Peter's Cathedral, Rome. The reverse view of **21.7** — looking back across Bernini's colonnaded piazza from the base of Michelangelo's dome.

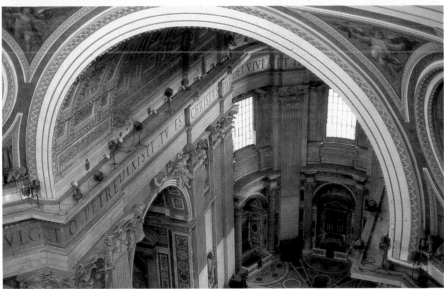

21.9 St Peter's Cathedral, Rome. The east end seen from the dome. Barrel-vaulting, coffering, mosaic and coloured marble all reminiscent of the opulence of ancient Roman buildings (cf **16.8** and **17.30**)

21.10 An idea of the sheer size of St Peter's is given by this photograph of the base of two of Bernini's columns.

22 Renaissance architecture in northern Europe

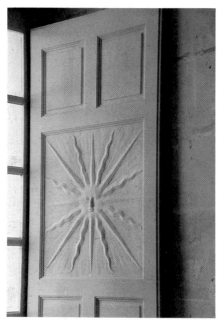

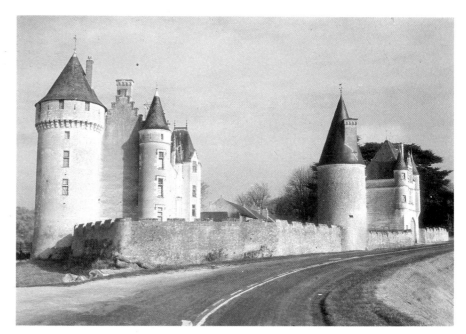

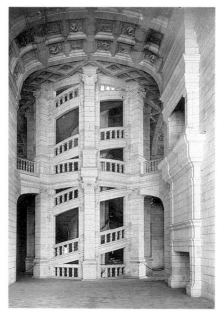

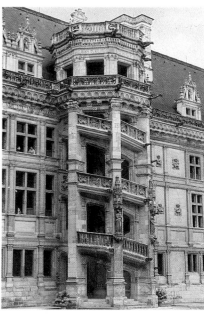

22.1 (above) A window shutter in Chambord which was added during the reign of Louis XIV. Each of these carries a portrait of the 'Sun King'.

22.2 (top right) The château of Montpoupon, Loir-et-Cher, France. Commenced in the thirteenth century, this beautiful small castle was rebuilt several times and completed in the sixteenth century. During this time Europe became more civilised and castles became less fortresses (cf. **17.15**) and more comfortable country homes for the wealthy

22.3 (left) Inner staircase of Chambord, showing how spartan were the interiors of even a king's home in the sixteenth century. The barrel-vaulted roof is a four-centred arch (see **17.24**)

22.4 (right) Outside ('Francis I') staircase of the château of Blois, Loire valley, France, built for Francis I in 1515–19. It may be that Leonardo da Vinci designed this staircase. Italian Renaissance influence is evident in the square-topped windows and the decoration.

The late phases of Gothic architecture (Flamboyant and Decorated) flourished in northern Europe well into the sixteenth century. The Henry VII Chapel in Westminster Abbey (**17.30**) was built in 1503–19, a full century *after* Brunelleschi was working in Florence (see **21.1–4**).

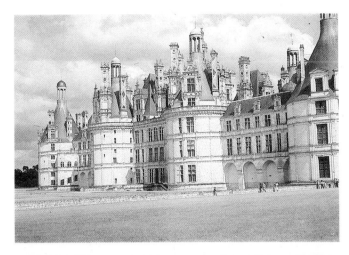

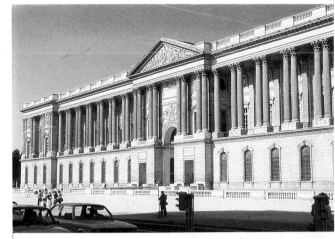

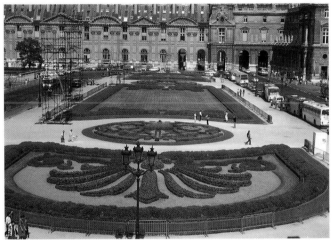

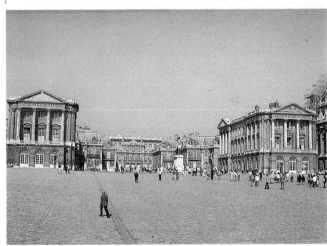

However, northern Europe then began to respond to the influences of the many Italian Renaissance artists who were being imported to work in the northern courts. The most famous of these were Leonardo da Vinci, who spent the last years of his life at the court of Francis I of France, and Bernini, who was invited to Paris by Louis XIV in 1665.

Thus Italian fashions were adopted in northern Europe, but often with little regard to the differences in climate or for local traditions, and this was one of the causes of the reaction by twentieth-century architects to what had, by then, become 'traditional' architecture.

The châteaux (castles) which were built by the French kings in this period, somewhat away from Paris and particularly in the Loire valley, were really grand country residences, not castles built for defence. The Louvre Palace and the châteaux of Blois, Chambord and Chenonceaux (**22.2–22.7**) were all built or added to in this period, and Italian Renaissance influences dominated. Since the French Revolution all the châteaux and palaces of the kings have become museums, the most famous of these being the Louvre. Pierre Lescot (1500/17–78), a Frenchman, commenced work on the Louvre in 1546, but its completion is credited to Claude Perrault (1613–88; **22.6**).

Baroque

Jules Hardouin-Mansart (1646-1708; see **26.12**) was the greatest French Baroque architect. He built, with Louis Levau (1612–70) the magnificent Palace of Versailles (**22.8**, **22.10**) for Louis XIV. This, the first

22.5 (top left) The château of Chambord, Loire valley, France: the largest of the French Renaissance castles, commenced by Francis I in 1519. Renaissance features include the semicircular arches and windows topped by lintels rather than pointed Gothic arches.

22.6 (top right) The Louvre palace, Paris — east front built by Claude Perrault in 1667–70. The rectangular overall shape (compare with the typical French Gothic shape of **17.20**), the columns with Composite capitals, and the pediment filled with sculpture like those in ancient Greece (see **15.2**), show Italian Renaissance influences.

22.7 (lower left) Part of the formal gardens of the Louvre palace, Paris

22.8 (lower right) The palace of Versailles. The central brick section topped by a mansard roof, was built for Louis XIII. When Louis XIV enlarged it by adding wings on each side the style of an Italian Renaissance palace or a Greek temple (see **15.2**) was used.

Baroque palace, became the model for a number of such palaces which were built for rulers all over Europe. Kensington Palace, London (**22.11**) is an example. Versailles, which could accommodate 10 000 people, is set in a huge and magnificent formal garden, designed by André Le Notre. The roof of the older part of the palace (centre of the picture in **22.8**) is a typically French roof — the *mansard roof* (named after the great-uncle of Mansart, who was also a great architect).

Rococo

During the eighteenth century wealthy merchant-class people, who felt increasingly independent of both Church and kings — a movement which eventually resulted in the French Revolution of 1789 and, in England, of the development of constitutional monarchy — rejected the Baroque in favour of a less tense, more light and decorative style of architecture, the Rococo (**22.17**). The finest example of European Rococo is the Church of Vierzehn Heiligen (fourteen saints) in Franconia, by Johann Balthasar Neumann (1687–1753).

England

In England, the Tudor and Jacobean periods saw the transition from Mediaeval to Renaissance architecture. Few churches were built but there was considerable development in domestic architecture (due to the increasing wealth of the middle classes). The half-timbered house featured revealed beams, posts and diagonals of wood with plaster or brick in-fill, giving its characteristic black-and-white appearance (see **17.31**). Decoratively curved gables, of Flemish origin, and grouped chimneys arranged for decorative effect are typical of this period.

A fully developed Renaissance style of architecture was introduced by Inigo Jones (1573–1652), who built the Banqueting Hall, Whitehall, London (**22.13**). Jones had studied in Italy, where he fell under the influence of the Renaissance architect Palladio, who published his *Treatise on Architecture* in 1570. Palladian architecture emphasises grace and clean lines, and this style proved popular in England for many years.

Sir Christopher Wren (1632–1723) was commissioned to rebuild much of London after the enormous destruction of the Great Fire of 1666. He built 53 churches, including St Paul's cathedral, which is closely modelled on St Peter's, in Rome, and is the greatest example of the Baroque in England. Wren met Bernini (see **21.8**) in Paris when Bernini was working on the Louvre.

Neoclassicism

Throughout most of northern Europe in the eighteenth century (the 'Age of Reason') the new and independent middle classes sponsored a movement of reaction to the excesses of Baroque and Rococo which were, after all, styles of the monarchs. In architecture this resulted in an increase in the popularity of the restrained Neoclassicism of the Palladian style in England and the work of the post-Revolution architects, Étienne-Louis Boullée (1728–99) and Claude-Nicholas Ledoux (1736–1806) in France. Boullée and Ledoux were, however, much ahead of their time as their schemes foreshadowed the simple, uncluttered lines and cubical structure of twentieth-century architecture (see **25.2**).

English Palladian (or *Georgian*) architects, like Colen Campbell (d. 1729), built palaces and villas for wealthy middle-class men and nobles in the style that Inigo Jones had used — a central portico with a

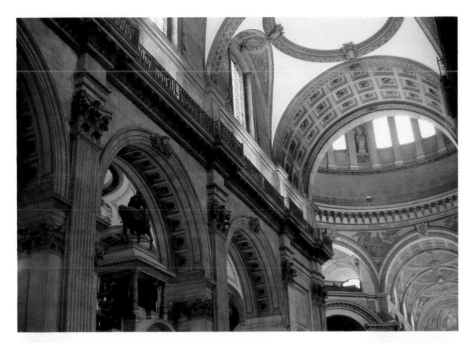

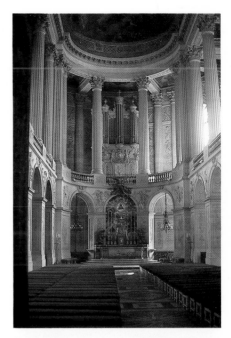

pediment supported by a colonnade and a dome with long wings on either side. Both these types of building were symmetrical about the portico or dome. Campbell's Mereworth, Kent, is a good example of the villa, and his Houghton Hall of the palace. Informal gardens, like those of Lancelot ('Capability') Brown (1715–83), were often associated with these residences — another reaction to the Baroque, which featured formal gardens (**22.7**).

Another aspect of English Neoclassicism was the development of a fine, unpretentious style of smaller and town domestic architecture. This style was exported to the new colonies in America and Australia, and examples can be seen today in Williamsburg (Virginia, United States), Sydney, Hobart and old Australian country towns (see **25.4, 27.1-3**).

Furniture designers, Thomas Chippendale (1718–79), Thomas Sheraton (c. 1751–1806) and George Hepplewhite (d. 1786) also belong to the Georgian period.

Revivalism

The search for styles which would express the individualism of the Romantic period led to a revival of styles of the past (*Revivalism* or *Historicism*) and to the importation of Asiatic styles in the nineteenth cen-

22.9 (top left) Interior of St Paul's, London, showing a treatment which is similar to an Italian Renaissance building (see **21.9**) and the clearstory windows in the drum of the dome

22.10 (top right) Royal Chapel, Versailles Palace. Built by Jules Hardouin-Mansart in 1699–1710. In this airy building, with its light-coloured stone and delicate, gilded carving, we see Baroque becoming Rococo.

22.11 (lower left) The Orangery, Kensington palace, London. Rectangular lines, lintels or round arches over the windows. An orangery is a glass-house built for growing oranges in a cool climate. Most of the royal palaces had one. Sir Christopher Wren, 1704

22.12 (lower right) Details of the wall of St Paul's, showing decoration reminiscent of Roman art — Composite order columns and pilasters with round arches. Compare with the Gothic churches in section 17.

22.13 The Banqueting Hall, Whitehall, London. 1619–22. One of the earliest Renaissance buildings in England. Note the columns with Ionic capitals (ground floor) and Composite capitals (top floor), also the windows topped by lintels and pediments (triangular and curved), and the rectangular shape of the building (compare **17.20**). Inigo Jones was the architect and Rubens decorated the ceiling in 1635.

22.14 (top right) St Martin's-in-the-Fields, London. James Gibbs, 1722. A church in Renaissance style, but with a spire like a Gothic building (see **17.23**) — a purely English idea, started by Wren.

22.15 (right) A section of the fine wooden decoration of the interior of St Paul's. Grinling Gibbons (1648–1720), the carver, has used motifs derived from ancient Rome (see **16.2, 16.3, 16.11**).

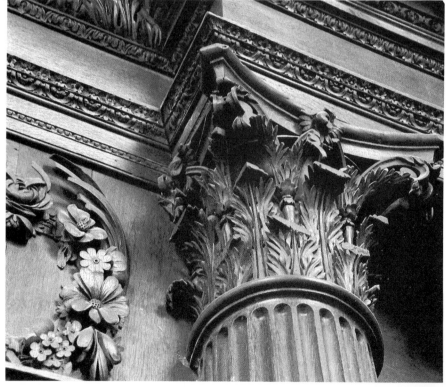

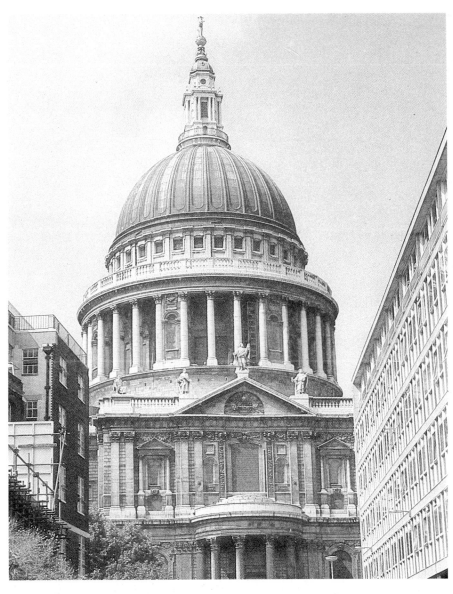

22.16 St Paul's cathedral, London. Sir Christopher Wren, 1668–1710. The south transept, with the dome, which is placed on a colonnaded drum, and the lantern on top (compare **21.6–10**)

22.17 The music room of Norfolk House, London; now rebuilt in the Victoria and Albert Museum. Palladian architect, Matthew Brettingham, built the room in 1756. The thin, delicate plaster decoration, painted gold on white, and the use of mirrors, are typical of Rococo.

22.18 The Arc de Triomphe, Paris (1806–36), commissioned by Napoleon to commemorate his victories, is an example of Revivalism (compare **16.9**)

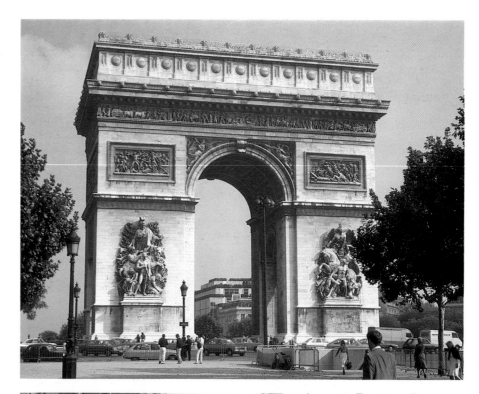

22.19 The Houses of Parliament, London, begun in 1839, are in the Gothic Revival style. It is hard to believe that Westminster Abbey, the building to the left in this picture, was built nearly 400 years before the Houses of Parliament (the right-hand half of the picture). Of course, the architects, Charles Barry and A.W. Pugin, tried to match the old style as much as possible.

tury. The large number of Gothic style churches in Australia is a result of this movement and so, too, are the British Houses of Parliament, Westminster, which were built in 1839–52 (**22.19**). However, these styles were often applied only superficially as decoration, and a satisfactory solution to the problem of expressing individualism was not found until the great reassessment of the purpose of architecture occurred at the turn of the twentieth century.

22.20 St Pancras Station, London 1868–74), is another Gothic Revival building (compare **17.21**). However, by the mid-nineteenth century it was cheaper and more efficient to use iron to span the large area needed for a major railway station, hence the network of metal in the upper part of this picture (see also **25.3**)

Things to do

1 Find local examples of the building styles mentioned in this chapter and make sketches of them.

2 Use encyclopaedias and library books to find out more about the architects mentioned here.

3 Look up the most important styles in a book on architecture and find out more about them.

23 Painting in the eighteenth and nineteenth centuries

Rococo was the established style throughout most of Europe at the start of the eighteenth century. It developed from the Baroque, but was also a lighter reaction to it: a style of delicate movement and colour. Rococo was more a form of architectural decoration than a school of painting as such (see **22.17**).

The most typical Rococo painters were those associated with the French court of Louis XV and XVI, and the frivolity and extravagance of court life is reflected in the asymmetrical curves and counter-curves, and the lightweight themes of their work. Antoine Watteau (1684–1721) often painted his actor friends; François Boucher (1703–70; **23.2**) and Jean-Honoré Fragonard (1732–1806) painted more intimate themes. The Italians Giovanni Battista Tiepolo (1696–1770) and his brother-in-law Francesco Guardi (1712–93; **23.1**) were also Rococo painters.

William Hogarth (1697–1764; **23.3**), the first great English painter, was influenced by French Rococo, but his leaning towards narrative and descriptive subjects, and his strong tendency to moralise, distinguish him as truly English. He has, in fact, been called 'the John Bull of painting'. He painted fine, discerning portraits, like *The Shrimp Girl* (National Gallery, London), and several cycles of didactic pictures (*The Harlot's Progress*, *The Rake's Progress*, *Marriage à la Mode* and *The Election*), most of which he later engraved and printed for sale to a wider public, thus contributing to his income.

Neoclassicism

Rococo was the style of absolute monarchy. Throughout the eighteenth century (the 'Enlightenment' or 'Age of Reason'), the middle class (called *bourgeoisie* in France) worked to modify this system of government — in England through the development of parliamentary government, and in France through revolution (the first in 1789). Both these processes extended into the nineteenth century.

Rococo was not acceptable to middle-class people, and a new style was sought to express their morality which was based on thrift, trade, and the family. The city of Rome was again prominent, now as a centre for tourism. Most young gentlemen and nobles made a 'Grand Tour' which included an extended stay in that city, where they identified themselves with both the republican ideals of ancient Rome and the more restrained and noble classical art of the High Renaissance. The style of art they favoured was one of 'noble simplicity and calm grandeur' (a famous quotation from Johann Winckelmann, an early authority on Greek art); we now call this style *Neoclassicism*.

The change of style was most marked in France. After the 1789 Revolution, the Academy, which had laid down rules of style for the monarchy, was abolished. Jacques Louis David (1748–1825) established the Institute, which formulated new rules to suit republican tastes. David's own pictures exemplify the new style. They are noble and simple in subject matter and austere in execution (**23.8**). The painterly style of the Rococo painters (known as Rubénism, after the loose, open style of brush-stroke used by Rubens and by them) gave way to an emphasis on drawing, clean lines, and restrained colour (called Poussinism, after the style of Poussin; compare **20.2**, **20.4** and **20.11**).

David, although an artist, took an active part in the Revolution and the republican governments which followed it, and was awarded the Legion of Honour. He was a life-long supporter of Napoleon and painted a number of pictures of him. After the defeat of Napoleon, David was forced to flee to Brussels, where he remained for the rest of his life.

Perhaps the greatest French Neoclassical painter was Jean Auguste Dominique Ingres (1780–1867), whose portraits and figure compositions, many of which include finely executed nudes, are based on curved composition lines and fine economical drawing (**23.7**).

In England there was a more gradual acceptance of the new style. The Royal Academy was founded in 1768 with Sir Joshua Reynolds (1723–92; **23.4**) as its first President (PRA). It fostered the development of a school of classical portraiture and *history painting* (noble passions and intellect illustrated through pictures of ancient myths and Christian stories), which was then regarded as the highest form of art.

Great English portrait painters, most of them associated with the Academy, included Thomas Gainsborough (1727–88), who was Reynolds' greatest rival, George Romney (1734–1802) and Sir Thomas Lawrence (1769–1830).

Romanticism

Throughout the eighteenth century, underlying the rationalism of Neoclassicism, was an interest in the irrational, the mysterious and exotic, the sublime and picturesque, and in the expression of emotion. This was at first evident in literature but eventually was expressed in *Romantic* art, the other side of Neoclassicism, and sometimes mixed with it. Romantic art expresses emotion, particularly tragic emotion (see **1.2**, **23.11**, **23.12**), and Romantic painters usually favoured painterly ('Rubénist') styles.

The first French Romantic painter was Théodore Géricault (1791–1824), who painted the *Raft of 'The Medusa'* (1819) which is now in the Louvre, Paris, and which illustrates the tragedy of a famous shipwreck. Géricault influenced Eugène Delacroix (1789–1863), perhaps the greatest French Romantic. The titles of Delacroix's pictures indicate his interest in narrative and tragic emotion — *Liberty Leading the People* (Louvre, Paris), *The Crusaders Entering Constantinople* (Louvre, Paris), and *Dante and Virgil in Hell* (Louvre, Paris). He was strongly influenced by the Venetians and also by Rubens (see **23.12**).

In England, narrative painting was practised by the *Pre-Raphaelite Brotherhood* who looked back to the Italians before Raphael and painted the Arthurian legends and biblical subjects.

But the most important English Romantic was William Blake (1757–1827), a largely self-taught painter and engraver of his own mystical visions, and literary and biblical illustrations. He violently opposed anything un-English (he included Reynolds and the Royal Academy in this,

23.1 (top left) Francesco Guardi, *Gates of Venice* (*View of the Venetian Lagoon with the Tower of Malghera*), c 1770–80. Oil on panel. 25 × 35 cm. One of the many views (*vedute*) of Venice this artist painted for sale to visitors to his city in the light, Rococo style. National Gallery of Victoria; Felton Bequest, 1927

23.2 (top right) François Boucher, *Diana Resting after her Bath*, 1742. Oil on canvas. 56 cm × 73 cm. The French court favoured this kind of art (Rococo), which treated life as if it were a pretty and amusing fairy-tale. Louvre, Paris

23.3 (left) William Hogarth, *Dr Benjamin Hoadly, MD*, 1740? Oil on canvas. The Art Gallery of New South Wales

23.4 (right) Sir Joshua Reynolds, *Dr Armstrong*. Oil on canvas. The Art Gallery of South Australia. An excellent character study by the first President of the Royal Academy.

23.5 Paul Sandby, *A Scene in Windsor Forest*, 1801. Gouache and watercolour. 81 cm × 107 cm. A typical sublime scene by 'the father of English watercolour'. City of Hamilton Art Gallery

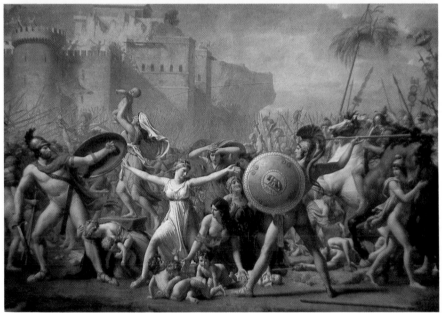

23.6 (top left) John Constable, *Study of a Boat Passing a Lock*, 1825. Oil on canvas. A typical Constable, full of light and life. His work influenced the young French Impressionists. National Gallery of Victoria, Felton Bequest

23.7 (above) Jean Auguste Dominique Ingres, *Mme Rivière*, 1805. Oil on canvas. 11.7 cm × 8.2 cm. Louvre, Paris. The clear, linear quality of French Neoclassicism to which Ingres adds his wonderful drawing skill and characterisation.

23.8 (left) Jacques Louis David, *The Sabine Women Stopping the Battle between the Romans and the Sabines*, 1799. 38.5 cm × 52.2 cm. Louvre, Paris. The clean lines and noble idealism of this picture, compared with **23.2**, indicate the change in style which occurred in French painting after the Revolution. The subject, too, is typical — in pre-republican Rome, the Romans stole wives from the Sabines and these women later stopped a tribal war to prevent their husbands and brothers killing each other. The message for the new French republic was clear.

because of their respect for European art), and worked regular and symmetrical compositions in a highly individualistic water-colour style. 'Exuberance is beauty,' he said. His illustrations to the Book of Job and of Genesis, Dante's *Divine Comedy* (see **23.11**), Milton's *Paradise Lost*, and his own *Europe* are quite unlike any earlier work.

Francisco Goya y Lucientes (1746–1828), known simply as Goya, a Spanish painter of great portraits, was a Romantic artist. His *Family of Charles IV* (Prado, Madrid), *The Executions of May 3rd, 1808* (Prado, Madrid), the two studies called *Maja* (Prado, Madrid), and his etchings and mezzotints for *Tauromachia*, *Los Caprichos* and *The Disasters of War* are realistic, dramatic and expressive (see **1.2, 23.9**).

23.9 Goya, *The Marquesa de la Solana*. Oil on canvas. About life-size. Louvre, Paris

23.10 (right) Central section of the huge *Real Allegory of a Period of Seven Years of My Artistic and Moral Life*, 1855, by Gustave Courbet (oil on canvas. Louvre, Paris), showing the Realist artist painting a landscape in his studio watched by a model (an unideal, ordinary woman) and some of the people he had painted. In symbols we do not understand, Courbet in this picture, was protesting at the censorship of the arts which operated under Napoleon III.

The Sublime

Up until the time of the Renaissance, and even after, people felt threatened by nature because life was a constant struggle for survival. Because of their fearsome power, the elements were made into gods and the sea, the sky, the forests and the night were peopled by ghosts, demons and evil spirits. But, as agriculture, science and industry controlled some of the threat of nature people began to see beauty and wonder in its wild, grand and terrifying aspects — mountains, the sea, the dawn and the sunset; and they became the subjects of the kind of art known in the eighteenth century as the *Sublime* or the *Picturesque*. The concept is similar to what we have called *expression* in section 1, and is an aspect of Romanticism. It is also the beginning of what has become an important social movement in this century — the interest in conserving the environment and, particularly, the wilderness areas of the world.

The development of landscape as an independent art is also part of this movement. The purely English art of water-colour was developed to a high degree by Paul Sandby (1726–70; **23.5**), Thomas Girtin (1775–1802), John Sell Cotman (1782–1842), David Cox (1788–1859), John Crome (1786–1821) and Richard Parkes Bonington (1802–28). The success of the greatest English landscapists, Joseph Mallord William Turner (1775–1851; **1.18**) and John Constable (1776–1837; **23.6**) spread the influence of English painting back to Europe for the first time for centuries.

Realism and Impressionism

The *Realism* of Jean-Baptiste Chardin (1699–1779; see **1.17**) and Gustave Courbet (1819–77) is part of Romanticism. Its concentration on nature and rejection of fantasy and imagination are reactions to both nineteenth century materialism and Rococo art. Courbet thought art should be about real things and real life. When asked why he did not paint religious pictures, he replied, 'Show me an angel and I will paint it', and this exemplifies his approach. Like David a couple of generations before, Courbet involved himself in the political revolutions of the latter half of the nineteenth century. Thus he was in the *avant-garde* in both senses — and

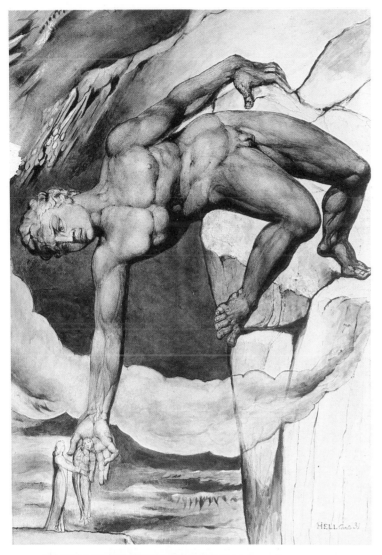

23.11 William Blake, *Antaeus Setting Down Dante and Virgil in the Lowest Pit of Hell*, 1824–7. 53 × 37 cm. Towards the end of his life Blake was commissioned to illustrate a publication of Dante's long poem, *The Divine Comedy*, which relates Dante's dream of visiting Hell, Purgatory and Heaven in the company of the Roman writer, Virgil. During this visit they encounter many famous historical and legendary figures, including the giant Antaeus (the same as in **20.4**). A subject of mystery and grandeur well suited to Romantic interpretation. This is one of the series of watercolour drawings from which engravings were made. A large number of drawings from this series, including this watercolour, are in the National Gallery of Victoria (Felton Bequest, 1920).

23.12 Eugène Delacroix, *The Death of Sardanapalus*, 1827 Oil on canvas. Louvre, Paris. This huge canvas (392 cm × 496 cm) represents the king of Babylon, facing defeat, reclining on his funeral pyre while all his slaves, concubines and horses are massacred, and Delacroix's dramatic composition and colour give the subject great force.

23.13 Jean Baptiste Camille Corot, *The Woodgatherer*. Oil on canvas, 33 × 42 cm. A typical example of the Barbizon school, which preceded Impressionism. Bendigo Art Gallery

suffered for it on both counts: he had a lifelong battle for recognition as an artist, and spent the last years of his life a political exile in Switzerland.

The *Barbizon* group of painters and Jean Baptiste Camille Corot (1796–1875) often painted their pictures and landscapes completely out of doors (*en plein air*) rather than in the studio, something which had never been done before. This technique enabled them to catch the character and light of the scene more effectively (**23.13**). The *plein air* method of the Barbizon painters, together with the wonderfully fresh landscapes of Constable and Turner, influenced the *Impressionists*, who believed that the essential thing in capturing a natural effect in a picture was to paint the *light* that fell on the subject, rather than the subject itself (**23.19**). This seemed logical because, as nineteenth century people had come to recognise, our seeing depends upon there being light — and light is actually made up of the colours of the rainbow. Hence, the Impressionists used the Rubénists' *broken colour*, applied only in small touches of pure primary and secondary colours (spectrum colours) placed side by side, and relying on the action within the viewer's eye to 'mix' these into the duller, greyer colours of which the world is largely made up (**23.16, 23.17**).

The chief Impressionists were Edouard Manet (1832–83), a disciple of Courbet; Claude Monet (1840–1926); Englishman Alfred Sisley (1839–99); Edgar Degas (1834–1917); Pierre Auguste Renoir (1841–1919); and Camille Pissarro (1831–1903). Impressionism achieved the ultimate in naturalistic painting and set the stage for the reactions of the twentieth century (see section 24).

Things to do

1 Find reproductions of all the pictures mentioned in this section.

2 From reference books, find out more about the most important painters mentioned.

3 Find out more about the lives and work of the other painters whose names appear in this section.

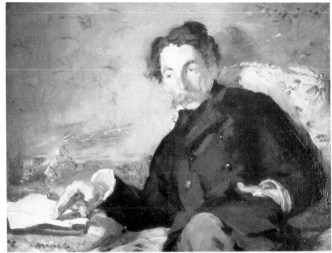

23.14 (top left) Edouard Manet, *Olympia*, 1863. Oil on canvas. 13.05 cm × 19 cm. Jeu de Paume Gallery, Paris. This picture of a well-known courtesan, naked rather than nude, shocked Paris by its realism (compare **23.2**).

23.15 (top right) Edouard Manet's portrait of writer Stephan Mallarmé, painted thirteen years after *Olympia*, shows the influence of the younger Impressionists on Manet. Jeu de Paume Gallery, Paris

23.16 (centre left) Claude Monet, *La Corniche de Monaco*, 1884. Oil on canvas. 74 cm × 92.5 cm. Stedelijkmuseum, Amsterdam. Mature Impressionism.

23.17 (centre right) Detail of **23.16**, showing Impressionist 'broken colour' technique and how the effect of green foliage is achieved through dashes of yellow, blue and red.

23.18 (left) Camille Pissarro, *Peasants' Houses, Eragny*, 1887. Oil on canvas. © Art Gallery of New South Wales. One of the works of late Impressionism, showing the influence of the Pointillism of Seurat (see **24.9**, **24.16**).

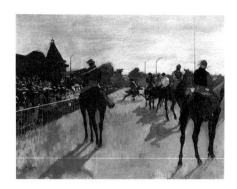

23.19 Edgar Degas. *Racehorses before the Judges*, c. 1869–72. Oil on canvas. 4.6 cm × 6.1 cm. This small picture of one of the new subjects introduced by the Impressionists (see page 148) shows the influence of the photograph in the 'snapshot' effect of cutting off the horse on the right. Jeu de Paume Gallery, Paris

4 Paint a picture of a romantic or picturesque subject.

5 Paint a picture in the Impressionist style.

6 Fill in the life-spans of the artists listed on this blank time-chart:

1200 1300 1400 1500 1600 1700 1800 1900 2000

Duccio
Martini
Giotto
Leonardo
Michelangelo
Raphael
Giovanni Bellini
Giorgione
Titian
Tintoretto
Correggio
Veronese
Caravaggio
Tiepolo
Jan van Eyck
Bosch
Breughel
Rubens
Rembrandt
Grünewald
Dürer
Holbein
El Greco
Velasquez
Goya
Hogarth
Reynolds
Gainsborough
Blake
Turner
Constable
de la Tour
Poussin
Lorrain
Watteau
Ingres
Delacroix
Corot
Manet
Monet
Sisley
Degas
Renoir
Pissarro
Cézanne
Gauguin
Van Gogh
Seurat
Matisse
Picasso

24 Twentieth century painting

The end of the nineteenth century saw the culmination of painters' ability to represent natural subject matter in a convincing way. As we have seen, the process began with Giotto in the thirteenth century and contributions were made by such great painters as Leonardo, the Venetians, Goya, Rubens, Turner and, finally, the Impressionists.

Even before this achievement itself was accepted by the general public, younger artists of the avant-garde were seeking new challenges. At the risk of over-simplifying the subject, we could say that these artists fell roughly into two groups:

Abstract artists

Abstract artists aimed at creating *ideal harmony* or beauty; consequently they had no doubt that they ought to change natural appearances if this would make their works more harmonious or beautiful. As the painter Maurice Denis wrote, 'A picture — before being a war-horse, a nude woman or any subject whatever — is essentially a plane surface covered with colours assembled in a certain order.' (See **24.28, 24.31**.)

Non-representational artists belong to this group also because they, too, aimed to create works of ideal harmony or beauty. However, they did not consider it necessary to start from natural subject-matter at all: they completely invented all the elements of their pictures (lines, shapes, colours, textures) and manipulated them until they achieved an arrangement of harmony. They never had any intention of creating pictures that 'looked like' anything (see **24.32, 24.56**).

Expressionist and Symbolist artists

Expressionist and Symbolist artists also believed that they should change natural appearances in their pictures; however, this was not for the above reasons but to give more effective *expression to their feelings* about the subject-matter, or else to *represent their ideas and imagination*. If they wished to express unusual or unpleasant ideas they produced unusual or, even, unpleasant pictures (see **24.42, 24.52**).

We should note in passing that distortion of natural shapes for abstract or expressionist reasons was by no means unheard of in the history of art — even western art (see sections 6, 7, 15, 17). But the public had become so used to art being realistic since the Renaissance, and naturalistic in the nineteenth century, that they found twentieth century art shocking.

During the latter part of the nineteenth century, Paris replaced Rome as the main centre of European painting and artists flocked there from many countries. Consequently, from that time on, national schools became less important than what has become known as 'the School of

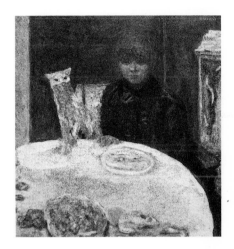

24.1 The realist-impressionist tradition has never completely died away. Pierre Bonnard painted this *Woman with Cat* in 1912, but he continued to paint in this way until his death in 1947. Bonnard is called an Intimist because his works seem to reveal peoples' intimate lives. Palais de Tokyo, Paris

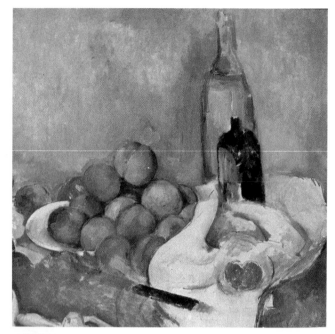

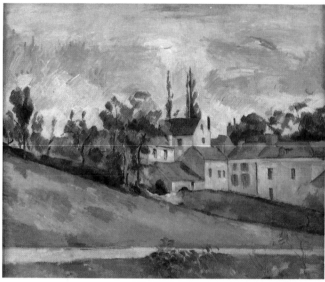

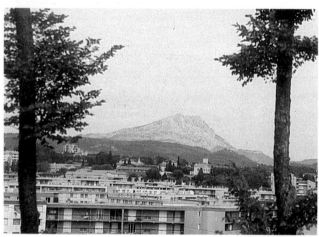

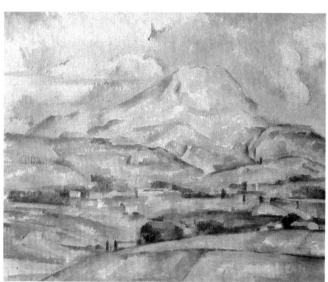

24.2 (top left) Paul Cézanne, *Bottles and Apples*, 1890–94. Oil on canvas. Cézanne often left pictures unfinished if he was not completely satisfied with the composition — and this is one of them. However, it lets us see how he moved objects around in the picture until he achieved a composition of abstract balance. Cézanne's use of cool colour to turn the edge of a form is seen in the large bottle and the top peach. Stedelijkmuseum, Amsterdam

24.3 (top right) Paul Cézanne, *La Route Montante*. Oil on canvas. This landscape illustrates Cézanne's ability to create a satisfactory composition while representing space and the solidity of objects. Cézanne preferred painting things to people because things did not move while he carried out his careful study of them. Even so, flowers and fruit often withered before he had finished with them, so he sometimes used paper flowers and wax fruit. National Gallery of Victoria, Felton Bequest

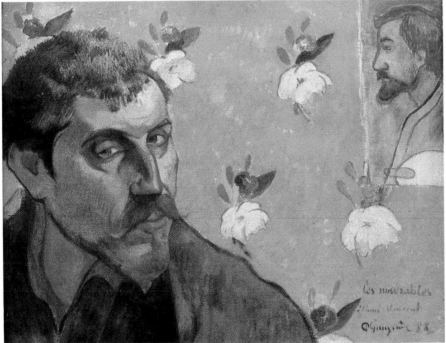

24.7 (top) Paul Gauguin, *Seascape*, 1886. Oil on canvas. Early picture by Gauguin showing both impressionist broken-colour and his emerging interest in colour for its own sake (rocks on the right-hand side). Art Museum, Gothenburg

24.8 Paul Gauguin, *Self-Portrait*, 1888. Oil on canvas. Gauguin, unhappy in Brittany, sent this self-portrait to van Gogh, in Arles. On it he wrote 'les miserables — à l'ami Vincent' The next year he went to live with van Gogh, but this did not work out. The sketch on the wall is of Émile Bernard, a fellow-artist. All three were friends of Australian John Peter Russell at the time (see **1.16**). Van Gogh Museum, Amsterdam

(page 146)

24.4 (centre right) Paul Cézanne, *Mont Sainte Victoire*, 1887. Oil on canvas. Although this is a convincing representation of the mountain (see **24.5**), Cézanne has been more interested in balancing it, the foothills and trees and buildings in a harmonious abstract design. Stedelijkmuseum, Amsterdam

24.5 (centre left) Photograph of Mont Sainte Victoire taken from Aix-en-Provence, near where Cézanne had his studio.

24.6 (bottom) *Woman with Coffeepot* (detail). Oil on canvas. Shows how Cézanne treated both people and things as if they were geometrical solids and also that traditional perspective and light-and-shade were almost replaced by line and colour in his mature work. Jeu de Paume Gallery, Paris

Paris' — although what these artists had most in common with each other was that they all developed in different directions from each other. What characterised the 'School of Paris' was the radical individuality of each of the artists in it; however, it will help to understand the aims of each one of them if we remember the broad distinctions between abstract and expressionist art outlined above.

Development of twentieth century painting

The 1870–80 period has been called the 'classical period' of Impressionism because at that time each of the five originators developed his own version of the style and painted great pictures. By now they were win-

ning the battle for recognition but, at the same time, attracting a flock of imitators. In fact, a large number of painters around the world even today are working in variations of Impressionism, but only a handful have produced original work. One of these is Pierre Bonnard (1867–1947; **24.1**).

The Post-Impressionists

The next generation of great painters — Cézanne, Gauguin, van Gogh and Seurat — all tried Impressionism at first, but each soon developed his own individual reaction to it. Thus, whereas Impressionism had been truly a school of painting, with the artists sharing a common style, we cannot say that there was a 'school' of Post-Impressionism — only different Post-Impressionist artists. But we can discern a number of links between the Impressionists and the Post-Impressionists.

First, the kindly and understanding Camille Pissarro who, through his respect for his fellow humans and his enthusiasm for the new art, encouraged and advised younger men of talent, among them the four great Post-Impressionists (see **23.18**).

Another link was colour. The Impressionists, of course, used touches of pure colour to represent the effect of light, but in doing so they opened the way for other uses of colour in pictures, and other artists began to use colour for its own sake to express emotion or to create decorative effects (see **24.37**, **24.41**).

Thirdly, the Impressionists' use of the broken-colour technique often gave their pictures an appearance of great freedom, as if there were no rules any more. This is a misunderstanding of their art but, nevertheless, freedom of handling paint became a major aspect of some twentieth century art — not to represent effects of light but to express ideas or emotion. Gauguin and van Gogh were the first to do this.

Finally, the Impressionists had ignored history painting and religious subject-matter — both mainstays of earlier art — and, instead, brought about the recognition of landscape, still-life and a range of genre subjects in their place. This too was taken by the next generations as an invitation to paint a whole range of subjects that had never before been attempted (**24.9**, **24.17**, **24.18**, **24.40**).

Most of the Post-Impressionists criticised Impressionism for ignoring anything but the surface appearance of things. Paul Cézanne (1839–1906), a Frenchman who did not get on very well with people and worked doggedly away at painting in Aix-en-Provence, in the south of France, wanted to make Impressionism into 'something solid and enduring — like the art in the museums'.

Impressionist pictures, Cézanne felt, had too many hazy effects, and composition was often loose. He pointed out that reality consists of solid forms as well as effects of light and advised younger painters to look for basic geometric solids (cylinders, cubes) underlying the forms of people and the landscape (**24.6**). Perhaps we could say that, in Cézanne's art, Rubenism and Poussinism are joined, because he composed his pictures as carefully as Poussin did (**24.2**), but he painted them using impressionist technique. Cézanne slaved away at perfecting his system of representing solidity of form and developed a way of 'drawing with colour' — that is, he exploited the way warm colours advance and cool colours recede (**24.2**). He painted mainly still-lifes, landscapes and portraits.

Paul Gauguin (1848–1903) was also a Frenchman. After a promising business career, he renounced civilisation as false, took up painting, lived primitively in Brittany, and then in the Polynesian islands (**24.15**,

24.9 (left) Georges Seurat, *Le Chahut*, 1889–90. Oil on canvas. 169 × 139 cm. Although this picture represents a noisy scene and great movement (it represents a dance like the 'can-can'), it is as if it has been frozen by Seurat in his effort to put some stability into Impressionism. His studies of the science of colour led him to paint areas of 'irradiation' around the lights. Kröller-Müller Museum, The Netherlands (see **24.16**) (**24.9** and **24.13** are reproduced in colour on the front cover.)

24.10 (right) Paul Gauguin, *Portrait of Tehura*, a woman he lived with in Tahiti. Wood-carving, 1891–93. About 24 cm high. Jeu de Paume Gallery, Paris

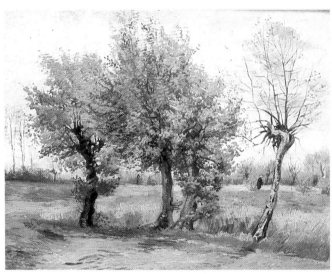

24.11 (centre left) Vincent van Gogh, *Landscape with Four Trees*, 1885. Oil on canvas. An early picture by van Gogh, painted before Impressionism influenced him. Kröller-Müller Museum, The Netherlands

24.12 (centre right) Vincent van Gogh, *Still Life with Open Bible and Extinguished Candle, 1885*. Oil on canvas. This picture was painted shortly after the death of van Gogh's father and the extinguished candle, the Bible and the other book (entitled *Joy of Life*) comment on life, death and religion. A beginning to van Gogh's expressionism. Van Gogh Museum, Amsterdam

24.13 (left) Vincent van Gogh, *Montmartre*, 1887. Oil on canvas. Now in Paris, van Gogh has discovered the colour and brushwork of Impressionism (compare **24.16**), although already adapting it to express his strong feelings. In 1887, Montmartre was a village but now it is part of the city of Paris. Stedelijkmuseum, Amsterdam

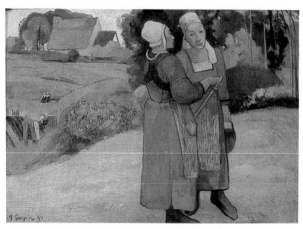

24.14 (above) Paul Signac, *The Seine at Herblay*, 1889. The uniform dots of pure colour, about 3 mm wide, give a convincing effect of light and distance. Palais de Tokyo, Paris © SPADEM, Paris 1982

24.15 (top right) Paul Gauguin, *Breton Peasant Women*, 1894. Oil on canvas. Painted on a visit back to France from Tahiti, it shows very well Gauguin's free use of colour and large, flattish shapes — both forerunners of abstract art. Jeu de Paume Gallery, Paris

24.16 (right) Georges Seurat, *Le Chahut* (detail of **24.9**). This enlargement shows the Divisionist technique of Seurat — small, uniform dots, mainly of orange and blue (two complementary colours) which the eye fuses to make the colours of flesh and cloth.

24.17 (bottom) Paul Gauguin, *Two Tahitian Women* or *Te Rerioa (Daydreaming)*, 1897. Oil on canvas. One of Gauguin's last pictures painted in his hut in Tahiti, this picture shows the influence of Polynesian sculpture on his art and how his hut was decorated with murals which expressed his interest in primitive life. Courtauld Institute, London

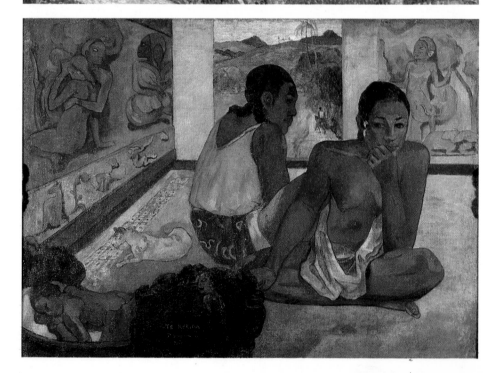

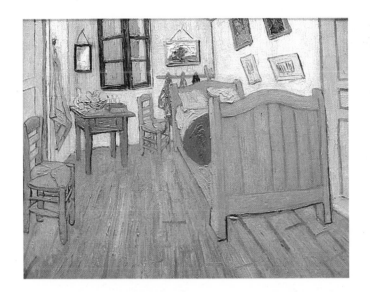

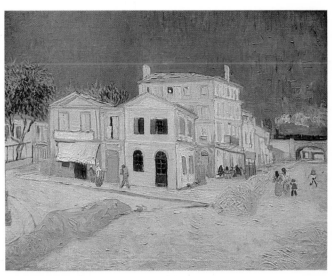

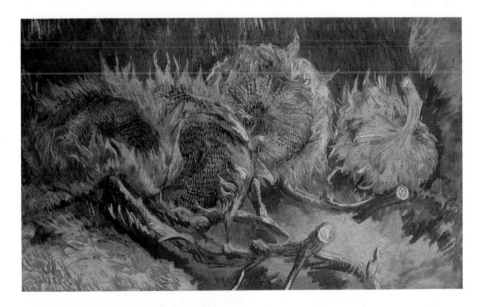

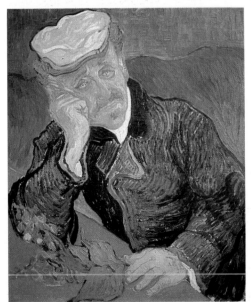

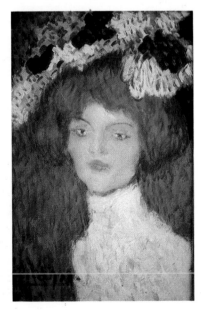

24.18 (top left) Vincent van Gogh, *Bedroom at Arles*, 1888. Oil on canvas. Van Gogh's bedroom in the house in **24.19** (room with green shutters). One of the two studies of this subject, this one is in the Van Gogh Museum, Amsterdam. Van Gogh said he wanted to express rest in this picture and to use empty space as in the Japanese prints (see **13.6**).

24.19 (above) Vincent van Gogh, *House at Arles*, 1888. Oil on canvas. The house in which van Gogh (and Gauguin) lived in Arles. Note the use of yellow and other pure colours, and the heavy impasto. Mature van Gogh. Van Gogh Museum, Amsterdam

24.20 (centre) Vincent van Gogh, *Sunflowers*, 1887. Oil on canvas. Van Gogh thought the sun, sunflowers and the colour yellow expressed life and happiness. But he was not to use pure colour much for a few months yet. Kröller-Müller Museum, The Netherlands

24.21 (far left) Vincent van Gogh, *Dr Gachet*, 1890. Oil on canvas. Dr Gachet, a medical man, was a friend of artists, a collector of Impressionist art and something of a painter himself. The artists called him 'Dr Saffron' because of the colour of his hair. He was van Gogh's doctor and van Gogh was staying in his house at the time he committed suicide in 1890. Jeu de Paume Gallery, Paris

24.22 (left) Pablo Picasso, *Portrait of a Woman*, c. 1901. 52 × 33 cm. Oil on canvas. An early Picasso, painted just after he went to Paris and discovered Impressionism. Kröller-Müller Museum, The Netherlands

24.23 Paul Gauguin, *Portrait of Vincent van Gogh*, 1889. Oil on canvas. When Gauguin arrived at Arles he painted van Gogh painting his famous sunflower pictures. Flat, almost abstract shapes, especially in the background, and a composition influenced by Japanese prints (see **13.6**). Van Gogh Museum, Amsterdam

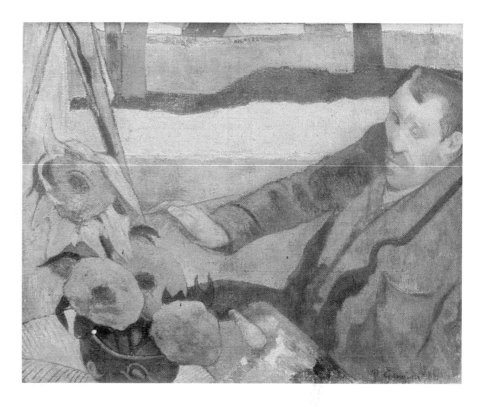

24.17). He was a colourful figure. His pictures have large areas of flat, rather bright and unnatural colour, little light-and-shade, and bold outlines. They are well-balanced and highly decorative, showing the influence on Gauguin of *Art Nouveau* (see **25.8–14**) and Japanese prints (**24.23**). He painted many pictures of the life and beliefs of the Polynesians.

Vincent van Gogh (1853–90) was a Dutchman who was all his life driven by a strong impulse to express his feelings (**1.16, 24.12, 24.18**). His intense love of mankind made him particularly interested in painting ordinary people, and he did this with bright colour and expressive brushstrokes. His life was often tempestuous and miserable and, after periods of insanity, he eventually took his own life. Though his painting career only lasted ten years, he executed many pictures.

Georges Seurat (1859–91) was a Frenchman who, using an almost scientific technique, refined and purified Impressionism. He painted only in dots of uniform size and used only pure spectrum colour. This method became known as *Pointillism*, or *Neo-Impressionism*, and was also used by Paul Signac (1863–1935), although Seurat himself called it Divisionism or 'my method' (**24.9, 24.14, 24.16**).

The next generation of twentieth century painters falls more clearly into the categories of abstraction and expressionism. However, each of the artists mentioned below derived characteristics from the four great pioneers.

Abstract and non-representational art

Abstract art owes its origin to Cézanne's doctrine that solid geometrical forms are the underlying basis of visual perception, and also to the way artists like Gauguin changed natural appearances to suit their own artistic ends.

Cubism was still basically representational. Pablo Picasso (1881–1973),

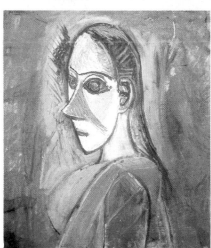

24.24 (top left) Pablo Picasso, *La Belle Hollandaise*, 1905. Gouache. From Picasso's tender and compassionate 'Pink Period'. Queensland Art Gallery © SPADEM, Paris 1970

24.25 (top right) Juan Gris, *Still-life with Lamp*, 1912. Oil on canvas. Gris (1887–1927) painted the most harmonious and restrained pictures of all the Cubists. Kröller-Müller Museum, The Netherlands

24.26 (above) Pablo Picasso, *Woman's Head*, 1907? Oil on canvas. The influence of Negro art on Picasso (compare **4.17**) Centre Pompidou, Paris © SPADEM, Paris 1982 (Reproduced in colour on front cover)

24.27 (left) Pablo Picasso, *Still-life with Guitar*, 1924. Oil on canvas. In Synthetic Cubist pictures like this Picasso and Braque were building on Gauguin's attitude that the subject is less important in a picture than the arrangement of the shapes and colours. Stedelijkmuseum, Amsterdam

24.28 Georges Braque, *The Rio Tinto Factory at L'Estaque*, 1910. Picasso and Braque painted a number of landscapes around this time which derive from Cézanne (see **24.4**). Early Cubism. Centre Pompidou, Paris

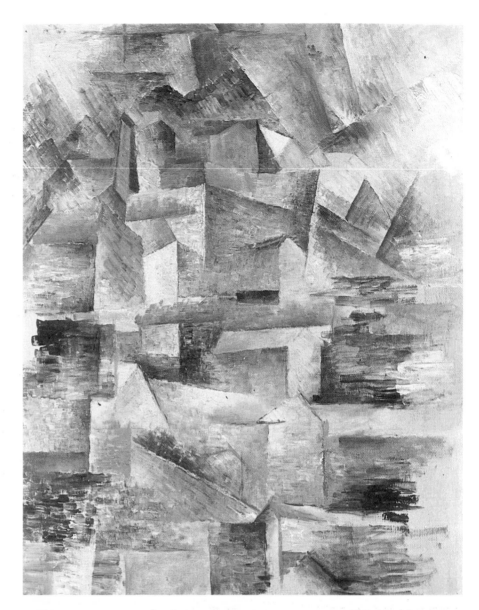

24.29 (left) Piet Mondrian, *Net Gein, Trees and Water*, 1905/6. Oil on canvas. An early Mondrian, deriving from realism but showing a strong interest in pattern and design. Gemeentemuseum, The Hague ©️ SPADEM, Paris 1982

24.30 (right) Piet Mondrian, *Composition with Blue*, 1937. Oil on canvas. Mondrian's last pictures are reduced to black lines and small patches of colour very carefully arranged in beautifully balanced, clean compositions. Gemeentemuseum, The Hague ©️ SPADEM, Paris 1982

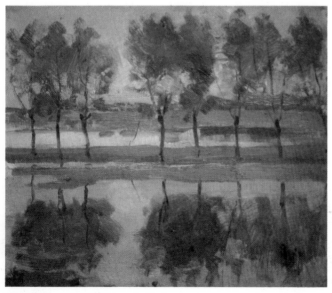

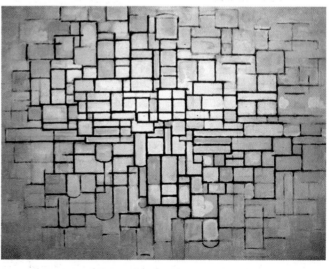

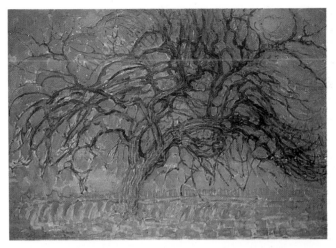

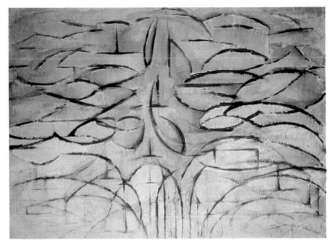

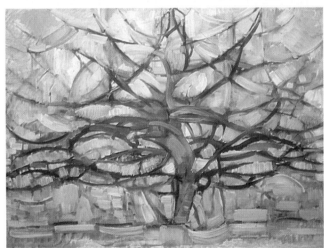

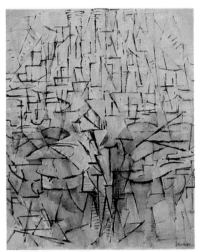

24.31 Piet Mondrian — four studies of trees showing how he developed his abstract style from his early realism: *Red Tree* (1908); *Blossoming Apple Tree* (1912); *Grey Tree* (1912); *Composition No 3 Tree* (1912/13). Gemeentemuseum, The Hague © SPADEM, Paris 1982

24.32 František Kupka, *Ordonnance en Verticale*, 1911–12. Oil on canvas. An early picture by the artist who painted the first abstracts. Centre Pompidou, Paris

24.33 (above) Wassily Kandinsky, *With the Black Arc*, 1912. Oil on canvas. Kandinsky was one of the first to paint non-representational pictures. Centre Pompidou, Paris

24.34 (right) Kasimir Malevich, *Suprematist Painting — Black Rectangle, Blue Triangle*, 1915. The Suprematists believed that only geometric shapes could make the most supreme art. If such pictures seem very modern remember that this one is well over half a century old. Stedelijkmuseum, Amsterdam

24.35 Henri Matisse, *Still-life*, pre-1905. Oil on canvas. A beautiful early picture by Matisse, showing the influence of Realism and Cézanne (whose work had just been 'discovered' by the younger painters). The calm of this picture contrasts with Matisse's Fauve work. Musée Fabre, Montpellier

a Spaniard, and Georges Braque (1881–1963), a Frenchman, in their early Cubist pictures (1907–10), represented real objects in a simplified and geometrical way (**24.25**). They were influenced by Negro sculpture (**24.26**) which was just becoming known in Europe, admiring its elemental simplicity and primitive force. In the *Analytical phase* (1910–12; **24.28**) the Cubists analysed the structure of their subject-matter, superimposing one view on another, thus introducing the dimension of time

into painting. They did this because they wanted to represent reality and thought it artificial to confine themselves to a single view, which painters had done since the beginning of art. They were influenced in this view by talk about the new Theory of Relativity, which gave time a place in the dimensions of space. Colour was almost eliminated from analytical Cubist pictures.

Picasso is perhaps the most representative painter of the age. He continually searched for new forms of expression and originated more than one style of twentieth century art, but also returned to realism from time to time (**24.24**).

In *Synthetic Cubism* (1912–14) the artists invented (synthesised) most of their shapes and colours (which were often strong and applied flat) and their pictures were, therefore, less representational (**24.27**).

It was left to non-representational or non-figurative artists to abolish subject-matter entirely, however. The chief non-representational painters were the Russians Wassily Kandinsky (1886–1944; **24.33**) and Kasimir Malevich (1878–1935; **24.34**), and Piet Mondrian (1872–1944), a Dutchman (**1.19, 24.29–31**). But the first completely non-representational picture were painted by František Kupka (1871–1957), a Czech, about 1909 (**24.32**).

Expressionism

The freedom of expression so highly valued by Gauguin and van Gogh formed the basis of Expressionism, which revolted — sometimes violently — against all previous styles. Spontaneity of expression and strong, often quite unrealistic and fanciful colour were the chief marks of expressionist pictures, with the result that they often seem to have been simply 'dashed off'.

The most typical Expressionists are of Germanic stock — the Norwegian Edvard Munch (1863–1944; **24.40, 24.42**), the Austrian Oskar Kokoschka (1886–1980; **24.43**) and the Germans Emil Nolde (1867–1956) and Käthe Kollwitz (1867–1945). This may be due to the long tradition of expressionistic art in Germany dating back to the Gothic period. German Expressionists formed the *Brücke* (Bridge; **24.39**) and *Blaue Reiter* (Blue Rider; **24.47**) groups.

The French group *Les Fauves* ('The Wild Beasts', so called because of their rejection of any 'civilised' style), whose pictures are bold, colourful and decorative, were also Expressionists. The chief Fauves were Henri Matisse (1869–1954), Maurice de Vlaminck (1876–1958), Georges Rouault (1871–1958), Raoul Dufy (1877–1953) and Dutchman Kees van Dongen (1877–1968). Matisse emphasised that his intention was to give pleasure to the viewer — nothing else. Once, when criticised for distorting the shape of a woman in a picture, he replied, 'That is not a woman — it is a picture' (**24.38**).

Surrealism

Surrealism can be considered an aspect of Expressionism or Symbolism because it is similarly concerned more with the content of works than with their formal values. Surrealists believe that the highest reality (*surréalisme* in French) lies in the unconscious mind and, hence, the content of their pictures and sculptures is unusual and disturbing, to say the least.

Surrealists like Salvador Dali (b. 1904), a Spaniard, and René Magritte (1898–1967), a Belgian, employ a very naturalistic or realistic style to make pictures of impossible or irrational things, like dreams, obsessions and other unconscious experiences (**24.45**). Others, like Germans Max

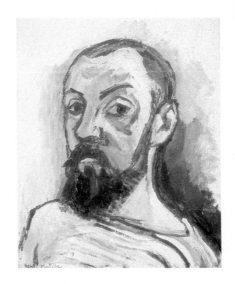

24.36 Henri Matisse, *Self-Portrait*, 1906. Oil on canvas. An example of Fauvism (compare **24.35**). Royal Museum of Fine Art, Copenhagen © SPADEM, Paris 1982

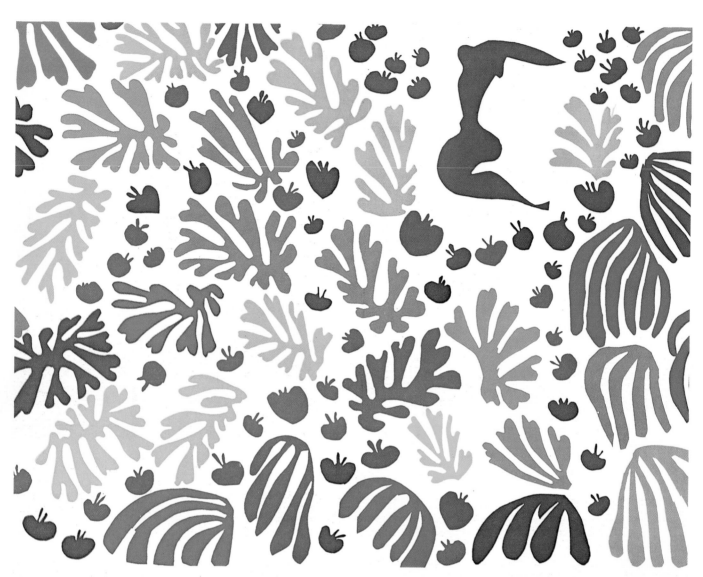

24.37 Henri Matisse, *Parakeet and Mer-maid*, 1952–53. Cut-paper (collage). The photo shows about one-third of this large picture, which measures nearly seven metres long. The mermaid can be seen clearly, and the parakeet is in the other part of the picture. But the main picture is a pattern of free forms suggesting living things in great profusion. Stede-lijkmuseum, Amsterdam

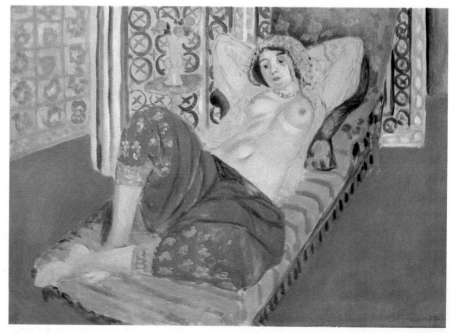

24.38 Henri Matisse, *Odalisque with Red Trousers*, 1922. Oil on canvas. Mature Matisse, illustrating his desire to give pure pleasure to the spectator and his use of pattern and colour for their own sakes. Centre Pompidou, Paris

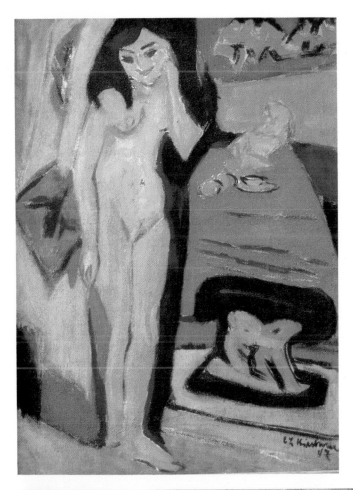

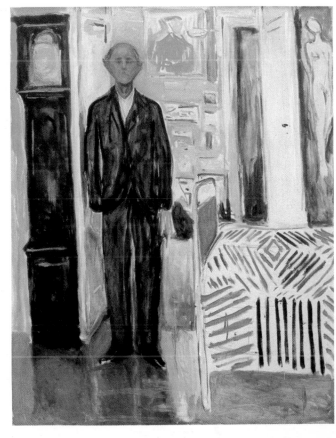

24.39 (top left) Ernst Ludwig Kirchner, *Nude Behind Curtain*, 1910. Oil on canvas. One of the original Brücke group, Kirchner represents the most restless and emotional German Expressionism. Stedelijkmuseum, Amsterdam

24.40 (above) Edvard Munch, *Self-Portrait Between the Clock and the Bed*, 1940/42. Oil on canvas. This represents a sad, reflective Munch near the end of his life. An atmosphere of anxiety is created by the surprising colours and the emotional way the paint has been applied. Munch Museum, Oslo

24.41 Gabriele Münter (1877–1962), *View Towards Mernauer Moss*, 1908. Blue Rider artists like Münter rejected materialism and sought to express the simple spiritual essence of things. Hence their pictures often resemble those of children. Lenhaus, Munich

Ernst (1891–1976) and Paul Klee (1879–1940), and Frenchman André Masson (b. 1896) start to work without any idea of what they are going to create and allow their unconscious minds and the materials they are using

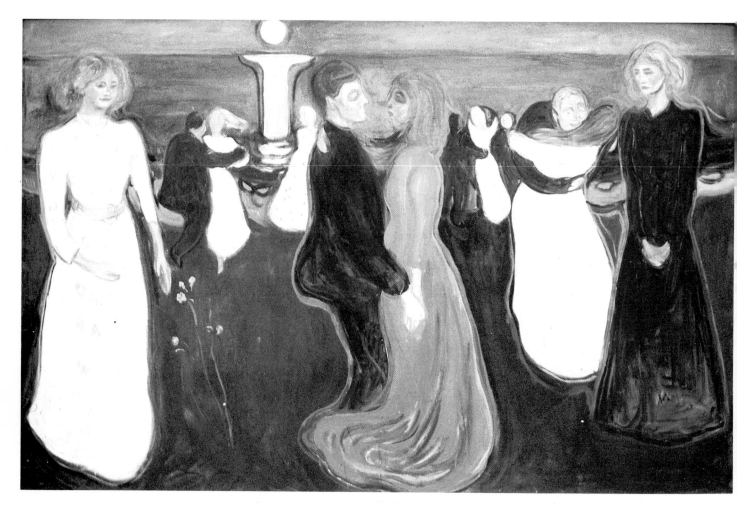

24.42 Edvard Munch, *Dance of Life*, 1899. Oil on canvas. All Munch's pictures are about life, human passions and death. In this large picture (the figures in the front are about 1.5 m high) he depicts the same woman at different ages, plus others who have shared her life, as if they were engaged in a great, tragic dance. Over all stands a great phallic symbol (the Moon?). National Gallery, Oslo

to interact without conscious control. Their pictures are full of half-formed images and ambiguous scratches and stains, which are intended to react with the unconscious minds of viewers. Surrealists consider they have been successful if their works are found to be disturbing or shocking.

Artists whose works are related to Surrealism are Joan Miró (b. 1893), a Spaniard (see **24.46** and **26.26**), and Maurits Escher (1898–1972), a Dutch painter whose 'impossible' pictures are well known.

Other schools

There are, or have been, many other schools of twentieth-century art. Notable among them are *Futurism*, an Italian school lauding machines and speed, and *Dada*, a school of 'anti-art'.

Dada

Dada is a nonsense title symbolising the irrational and nihilistic style of the movement, which phased into Surrealism about 1920. Dadaists like Frenchman Marcel Duchamp (1887–1968) exhibited outrageous sendups of traditional culture, like a reproduction of Leonardo da Vinci's *Mona Lisa* with a pencilled moustache and enigmatic and obscene inscription, or of pieces of commonplace plumbing or furniture ('readymade' sculptures). Ridiculous as it may seem, Dada forced people to consider what art really is and to realise that what the artist has to say is more important than the material or technique used. As such it has had a profound effect on art right up to the present time (**24.51**).

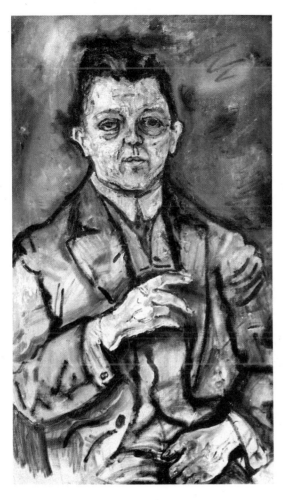

Twentieth century English painters

There is a group of great twentieth century English painters, the chief of whom are Paul Nash (1889–1946), whose pictures are rather surrealist; Graham Sutherland (1902–80), whose landscapes express the forces of nature; John Piper (b. 1903), whose work is often semi-abstract; and Ivon Hitchens, CBE (1893–1979) and Sir Matthew Smith (1879–1959), who were Expressionists.

Social realism

Social realism, as the name suggests, has a realistic approach to subjects of social relevance, such as the relationship between labour and management, and between opposed political forces. The only officially accepted style in communist countries (where Abstract art is regarded as 'too *bourgeois*'), social realism has sometimes included caricature, as in the art of George Grosz (1893–1959; **24.44**), and one of his nineteenth-century predecessors, Honoré Daumier (1808–79).

Abstract Expressionism

This school, which developed about 1950, was sometimes called *Tachisme* (*tache* is French for 'blot' or 'stain'), *Action Painting* or *Art Brut*. Using abstract symbols, the artists of this school attempt to express their feelings about a subject or to describe the forces of nature in visual metaphors. The technique often involves allowing paint to run and

24.43 (left) Oskar Kokoschka, *William Waver*, 1910. Oil on canvas. A deeply-penetrating study of character. Expressionism. Stedelijkmuseum, Amsterdam

24.44 George Grosz, *Café*. Indian ink on white paper, 59.3 × 46.0 cm. Art Gallery of South Australia

24.45 (top left) Salvador Dali, *Dante Purificato*. Print from a watercolour: one of a series illustrating Dante's *Divine Comedy*. Dali uses a Renaissance style of realism to present impossible and intriguing dream-like images which are often disturbing. Private collection.

24.46 (centre) Joan Miró, *Montroig I*, 1973. Lithograph. Typical surrealist interest in the mysterious, ambiguous and comical. Miró once lived in the Spanish town of Montroig. Collection Mr and Mrs G.C. Phillips

24.47 (top right) Franz Marc (1880–1916), *Blue Horse*, 1911. Oil on canvas. Marc mainly painted animals and tried to express his belief that they are spiritually one with the landscape. His large areas of flat colour derive from Gauguin, but he used colour symbolically: to him blue is masculine and spiritual. (It was a picture by Kandinsky, not this one, which gave The Blue Rider group its name.) Lenhaus, Munich

24.48 (right) Joseph Albers, *The Gate*, 1936. Oil on canvas. Purely non-representational, constructivist art, tending towards Op Art. Albers created ambiguous pictures which make us wonder which is in front of which. They appeal to the intellect as well as the senses. Societé Anonyme, Yale University. Photograph by Sandak, Inc., New York

smudge and to drip out of tins in long skeins, and the results can have the cosmic beauty of racing clouds or driving rain. Its chief exponents are the Americans Jackson Pollock (1912–56; **24.49**), Franz Kline (1910–62), Robert Motherwell (b. 1915), William de Kooning (b. 1904) and Sam Francis (b. 1923), the Frenchman Pierre Soulages (b. 1919), and the German Hans Hartung (b. 1904). In this style we can see a marriage of the two main streams of twentieth century painting, Abstract art and Expressionism.

Art in the sixties and seventies

Most of the artists of the 'School of Paris' had died by 1960 — although some (Picasso, Braque, Kokoschka, Dali, Ernst and Miró) lived on for up to 20 years more and became honoured as 'old masters' of modern art. By then the great freedoms won for art by these artists — freedoms which had seemed so extreme in their day — had spawned a new crop of freedoms, practised by the next generation of artists. Again, it helps to understand the work of these artists if we try to distinguish between expressionist and abstractionist intentions.

Those among the general public who had never accepted abstract or expressionist art and looked for a return to naturalism were surprised and disappointed when it came — but in the form of *Pop Art*. Artists like the Americans Roy Lichtenstein (b. 1923), James Rosenquist (b. 1933), Robert Rauschenberg (b. 1925), Andy Warhol (b. 1930; **24.52**) and Jim Dine (b. 1935) used both the imagery and the techniques of the

24.49 (top) Jackson Pollock, *Blue Poles*, 1952. Duco and other media on canvas. 211 × 488 cm. In Abstract Expressionism non-representational art and Expressionism join: there is no subject-matter and the artist freely expresses feelings. This is not a picture of poles; the name is simply a tag to identify the picture. Australian National Gallery, Canberra

24.50 (right) Martial Raysse, *Painting Under High Tension*, 1965. Retouched enlarged photograph with neon tube. Here the artist uses two twentieth century media which are not normally associated with art (and the title) to comment on twentieth-century life. Stedelijkmuseum, Amsterdam

24.51 (left) Robert Rauschenberg, *Cardbird*, 1971. Collage. Rauschenberg's art derives from Dadaism. The materials he uses are not usually associated with art and even the name of this picture asks us to think twice. The bottom layer (greyer-coloured) is actually a photograph of a piece of cardboard packing-case: an appeal to the intellect as well as the senses. Art Museum, Gothenburg

24.52 Andy Warhol, *Bellevue II* (detail), 1963. Silk-screen printing on canvas. Warhol's comment on the tensions and violence of life today in New York (Bellevue is a mental hospital). Another non-traditional use of media, but the repetition of the same print (with intentional bad patches) expresses the theme well. Stedelijkmuseum, Amsterdam

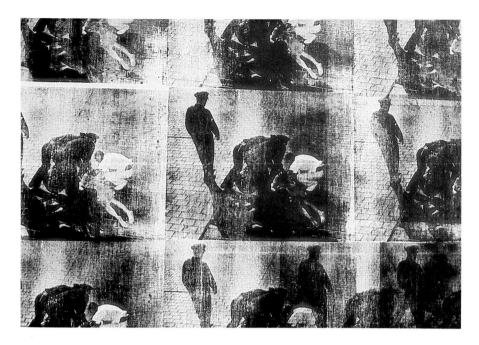

mass media, the comic-strip and advertising. Their highly realistic works seem devoid of either beauty or style (**24.52**). Sometimes photographs are incorporated with the painted surfaces (*montages*; **24.50**; **24.51**). While American Pop artists simply present their subject-matter without comment or expression, their British counterparts, like David Hockney (b. 1935), Michael Andrews (b. 1928) and R.B. Kitaj (b. 1926), often seem to make some social comment, as does the Frenchman Martial Raysse (b. 1936).

The non-representational art of earlier decades was continued under the name of *Constructivism* (or *Non-objective art*) in the sixties, but by then the influence of Dada had eroded the age-old distinction between painting and sculpture and the dominance of the traditional media of both arts. Pictures and sculptures alike were made from metals, wood, composition-board and plastics (*collage*) as well as the more usual media (see **24.51**). Two artists who have been working in this way for many years are the Englishman Ben Nicholson (b. 1894) and the German Joseph Albers (1888–1976), whose paintings have an ambiguous quality which relates them to *Op art* (**24.48**).

Op art used well known visual illusory devices to create pictures which seem to shimmer or move, or actually to distort the picture's surface. The most prominent Op artists are the Hungarian Victor Vasarely (b. 1908; **24.53**) and his English disciple Bridget Riley (b. 1931).

Colour Field paintings, like those of the Americans Mark Rothko (1903–70), Morris Louis (1912–62) and Helen Frankenthaler (b. 1928), as the name suggests, consisted almost entirely of large areas of subtle yet saturated colour. As the pictures themselves were usually large, the effect was often very striking. Large size was also characteristic of most of the pictures known as *Hard Edge*. In this style there was a similar reliance on the effect of areas of colour, but these were presented in neat and usually geometric shapes, as in the work of the Americans Frank Stella (b. 1936), Kenneth Noland (b. 1924), and Ellsworth Kelly (b. 1923; **24.56**). Often the canvases themselves were in shapes other than the traditional rectangle (**24.54**).

In this period the influence of Dada — the anti-art movement of the First World War period — was revived in the prevailing social climate of

protest. Just as the original Dadaists had questioned the very basis of western civilisation (and, along with it, its art), the *Neo-Dadaists* (**24.51**) questioned a social system dominated by the economic and cultural imperialism of the great powers, and the struggles of an increasing number of groups regarding themselves as oppressed or disadvantaged to achieve the freedom which had been first expressed by many artists since the time of David.

Experimental Art

Experimental art began in the 1950s when younger artists began to question the basis of everything — including traditional attitudes to and needs for art. They not only experimented with new media but also developed new forms of art. One of these, the *happening* of the fifties, was scarcely distinguishable from various forms of political and human-rights demonstration and protest, of which it was often a part. You did not have to be an artist to take part in a happening — in fact, some said all people are artists anyway.

In *performance art*, the artist performs some actions before an audience (usually quite a small one), such as when Australian Mike Parr wound gelignite fuse-wire around his naked leg and lit it, making a spiral burn-mark up his own leg (*body art; Leg Spiral*, 1975). As can be seen, these three forms of experimental art have a heavy emphasis on expressing ideas (as did Expressionism) and they rarely, if ever, produce an object which can be preserved in an art gallery. One has to question, in fact, whether they can be called *visual* art at all, and ask whether they should not perhaps be evaluated as theatre instead.

Conceptual artists maintain that art should not be about objects (like pictures and sculptures), but about ideas instead. There is a good deal of truth in this, as has been indicated in section 1. Lack of respect for objects is shared by the Aborigines (who abandon their bark-paintings at the end of a ceremony) and by many Asian peoples who make beautiful ceremonial objects from impermanent materials, such as leaves, and then discard them (see **9.9**).

An *installation* is, perhaps, more related to traditional sculpture — the artist creates an environment in a room or a corner of a gallery. Noel Sheridan exhibited his *Everybody Should Get Stones* in the Art Gallery of South Australia in 1974. A heap of large stones covered the floor of a gallery. On the wall were sheets of paper listing concepts about stones for spectators to think about. For example, they asked them to find a stone which was like a rose, a cloud or a bicycle, or which could be used as a book-end or a coathanger. They were invited to select the most odd, nice, plain or indescribable stone or one which was most like your mother, your fondest wish or your mind, or to select the one most apt for killing two birds with, for punishing a woman found in adultery, or for gathering moss.

Rumanian-American artist Jachareff Christo (b. 1935), in 1969 wrapped quite a large section of Little Bay, near Sydney, in sheets of fabric, tied down with ropes (**24.55**).

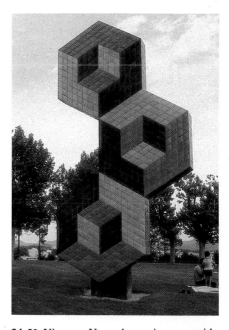

24.53 Victor Vasarely, sign outside Vasarely Foundation, Aix-en-Provence, France, 1975. This structure of tiles laid on to concrete is actually flat. Vasarely has used basic drawing (perspective and chiaroscuro) skills to create a convincing but conflicting illusion of three dimensions: do the small 'cubes' lie inside the large 'cubes', or outside them?

Things to do

1 Select a twentieth century artist whose work you like and make a fuller study of his/her life and work.

2 Paint pictures in each of the following styles: synthetic cubism, fauvism, pointillism, non-representational art.

3 Make a time-chart of the artists listed in this section.

4 Work your own installation.

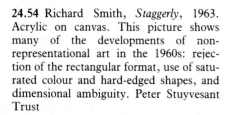

24.54 Richard Smith, *Staggerly*, 1963. Acrylic on canvas. This picture shows many of the developments of non-representational art in the 1960s: rejection of the rectangular format, use of saturated colour and hard-edged shapes, and dimensional ambiguity. Peter Stuyvesant Trust

24.55 Jachareff Christo, *Little Bay, Wrapped*, 1969. Photograph by *Herald and Weekly Times*

24.56 Ellsworth Kelly, *Blue, Green, Red I*, 1965. Acrylic on canvas, c 3m square. Pure shapes and colours beautifully balanced. Stedelijkmuseum, Amsterdam

25 Twentieth century architecture

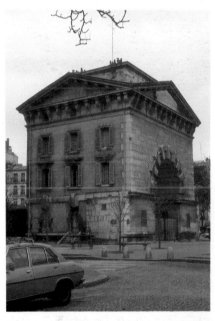

25.1 (top left) John Wood (1728–82) Queen Square (1824–28), Bath. Bath had been a resort since ancient Roman times but was redeveloped in the eighteenth century with an emphasis on planning the town as a whole (with squares, crescents and parks) and architecture of a classical simplicity which influenced twentieth-century architects.

25.2 (top right) Claude-Nicholas Ledoux (see p. 130), Pavilion, Place de la Nation, Paris. One of the few remaining of the fifty toll-houses Ledoux built in the then wall of Paris in 1784–89. Although based on classical elements, this building's lack of decoration, simplicity and cubical shape foreshadow twentieth-century buildings like that shown in **25.15**.

25.3 (left) In the latter half of the nineteenth century a number of large railway-stations were built. One of these, Paddington in London, shows how efficient iron and steel are when large areas have to be spanned so as to allow in a good deal of light. Trains were a new invention at that time, and they too (as well as the rails they ran on) were built of iron.

By the end of the nineteenth century, the position of European architecture was confused. The historical styles which some architects had revived (Historicism or Revivalism — see page 131), had failed to express the character and aspirations of an age of increasing democratisation and industrialisation. However, while many architects were looking

25.4 (left) A house in Bath, late eighteenth century. This style, Palladian or Georgian, was transported to Australia along with its first settlers (cf. **27.1–27.3**).

25.5 (right) The Eiffel Tower, Paris. Built of iron for the 1889 Paris World Exhibition by Gustave Eiffel. 300 metres high, and the tallest building in the world until New York skyscrapers were built, it literally pointed the way to a new architecture. 1889 was the centenary of the French Revolution and a world fair is planned for Paris in 1989.

25.6 (below) The Statue of Liberty, New York Harbour. This colossal sculpture by Bartholdi was presented to America by France in 1886. The photograph on the right is of the inside of the head and shows that it is basically a modelled sheet of copper supported on an iron framework (which was designed by Eiffel). Photograph: US Information Service

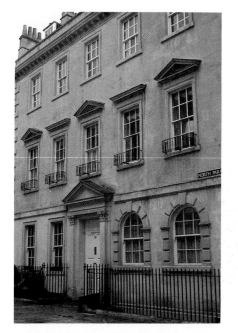

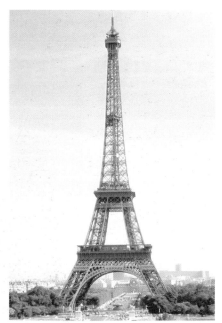

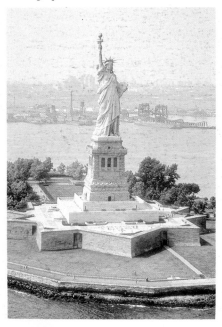

backwards, the great minds of the day were reassessing the basic principles of architecture in the light of the changed social, economic and political conditions — especially the increasing cost of labour due to industrialisation and the decreasing number of skilled builders.

The way was pointed, at first, not by architects at all. The Crystal Palace, built in London in 1851 to house the Great Exhibition, was designed by Sir Joseph Paxton (1801–65), a distinguished horticulturist, as a giant conservatory with thousands of panes of glass set in unornamented and mass-produced cast-iron frames. Iron bridges had been built since 1777, but this frank use of iron and glass — two materials new to architecture, but destined for a great future in building — inspired the first architects of this century. The Eiffel Tower (**25.5, 25.7**), built in Paris for the 1889 Exhibition (the centenary of the 1789 Revolution), was the work of an engineer and bridge-builder Alexandre Gustave

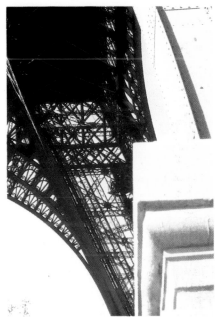

25.7 (left) The base of the Eiffel Tower, showing how it is made of plates and strips of iron rivetted together in a calculated web of tensions. The technology of making large pieces of steel had not then been developed. Although iron buildings like this were the first examples of functional architecture, people felt they had to have some decoration: the arch at bottom left has a motif based on Roman decoration (compare **16.13**).

25.8 (right) Art Nouveau tiles in the Museum of Applied Arts and Sciences, Sydney.

Eiffel (1832–1923). It, too, presaged the new style, particularly its dependence on engineering. Another engineer, the Swiss Robert Maillart (1872–1940) pioneered the use of reinforced concrete (*ferro-concrete*) in the graceful bridges he built from 1905 onwards.

In the 1880s a style called *Jugendstil* in Germany and *Art Nouveau* in France (after a modish shop) developed. It was the most original new style since the Renaissance, but it was mainly a style of decoration and was only short-lived. It consisted of flat, stylised, curvilinear designs resembling the organic forms of branches, leaves and flowers (**25.8–14**). The British designers William Morris (1834–96) and Charles Rennie Mackintosh (1868–1928), and illustrator Aubrey Beardsley (1872–98), the posters of Henri de Toulouse-Lautrec (1864–1901; **25.12**), and the Church of Sagrada Familia, Barcelona, by the Spaniard Antoni Gaudi (1852–1926; **25.13**) are leading examples.

25.9 (far left) One of the many entrances to the underground railway in Paris, the *Metro*. The standard, mass-produced cast iron arch-way, lamp-stand and balustrade (in typical Art Nouveau organic forms) were designed by Hector Guimard (1867–1942) in 1899.

25.10 (centre) A house in Amsterdam, built about 1890. Art Nouveau.

25.11 (right) Doorway of a house in Amsterdam, c. 1890. A beautiful example of Art Nouveau design using iron in patterns inspired by plant tendrils to unify the house with its fence.

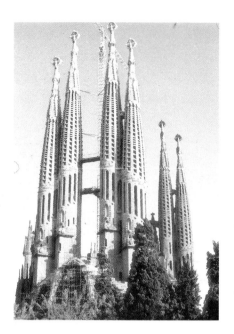

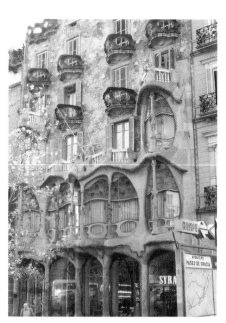

25.12 (left) Henri de Toulouse-Lautrec, poster advertising the appearance of dancer, Jane Avril, at the Jardin de Paris, 1893. Toulouse-Lautrec, a talented Impressionist, was influenced by Art Nouveau decoration, especially in posters like this one. He was also one of the first great poster artists.

25.13 (centre) Antoni Gaudi, church of Sagrada Familia (the Holy Family), Barcelona, commenced 1882 and still being built. The towers of the west front, like this whole building, are like no other in the world.

25.14 (right) Antoni Gaudi, *Casa Battló*, 1905–7. In this block of flats and shops in Barcelona, Gaudi reached the pinnacle of Art Nouveau; however, the style went no further — instead it was eclipsed by Cubism and Expressionism.

A new architecture

In the early twentieth century a new architectural aesthetic evolved, one that satisfied the conditions of the times and embraced its new materials — steel, concrete, glass and plastic.

The Romans had made very good concrete from the 'natural cement' of lava dust (*pozzolana*), but the art was lost during the Middle Ages. However, early in the nineteenth century, Joseph Aspdin invented Portland cement, which engineers combined with steel reinforcing to make ferro-concrete — a material of such tensility and compressibility that it could be used to build much wider spans and cantilevers than ever before (see **1.15**). Used in architecture, it replaced the expensive labour of stonemasons and other skilled handcraftsmen.

Machines increasingly replaced hand-tools and new methods (like *prefabrication*; **25.9, 25.17, 27.8**) cut costs while increasing speed. Designing in classical or Gothic styles gave way to designing buildings that would be efficient and convenient (*functionalism*). This approach spread to embrace the wider concept of *town-planning* to provide for safe multi-laned roads with clover-leaf crossings and over- and underpasses, housing and recreation areas set apart from factories, and multi-storeyed office blocks ('skyscrapers'). In addition, buildings were designed to suit climate. Renaissance architecture had been invented in sunny Italy and excluded most of the sunlight. Obviously this was not satisfactory in a cool temperate climate like that of northern Europe, where large glass windows were needed to allow maximum sunlight to enter.

Twentieth century architects respect the integrity of materials. They have been influenced by the painters in that they think a material should be used in a way that expresses and reveals its own natural qualities. Consequently, concrete is now rarely sheathed in some other more 'respectable' material and often even the marks of the formwork are left (see **25.22**). In fact, the style of painters like Mondrian (see **1.19, 24.29–31**) influenced designers like Rietveld (see **1.20**) and van Doesburg (see **25.15**) who developed the clean, cubical lines so characteristic of modern buildings. Decoration is rarely added — the colour and character of materials and the placing and proportions of openings alone give sufficient surface interest (see **25.17, 27.19, 27.22**).

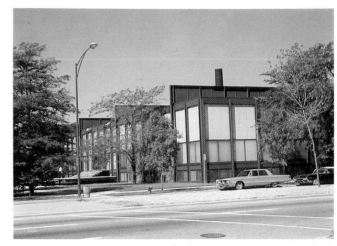

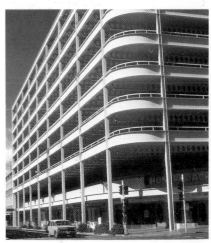

Gropius

The German architect Walter Gropius (1883–1969) was one of the first to adopt the new aesthetic. As early as 1911 he was using the new materials in buildings with flat roofs, glass-enclosed staircases and exposed steel frames which look 'modern' even today. He was head of the Bauhaus, a design academy in Germany, until he was forced to flee to the United States by the Nazi regime. He built the premises of the Bauhaus in Dessau (1925–26) using an asymmetrical plan in which cube-shaped blocks of various sizes were placed so that they balanced each other visually. His own teacher, Peter Behrens (1868–1938), was perhaps the first fully-fledged 'modern' architect.

Mies van der Rohe

Ludwig Mies van der Rohe (1886–1969), a compatriot and contemporary of Gropius, said 'steel is the essence of our time' and tried to express this in the blocks of apartments he built in Chicago and in his *German Pavilion* at the Barcelona Exhibition of 1929. In Crown Hall (Illinois Institute of Technology, Chicago) Mies exploited the tensile strength of steel *I-beams* to span the whole building without internal supports. The I-beams, together with the other steel structural members, are exposed for all to see (**25.16**).

Le Corbusier

The Swiss Le Corbusier (Charles Edouard Jeanneret, 1887–1965) once said 'the house shall be a machine for living', by which he meant that it should be functional and designed for efficiency and comfort. His teacher, Auguste Perret (1874–1955), was one of the first to use concrete satisfactorily in architecture.

Le Corbusier's logical and creative imagination has often been applied to town-planning. He has redesigned most of the large cities of the world to make them more efficient for modern living, but so far only Chandigarh, the capital of the Indian State of Punjab, has put his plan into practice (**25.18**). One of his pupils, however, the Brazilian Oscar Niemeyer (b. 1907), was commissioned to plan his country's new capital, Brasilia, together with the town-planner Lucio Costa (b. 1902). Le Corbusier designed a number of concrete houses in the 1920s and the famous Swiss Students' Hostel, in the Cité Universitaire, Paris.

25.15 (top left) Theo van Doesburg (1883–1931), model for his own house, 1929/30. In 1917 van Doesburg founded the magazine *De Stijl* (*Style*) around which Dutch artists like Mondrian formed a group (**1.19, 1.20**). Its cubical forms and lack of decoration derive from buildings like **25.2** and Cubist and abstract painting (**24.25–34**) and set the style for much of the architecture of the twentieth century. Stedelijkmuseum, Amsterdam

25.16 Ludwig Mies van der Rohe, Crown Hall, Illinois Institute of Technology, Chicago, 1939. A pioneering steel building. The tubular-steel light standard in the street outside is a development of the work of people like Mies. Such standards are mass-produced all over the world now.

25.17 Hassell and Partners, Rundle Street Car Park, Adelaide, 1980. This building is completely prefabricated from steel units bolted together and could be re-erected on another site if required. The Crystal Palace (1851) was the first such building, although it was made of cast-iron.

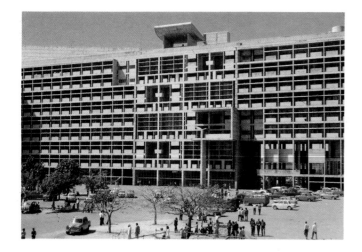

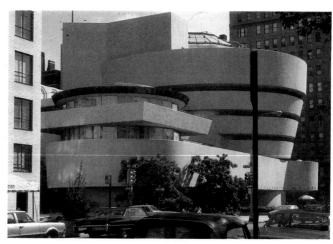

25.18 Le Corbusier, Secretariat Building, Chandigarh, India, 1951–56. A concrete building designed to make the office workers as comfortable as possible in the fierce Indian heat: there are shady breezeways and each window is set back under a canopy.

25.19 (top right) Frank Lloyd Wright, Solomon R. Guggenheim Museum, New York, 1943–59. Only the offices have windows: the exhibition section is a hollow cylinder of concrete on which the pictures hang, and they are illuminated from a central glass dome (just visible). Although the building is several storeys high the exhibition space is one continuous spiralling ramp. Perhaps the most functional art museum ever designed.

25.20 (right) Ed Stone, New York State University, Albany, N.Y. Stone, while using and respecting all the principles of modern architecture, infuses a romantic lightness and decorativeness into his buildings.

Wright

Frank Lloyd Wright (1869–1924), the individualistic, romantic American, worked under Louis Sullivan (1850–1924) who said 'form follows function', by which he meant that the form a building is given must come from the use to which it is to be put. Sullivan built the first entirely steel-framed skyscraper. Wright believed that architecture should be 'organic'. By this he meant that the various parts of a building should suit each other and be united as though they were parts of an organism; a building should appear to be an integral part of its environment; there should be a satisfactory relationship between enclosed and exterior spaces; the materials and methods used should look natural to the terrain; and the designer should take into account the people who are to use the building, as well as its purpose. Most modern architects would agree with these important points.

Wright built the Imperial Hotel, Tokyo, which is earthquake-proof; homes in the Arizona desert; the Guggenheim Museum, New York (**25.19**); and 'Falling Water' (the Kauffman house), Bear Run, Pennsylvania. His laboratory tower for the Johnson Wax Company, Wisconsin, features glass curtain-walls suspended from concrete floors cantilevered out from a central column — a principle commonly used now all over the world.

Other outstanding twentieth-century architects are: the Italian concrete engineer, Pier Luigi Nervi (1891–1979); the Hungarian Marcel

25.21 (top left) National Capital Development Commission, Canberra, Prefabricated concrete bus shelter with logo. Late 1970s.

25.22 (top right) I.M. Pei, Everson Gallery of Art, Syracuse, New York, 1968. The magnificent internal staircase. Only a ferro-concrete cantilever could support itself in this way. The marks of the wooden boxing have been left as a decorative texture ('*off-form*' *concrete*).

25.23 (left) Renzo Piano and Richard Rogers, The Pompidou Centre (also known as the Beaubourg), Paris, 1975–77. Perhaps the ultimate in the functional design of an art gallery, this building is made of prefabricated steel structural members, glass and perspex, and all the conduits for water, electricity, etc., together with the escalators, are on the outside of the walls. A revolutionary and controversial design.

Breuer (b. 1902–81); the Viennese Richard Neutra (1892–1970); the American firm of Skidmore, Owings and Merrill, which built the 24-storey glass-walled Lever House, New York; and Ed Stone (1902–78), I.M. Pei (b. 1917; **25.22**), Philip Johnson (b. 1906), and Paul Rudolph (b. 1918), also Americans.

Things to do

1 Find pictures of all the buildings mentioned in this section in library books.

2 Find out more about the architects and designers mentioned in this section.

3 List local examples of architecture which may have been derived from the work of the pioneers mentioned in this section.

4 Make a list of the articles and utensils in your home that you consider functional, and those which you consider are not.

5 Write an essay assessing the functionality and integrity of a building you know well.

6 Try to solve the traffic problems of your locality. Make a sketch plan of your solution.

7 Made sketches of three or four articles or utensils that you consider well designed.

26 Sculpture from the Renaissance to the twentieth century

26.1 Two reliefs from the doors of the baptistry of Florence Cathedral, by Lorenzo Ghiberti: top, from those he made in 1401–24 and, below, from those he made in 1425–52. The baptistry is an octagonal building and has three pairs of large doors, each containing a number of gilded bronze reliefs like these. The first pair was made by Andrea Pisano in 1329–36 and Ghiberti's first doors follow Pisano's pattern, with somewhat isolated figures in a frame. However, Ghiberti's second doors indicate how far Renaissance humanism had progressed in the century since Pisano worked. In these the figures relate to each other and to the landscape in a new way which foreshadowed how art was to develop over the next five centuries.

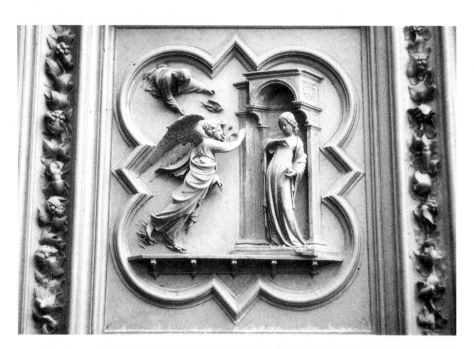

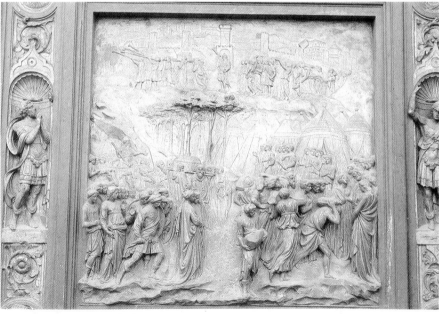

In general, the history of sculpture parallels that of painting. Since the thirteenth century there have been sculptors working in the Renaissance, Mannerist, Baroque, Neoclassical, Realist, Impressionist and the various twentieth century styles. The characteristics of these styles having been

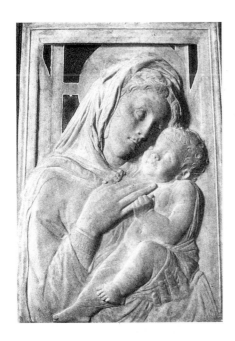

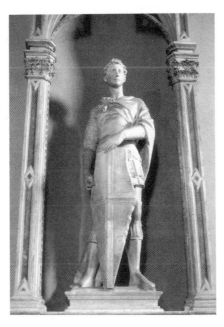

26.2 (left) Donatello, *Virgin and Child.* Marble low relief with blue enamel background. Height about 63 cm. Uffizi, Florence

26.3 (right) Donatello, *St George, c.* 1416. Marble, Height about 200 cm. Uffizi, Florence

sketched in the preceding sections, it will be interesting to look at the history of sculpture as a whole through a study of the chief personalities.

The Renaissance appeared somewhat earlier in sculpture than in painting. This is, perhaps, not surprising since late Gothic sculpture in northern Europe was quite naturalistic (see **17.37, 17.38**), and a number of ancient Roman sculptures survived in Italy throughout the Middle Ages. Both these things influenced the earliest Italian sculptors of the Renaissance period, giving the development of sculpture a smooth transition from Gothic to Renaissance.

It is easy to see that a sculptor wishing to represent nature convincingly has less of a problem than a painter does since, whereas the painter has to translate from three-dimensional reality to a two-dimensional surface, both the sculptor's model and his sculpture exist in three dimensions.

The Renaissance

Italian Renaissance sculptors were no less humanistic than Renaissance painters and they, too, aimed to master the technique of representing nature. From the earliest to the latest, anatomy, expression and movement of the human body improve and religious subject-matter gives way to secular subject-matter, like portraits and figures from classical myths.

Chief early figures were Nicola Pisano (c. 1206–78) and his son Giovanni (c. 1250–1330) who were often referred to as the *Pisani*; Andrea Pisano (c. 1270–1348), not related to the former, but famous as the sculptor of one of the three pairs of bronze doors for the baptistry of Florence Cathedral (see **26.1**); and Jacopo della Quercia (1373–1438). Giotto (1266–1337) probably carved some of the figures on the campanile of Florence Cathedral, which he designed (see **21.1**).

Donatello (1386–1466), the friend and associate of the painter Masaccio and the architect Brunelleschi, both of whom were catalysts in their respective arts, is credited with having the ability to make life seem 'to move within the stone'. This quotation is from the Mannerist art historian Vasari, speaking of Donatello's *St George* (**26.3**). Other works by this master are the pair of stone prophets called *Zuccone* and *Jeremiah* on

26.4 (left) Portrait of a woman by the master of Leonardo, Andrea del Verrocchio. In its realism and humanism more like an ancient Roman portrait (see **16.20**) than a Gothic sculpture. Marble. Uffizi, Florence

26.5 (right) Portrait of a man by an unknown Venetian sculptor of the late fifteenth century. Terracotta. Louvre, Paris

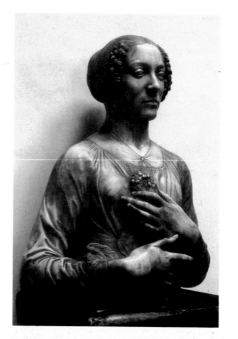
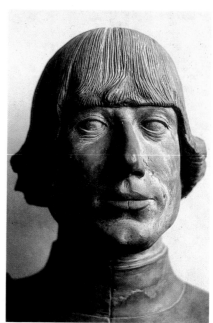

26.6 Luca della Robbia (1400–82), section of the *Cantoria* (or singing gallery) of Florence Cathedral, 1431–38. Marble high relief inspired by Roman sculpture. Della Robbia's *Cantoria* used to be opposite that of Donatello in the cathedral, but now is in the museum of the cathedral. Height about 100 cm.

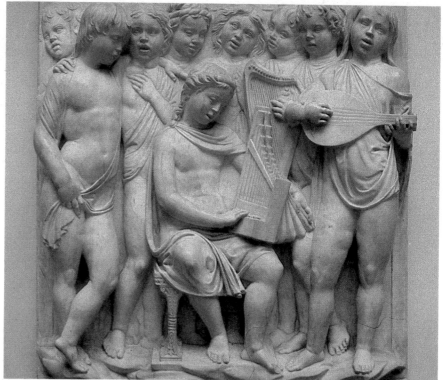

the campanile of Florence Cathedral, the equestrian statue *Gattamelata* in Padua, and part of the Cantoria (or singing gallery) in Florence Cathedral. Donatello also created relief sculptures in which he demonstrated his mastery of perspective and human anatomy (**26.2**).

Lorenzo Ghiberti's (1378–1455) most famous work is the pair of bronze doors he made for the baptistry of Florence Cathedral, known as 'The Gates of Paradise' since Michelangelo said they were beautiful enough to be the entrance to Heaven (**26.1**).

Although Michelangelo thought of himself mainly as a sculptor, his work and life have already been discussed in section 19 and 21 (see pages 111–112 and **1.3, 26.7, 26.8, 26.9**).

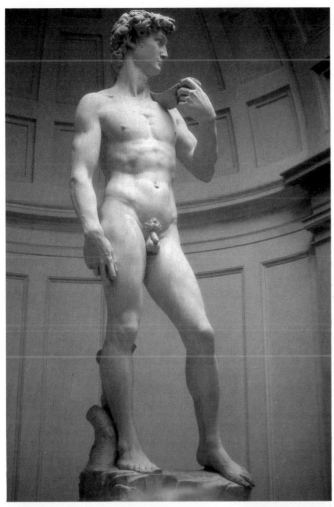

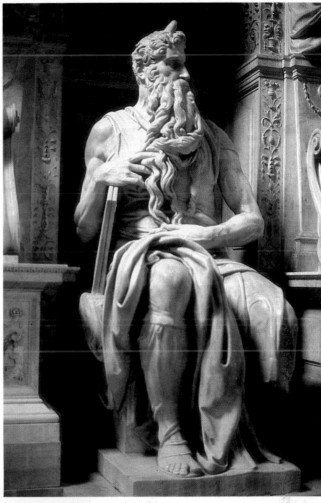

26.7 (top left) Michelangelo, *David*, 1501–04. Marble. Height 550 cm. (See page 111) Academy, Florence

26.8 (top right) Michelangelo, *Moses*, c. 1513–15. Marble. Height about 240 cm. One of the figures intended for the tomb of Pope Julius II but which rests, instead, in the church of S. Peitro in Vincoli, Rome.

26.9 (left) Michelangelo, one of the *Slave* figures intended for the tomb of Pope Julius II but in the Academy, Florence (see page 111). Although Michelangelo died before he could complete all the *Slaves* (compare **1.3**) he would not have wished to bring them to a finish like the Canova (**26.14**)

26.10 (right) Gianlorenzo Bernini, *David*, 1623–24. Marble. Over life size. Comparison with the Michelangelo *David* illustrates very well the difference between High Renaissance grace and nobility and Baroque energy. Villa Borghese, Rome. Pope Paul V, a Borghese, was Bernini's patron. The head is said to be a self-portrait of the artist.

In the Baroque period, Gianlorenzo Bernini, the architect who made the last additions to St Peter's cathedral, also created sculptures which exhibit the restless energy of Baroque art (**21.8, 26.10**).

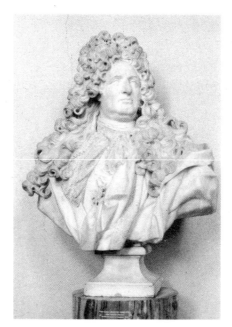

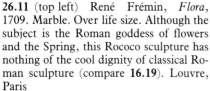

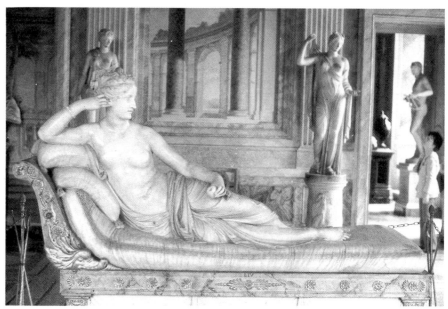

26.11 (top left) René Frémin, *Flora*, 1709. Marble. Over life size. Although the subject is the Roman goddess of flowers and the Spring, this Rococo sculpture has nothing of the cool dignity of classical Roman sculpture (compare **16.19**). Louvre, Paris

26.12 (centre) Jean-Louis Lemoyne (1665–1755), a famous French portrait sculptor of the eighteenth century made this marble bust of *Jules Hardouin-Mansart*, one of the architects of the Palace of Versailles (see **22.10**) for exhibition in the Academy in 1703. Louvre, Paris

26.13 (top right) Jean-Antoine Houdon, *Louise Brogniart*. Terracotta. About life size. A fine example of realistic portraiture. Louvre, Paris

26.14 (right) Antonio Canova, *Paolina Borghese-Buonaparte as the Victorious Venus*, 1805–08. Canova carved this life-size marble portrait of the sister of Napoleon (who married a Borghese) in the role of 'love triumphant' in a style inspired by the sculpture of republican Rome because Napoleon at that time was the admired emperor of a modern republic. He made a number of portraits of Napoleon. Villa Borghese, Rome. The apple in Paolina's hand is the prize Paris awarded to Venus for her beauty in the famous legendary contest

The eighteenth and nineteenth centuries

Rococo sculpture (**26.11**) has the same restlessness and light frivolity as Rococo painting.

The French sculptor Jean-Antoine Houdon (1741–1828) was a portraitist of great talent. He sculptured many famous people including Voltaire, Rousseau and Benjamin Franklin, but our illustration (**26.13**) shows that he could grasp the humanity of even a child.

The greatest Neoclassical sculptor was the Italian Antonio Canova (1757–1822). The calmness and cool eroticism of his highly polished marble carvings were perhaps the ultimate expression of eighteenth century classicism (**26.14**). Canova became so famous in his lifetime that he and his assistants were kept busy making copies of his most popular works for distribution all over the world. Some of these may be found in Australian cities.

The most notable sculptors of the nineteenth century were the Italian

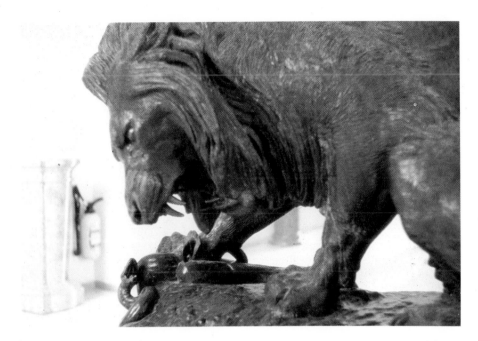

26.15 Antoine Louis Barye (1796–1875), *Lion and Snake* (detail). Bronze. Height about 130 cm. A good example of Romantic artists' interest in the drama and tragedy of nature. Louvre, Paris

Medardo Rosso (1858–1928) and the Frenchman Auguste Rodin (1840–1917), both of whom aimed to render a beautiful and sensuous surface, as their contemporaries, the Impressionist painters, did. Rodin used the human body in much the same way Michelangelo did (see **26.19**). He called it 'a temple that moves'. A copy of Rodin's great full-length bronze of the writer Balzac — a wonderful expression of proud individuality — is in the National Gallery of Victoria. It is possible to speak of 'a copy' of a Rodin bronze in this way because, from the nineteenth century, popular sculptors often made a number of casts of their bronze works from the clay original. This, of course, added to their incomes — an important factor because, by this time, artists had to sell their works to survive, in contrast to artists like Michelangelo who were employed by wealthy patrons on commissioned works for most of their lives. In the nineteenth century, too, sculptors like Canova and Rodin employed artisans to make copies of their sculptures in marble, which was a more popular material then than it is now. This is the reason it is possible to find copies of Rodin's famous *The Kiss*, for example, in both marble and bronze and in a whole range of sizes, in museums and galleries all over the world.

The twentieth century

The same ideas which influenced the Post-Impressionist painters also influenced the sculptors of the early twentieth-century, the two main early schools being Expressionist and Abstract. Although the attitudes of the two groups differed, much as the attitudes of their painter counterparts differed (see page 145), they held one important belief in common — that they should respect the integrity of the materials used, and this was the attitude expressed by Maurice Denis (page 145). To sculptors this meant that a bronze sculpture should have the look and 'feeling' of bronze (**26.20**) and a carving should have the look and 'feeling' of the stone or wood from which it was made (**26.24**) — even if it meant making certain changes in the form. This respect for the materials from which sculpture is made led to non-representational sculpture, such as that of the Constructivists (see below).

There is a great deal of expressionism in the works of Rodin (**26.19**), and this tradition was followed by the American-born Sir Jacob Epstein

26.16 (above) Auguste Rodin. Bust, 1904, of one of his favourite models, Mariana Antoinetta Matiocco, an Italian and wife of the Australian painter, John Peter Russell (see **27.34**), to symbolise his country, *France*. Bronze. Life size, Musée Rodin, Paris.

26.17 (centre) Rodin, *Girl with Flowered Hat*. Terracotta. Life size. In the period 1865–70 Rodin made a number of busts of fashionable young ladies to provide an income, but they are fine works nevertheless. From having to struggle for recognition at the beginning Rodin became so famous by the time of his death that church services were held in both England and Germany (who were at war). Musée Rodin, Paris

26.18 (top right) Pierre Auguste Renoir, *Mme Renoir*, 1916. Coloured plaster. Life size. The Impressionist painters Renoir and Degas often made sculptures. In his last years, Renoir was crippled with arthritis and Richard Guino helped him execute his sculptures. Renoir often painted his sculpture in life-like colours — something which sculptors had not done since the Middle Ages, Louvre, Paris

26.19 (right) Rodin, *The Thinker*, 1880–1904. Bronze. This, the most famous of Rodin's sculptures, formed the apex of the bronze doors he made for an art museum which was never built (known as *The Gates of Hell*), but is often regarded as a separate work. As can be seen, Rodin preferred Michelangelo's *Slave* (**26.9**) to Canova (**26.14**), and he also admired Ghiberti's *Gates of Paradise* (**26.1**). There are many copies of *The Thinker*. This one is in the Cleveland Museum of Art.

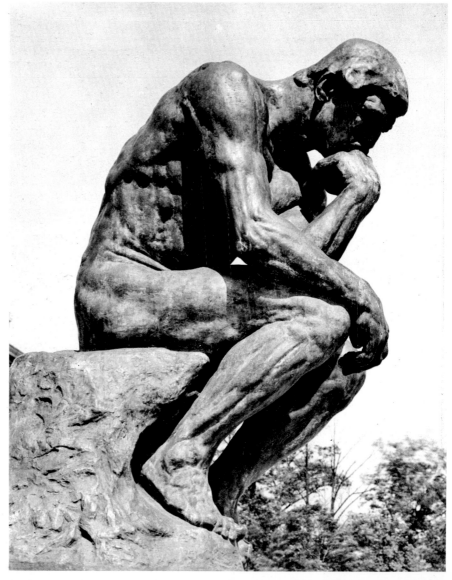

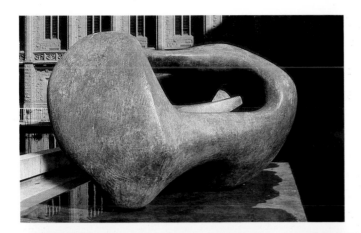

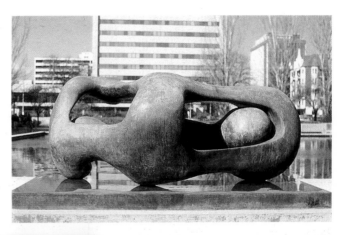

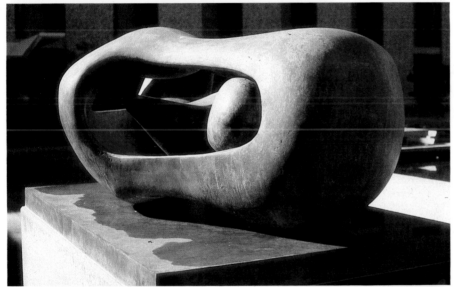

26.20 Henry Moore, *Reclining Connected Forms*, 1964. Bronze. Length about 220 cm. Modern sculptors, like Moore, believe a sculpture should be satisfactory from any point of view. Three views are shown here. University of Adelaide, Benham Bequest.

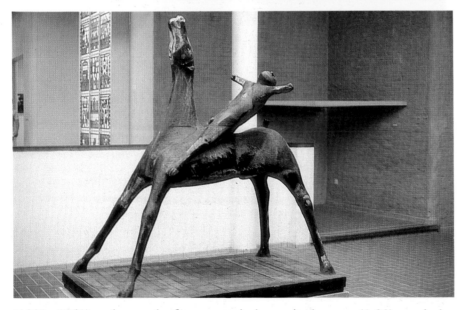

26.21 (left) Marino Marini, *Rider and Horse*, 1951–2. Polychromed wood (laminated pieces). Height 205 cm. Kröller-Müller Museum, The Netherlands

26.22 (above) Giacomo Manzu, *Death in the Air* — one panel from the bronze *Doors of Death* which he made for St Peter's Cathedral, Rome, in 1949–64. The *Doors of Death* — one of three sets of doors to the cathedral — are only opened for funeral services.

(1880–1959), who made fine portrait busts in bronze (**1.32**), and the huge bronze *St Michael* on the facade of Coventry Cathedral, as well as large stone carvings (e.g. *Adam* and the memorial to Oscar Wilde), which shocked the British public by their primitivism. Other Expressionist sculptors include the Yugoslavian Ivan Meštrović (1883–1962),

26.23 (left) Alberto Giacometti, *Standing Woman*. Bronze. About 270 cm high. Fondation Maeght, South of France. Giacometti's art went through Cubist and Surrealist periods, but he eventually developed a style in which he tried to define the relationship of the human figure with space.

26.24 (right) The style of Ossip Zadkine (1890–1967), a Russian-born sculptor of the School of Paris, illustrates the freedom modern sculptors allow themselves. He often hollowed out forms which should be raised and used incised lines to suggest forms rather than modelling them in the round. This is a detail of the marble *Torso Clementus*, 1941, in the Kröller-Müller Museum, The Netherlands, but his most famous work is *The Destroyed City*, erected on the waterfront of Rotterdam and commemorating the city's destruction in the Second World War.

the German woodcarver Ernst Barlach (1870–1938), the Italians Marino Marini (1901–80; **26.21**), Giacomo Manzù (b. 1908; **26.22**) and Alberto Giacometti (1901–66; **26.23**), and the Englishwoman Elizabeth Frink (b. 1930).

The French sculptor Aristide Maillol (1861–1944) was part of the modern movement in painting until he was nearly 40. He used the female nude to symbolise nature (see **1.1**) and human emotions, much as Michelangelo and Rodin had done, but his style is calm and classical in comparison.

The chief Abstract sculptors are Henry Moore, OM (b. 1898), an Englishman whose semi-abstract figures (**26.20**) are made to look like the 'natural' sculpture of driftwood and pebbles; Dame Barbara Hepworth (1903–75), an Englishwoman (**26.34**); Constantin Brancusi (1876–1957), a Rumanian who reduced his subjects to their ultimate formal elements (**26.32**); Cubists Alexander Archipenko (1887–1964), a Russian, and Jacques Lipchitz (1891–1973; **26.27, 26.28**) who was born a Lithuanian Russian but lived most of his life in Paris; and Alexander Calder (1898–1976), an American who invented *mobiles* — sculptures in which the parts are hinged together in such a way that they make a pleasing composition no matter how they are arranged (**26.29; 26.30; 27.21**). This was a significant innovation as it introduced the fourth dimension (time) into an art which had only used the other three dimensions up to then and, also, the effects of chance (sometimes called *serendipity*).

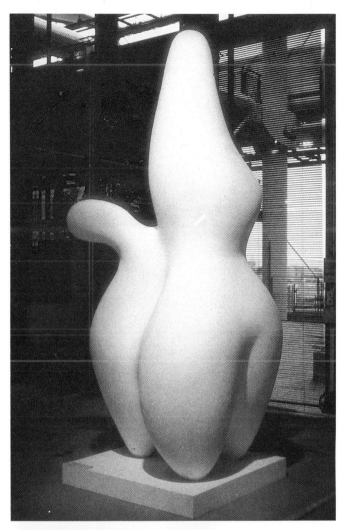

26.25 (top left) Jean Arp (1887–1966), *Shepherd of the Clouds*, 1953. Plaster. About 300 cm high. Arp's works are always enigmatic and somewhat amusing, which is typical of Dadaism and Surrealism. Centre Pompidou, Paris

26.26 (top right) Joan Miró, gargoyle in the Fondation Maeght, South of France. Ceramic, 1908. A Surrealist painter and sculptor, Miró creates odd and intriguing personnages (see also **24.46**).

26.27 (bottom left) Jacques Lipchitz, *Man with Guitar*, 1920. Marble. Height 140 cm. Cubist sculpture. Kröller-Müller Museum, The Netherlands: Jacques and Yulla Lipchitz Foundation

26.28 (bottom right) Jacques Lipchitz, *Gertrude Stein*, 1920–21. Plaster. Life size. An excellent portrait of the American writer, who was a patron of the Cubists. Taken with **26.27** it answers once and for all the question whether the Cubists had enough ability to work realistically. See also **4.17**. Kröller-Müller Museum, The Netherlands: Jacques and Yulla Lipchitz Foundation

26.29 (top left) Alexander Calder, *Nude*, c. 1926–30. Wire. About 78 cm high. Centre Pompidou, Paris. Calder said he thought best in wire and, certainly, the series of wire nudes and portraits he made early in his career are striking and remarkably original. They are like three-dimensional line drawings.

26.30 (top right) Alexander Calder, *Mobile*, c. 1960. Wire and metal. About 200 cm wide. Art Museum, Gothenburg

26.31 (left) Amedeo Modigliani (1884–1920), *Head of Woman*, 1912, Stone. About 60 cm high. Centre Pompidou, Paris. Both painter and sculptor, Modigliani was influenced by Cubism and the belief that a stone carving should have the 'feeling' of stone, as can be seen.

26.32 (right) Constantin Brancusi, *The Cock*, 1935. Brass, polished, on stone and wooden bases, which are actually part of the work. Figure of the cock about 100 cm high. Centre Pompidou, Paris. © ADAGP, Paris 1982

The Constructivists, as their name suggests, build up their sculptures rather than carving or modelling them. The materials they use are strips and pieces of wood, metal and plastic, and threads of wire and string. Constructivism has its roots in the works of post-revolutionary Russians like Vladimir Tatlin (1885–1953) of about 1920, and spread to the centres of western Europe between the world wars. The chief Constructivist sculptors are Calder, the Russian brothers Naum Gabo (1890–1977) and Anton Pevsner (1886–1962) and, more recently, the British Phillip King (b. 1934) and his teacher Anthony Caro (b. 1924), who weld pieces of structural steel into rangy forms which they paint in bright colours (**26.35**). The Greek Takis (b. 1930) and the Swiss-French Jean Tinguely

(b. 1925) continue Calder's interest in moving sculpture by harnessing their constructions to motors or electro-magnets so that they move continually while the power is switched on. Takis has used flashing signal-lights in an interesting and beautiful way, and Tinguely's 'machines' are often designed to self-destruct (*Homage to New York*, 1960).

Notable Australian Constructivists are Clement Meadmore (**27.57**), Inge King (**27.62**), Kenneth Unsworth (**27.64**) and Herbert Flugelman (**27.63**).

Frenchwoman Niki de Saint-Phalle (b. 1930), with her husband Jean Tinguely, represents the radical movements of the 1960s and 1970s which, reviving the principles of Dadaism (sometimes called *Neodada*), rejected all the 'sacred' aesthetic values of the past and delighted in 'shocking the middle classes'. One of their most notorious pieces was *Hon* (1966), a female nude, in the style and medium of **26.33** and the size of a room, which contained a milk-bar in one breast and was entered through the vulva!

Things to do

1 Find out more about the artists mentioned in this section.
2 Make a piece of sculpture in a style similar to that of one of the artists whose work you admire.
3 Make a time-chart, similar to that on page 144, of the sculptors listed in this section.
4 Make a mobile.
5 Collect six pieces of material of different sorts from which it would be possible to make a constructivist sculpture.
6 Find the meanings of the following sculpture terms:
claw
cire perdue (French for 'lost wax')
core
pointing
maquette
7 Visit a local park or garden where there are sculptures and try to identify the styles of the works there, or try to identify the artists mentioned in this section who may have influenced the sculptors of those works.

26.33 (top left) Niki de Saint-Phalle, *White Head*, 1970. Painted polyester resin. 230 × 223 × 97 cm. Stedelijkmuseum, Amsterdam

26.34 (top right) Dame Barbara Hepworth, *Ultimate Form*, 1973. Bronze. Height about 300 cm. Adelaide Festival Centre Plaza

26.35 (above) Phillip King, *Yellow Between*, 1971. Welded and painted steel. About 200 cm high. Adelaide Festival Centre Plaza. A companion piece to this work, *Blue Between*, is in the Sydney Opera House.

27 Art in Australia

27.1 John Lee Archer, Van Diemen's Land Company Store, Stanley, Tasmania, 1844. Although now neglected, this building by one of the first professional architects to work in Australia, shows the restraint and symmetry of Georgian (Neoclassical) building.

Australian Aboriginal art has been covered in section 4. In this section we now study architecture, painting and sculpture made in Australia by people whose traditions are European.

Not unexpectedly in a country colonised from Europe, the arts in Australia follow closely European trends in style. The first Australian artists were born and trained in Europe and when, in later generations, artists were born here they travelled to Europe to study. Although little Australian art can be truly called great by international standards, there has been much that we can call 'good'.

Three periods can be distinguished: Colonial (usually considered to extend from the first colonisation to 1880), Middle, and Contemporary (since the Second World War).

Architecture

The first buildings were not designed by architects. Master builders, well versed by experience in the canons of Georgian, the style current in Britain at the time (see **25.1, 25.4**), produced some masterpieces. Many of them still stand in the first large settlements (Sydney and Hobart) and early country centres (Parramatta, Windsor and Camden in New South Wales and Richmond in Tasmania).

The Georgian style actually lasted longer in Australia than it did in England. Some famous Georgian houses in Australia are Government House Parramatta (NSW); *Como*, South Yarra (Melbourne); *'Panshanger'*, Longford (Tasmania); *'Franklin House'* and *'Entally'*, both near Launceston (Tasmania); and *'Narryna'*, Hobart. In Tasmania, where the climate is fairly similar to that of England, the Georgian style was often used with little change; however, in New South Wales, especially in country houses, verandahs were often added against the heat of the sun. One of the first such was the Experimental Farm Cottage built at Parramatta in 1794 for John Macarthur (**27.14**).

By the first decades of the nineteenth century trained architects began to arrive in the colony and more pretentious buildings in Neoclassical and Italian Renaissance styles began to appear. Notable among these are the Customs House, Melbourne (by Robert Russell); Parliament House, Hobart, Ross Bridge and St George's, Battery Point (**1.6, 27.6** — all in Tasmania and by John Lee Archer); Lansdowne Bridge, near Liverpool, New South Wales (by David Lennox); and the Court House and St Matthew's, Windsor, New South Wales and St James' Sydney (**27.7**) (by Francis Greenway). Greenway's contribution to Australian culture has been commemorated by his portrait on the $10 banknote.

With the nineteenth century, too, came the revival of historical styles that Europe was experiencing (see **22.19, 22.20**), and this in its turn also lasted longer in Australia than in Europe (**27.4, 27.11**). Revivalism is especially evident in the large number of Gothic-style churches built throughout Australia. Gothic was considered in the nineteenth century singularly appropriate for churches as its soaring spires seemed to express the spirit of Christianity, and it is the style of most of the great cathedrals of northern Europe, the spiritual home of the first white Australians. Notable examples of Gothic-style churches are Mortimer William Lewis's St John's, Camden (NSW), and John Lee Archer's St John's, New Town (Hobart). Gothic-style churches were built until the Second World War, by which time twentieth century styles were beginning to be used.

But Greek and Romanesque styles were also revived at this time. St George's Anglican church, St John's Presbyterian church and Lady Franklin Museum, all in Hobart, are examples of the Greek style. James Blackburn's Tasmanian churches, St Mark's (Pontville), and Congregational Church (New Town), and John Watts' St John's (Parramatta) (**27.9**), are examples of the Romanesque.

27.2 (left) Salamanca Place, Hobart. Warehouses designed and built in the 1840s by persons unknown. Georgian.

27.3 (right) Georgian house, Battery Point, Hobart. One example of many such houses built in this period-style in New South Wales and Tasmania.

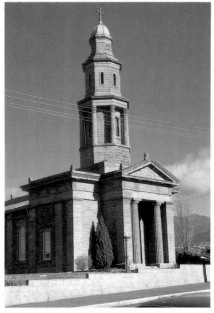

27.4 (left) E.W. Wright and Lloyd Taylor, Parliament House, Adelaide. An Italian Renaissance palace in the Antipodes. Commenced 1883 but not completed until 1939.

27.5 (right) E.W. Wright and Lloyd Taylor, Edmund Wright House, Adelaide, 1875–78. Another Italianate palace in Australia — although built as a bank. However, this building was considered beautiful enough for the South Australian Government to preserve it for the future. It has been renamed after its chief designer.

27.6 (bottom left) St George's, Battery Point, Hobart. A Greek portico with Doric columns — classical revivalism in colonial Tasmania. John Lee Archer began this building in 1834 and James Blackburn added the tower in 1840. The tower, over the crossing of the very small transept, is set like the one on St Martin's-in-the-Fields (**22.14**) — very English.

An interesting sidelight of early Australian architecture is the use of *prefabrication*. The nineteenth century was a period of technological ingenuity, and designers such as Eiffel (**25.5**) and Paxton (see page 168) prefabricated iron components of their buildings. The principle was soon adapted to housing and some entirely prefabricated houses arrived in Australia. The Victorian Governor La Trobe's first residence was partly prefabricated in wood (it has been removed from its original site and is now on the Domain, near the present Government House). Corio Villa, Geelong, was entirely prefabricated from iron (**27.8**).

The discovery of gold in 1851 and the Industrial Revolution increased the wealth of traders and industralists, some of whom built huge mansions, especially in Melbourne and Sydney. Many are now considered ostentatious and over-decorated, with ornate stuccoed facades and gables, towers and turrets (**27.12**). In this *Victorian Period* mass-produced cast-iron verandah trimming (now called 'iron lace', see **27.13**) was introduced, much of it beautiful and still to be seen today.

With the beginning of the twentieth century, a number of styles were briefly tried. The Art Nouveau influence was felt, and the tiled-roofed, white roughcast-walled Mediterranean style of domestic architecture, which was quite well suited to the climate of the warmer states, was introduced.

Queensland and the Northern Territory developed a distinctive style suited to their warmer climatic conditions. Here the house, built on piles to allow maximum circulation of air and to control termite damage, was protected on at least three sides by a deep verandah, often with slatted shutters (**27.15, 27.16**).

In the late 1920s the confusion of styles began to be resolved when men such as Desbrowe Annear and Walter Burley Griffin, who had been influenced by the new movements in Europe and America, began practising here. Functional design with the use of glass, steel and ferroconcrete was gradually accepted, after initial scepticism by both the public and builders.

Griffin (1876–1937), a pupil and associate of Frank Lloyd Wright in America, won an international competition for the design of the projected new federal capital of Australia, Canberra (**27.17**), and arrived here in 1913. He left Australia for India in 1932, having also planned the Sydney suburb of Castlecraig and the Murrumbidgee towns Leeton and Griffith (**27.17**). He also designed a number of fine homes in Castlecraig (**27.19**) and Toorak (Melbourne), and Newman College (University of Melbourne). Griffin's wife, Marion Mahony, was also an associate of

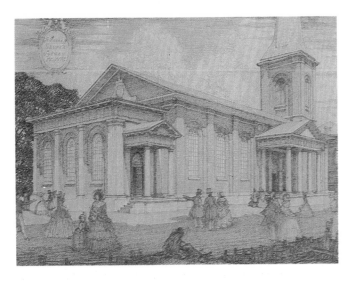

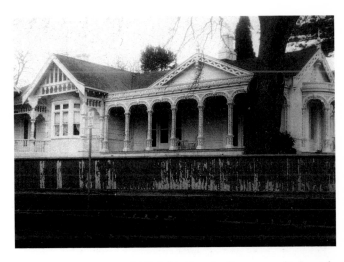

27.7 (left) Francis Greenway, St James', Sydney, 1820–24. A church which could have been built in London a hundred years before (see **22.14**). Greenway's portrait is on the $10 banknote. This drawing was done in 1914 by architect W. Hardy Wilson. Photograph: National Library of Australia

27.8 (right) Corio Villa, Geelong. This remarkable early prefabricated building is made entirely of iron — the walls of half-inch boiler-plate, the windows, columns, guttering and decorations of cast-iron; and the roof of corrugated iron. It was shipped out in pieces from Glasgow and erected in 1856.

Wright and collaborated with her husband on many projects. Although Griffin and Mahony worked in Wright's office in Chicago before coming to Australia it would be less than fair to say they were totally in Wright's shadow. There seems to have been a thorough three-way process of influence.

Among the notable buildings of the post-Second World War period are the following:

Australia Square (Sydney – **27.21**) and several Sydney houses by Harry Seidler, OBE (a pupil of Gropius and associate of Nervi);

Victorian houses by Grounds, Romberg and Boyd, their fine copper-sheathed dome of the Australian Academy of Science, Canberra (**27.22**), and the Melbourne National Art Gallery and Cultural Centre (**27.27**);

the imaginative Sidney Myer Music Bowl, Melbourne, by Yuncken, Freeman Brothers, Griffiths and Simpson;

the ingenious Melbourne Olypic Swimming Pool by Borland, Murphy and McIntyre;

the glass curtain-walled AMP Building in Sydney by Peddle, Thorp and Walker;

ICI House in Melbourne by Bates, Smart and McCutcheon;

the Adelaide Festival Centre, by Hassell and Partners;

the High Court and National Gallery, Canberra, by Edwards, Madigan, Torxillo and Briggs (**27.25**); and

Parliament House, Canberra, by Mitchell, Giurgola and Thorp (**27.26**).

Danish architect, Jörn Utzon (b. 1918) won an international competition for the best design for the projected Sydney Opera House in 1956, and building commenced on a magnificent site overlooking the harbour (**27.23, 27.24**) in 1959.

Painting

All the Colonial Period painters were trained in Europe and, as many of them were amateurs who did not have sufficient ability to vary the canons and techniques they had been taught, they found difficulty in capturing in paint the true character of the Australian Aborigines or the colour and effect of the gum trees. However, John Glover (1767–1849; **27.29**), Conrad Martens (1801–78), John Skinner Prout (1806–76) and F.G. Simpkinson de Wesselow (1819–1906) were all able, at times, to

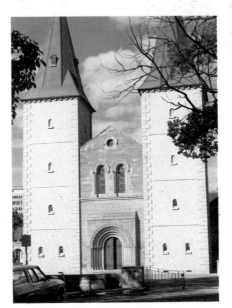

27.9 St John's, Parramatta, NSW. This church (of which Rev. Samuel Marsden was rector for 40 years) was commenced by Australia's first real architect, James Bloodsworth, but it has been extensively altered. However, the towers, built by John Watts in 1813, are original. Romanesque Revivalism (cf. **17.9, 17.15**).

27.10 (top left) James Barnet, Police Station, George Street North, Sydney, 1882. An Italianate gem surviving in 'The Rocks'.

27.11 (top right) Bonython Hall, University of Adelaide. Tudor Gothic — built 1933. An example of how Revivalism continued in Australia nearly fifty years after Eiffel built his tower (**25.5**) and while the Bauhaus (see page 171) had come and gone in Germany. One of the last revivalist buildings built anywhere in the world.

27.12 (right) 'Carclew', North Adelaide. 1897. Victorian-period villa — the combination of a number of motifs (chimneys, towers, brick and stone, and railings) gives a cluttered appearance — but it has charm, and the South Australian Government purchased it to preserve it for the future.

27.13 (bottom) Victorian-period villa, Geelong. The typically profuse decoration of the period has, in this house, been put together with delicacy and grace. The verandah posts and 'lace' — and the fence — are of cast iron. Much of this was made in England but it was transported cheaply in near-empty ships which came to Australia to take wheat to Europe.

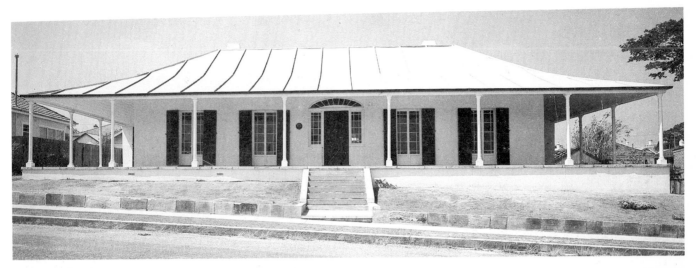

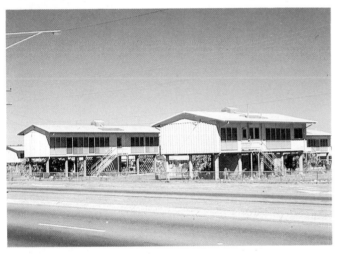

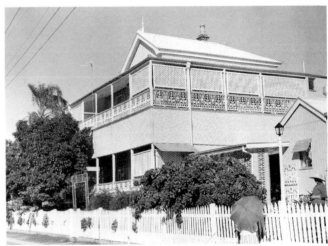

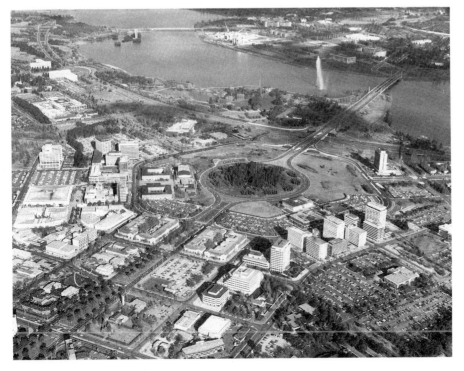

27.14 (top) Experimental Farm Cottage, Parramatta, built in 1794 for John Macarthur. To a simple, symmetrical Georgian building like **27.3** a verandah has been added. National Trust photograph

27.15 (centre left) Typical 1960s houses in Darwin — built on stilts to permit circulation of air for cooling and drying out after rain and to provide areas of shade, and with solar water-heaters on the roof. Unfortunately, such houses were not built to withstand very strong winds, and many of them were destroyed by Cyclone Tracy on Christmas Day, 1974.

27.16 (centre right) Typical Queensland adaptation of the English house, built before home air-conditioning was developed. Plenty of large windows opening on to shady verandahs, to which sun-screens have been added. Often such houses were built on piles. Late nineteenth century

27.17 Aerial view of Canberra city with Lake Burley Griffin in the background. Designed by Walter Burley Griffin, 1912. Photo: Australian Information Service

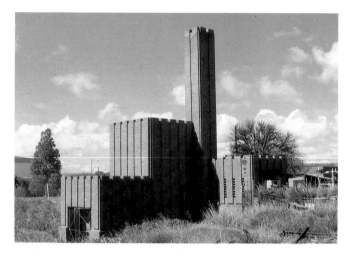

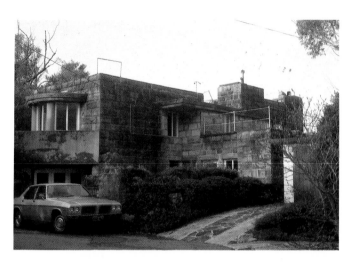

27.18 (top left) Walter Burley Griffin, Incinerator, Hindmarsh, Adelaide. 1935. He designed a number of incinerators in various parts of Australia, and this is indicative of twentieth-century architects' concern for providing functional solutions for civic problems.

27.19 (top right) Griffin, House at Castlecrag, Sydney. 1929. Griffin followed Frank Lloyd Wright in believing that buildings should appear to grow out of their setting, and he applied this principle in the suburb of Castlecrag, which he designed. One of the first 'modern' houses to be built in Australia, its asymmetrical lines resemble those of **25.15** rather than **27.3**.

27.20 (centre) E.B. Fitzgerald and J.R. Brogan, Adelaide High School, designed in 1940, but built after the 1939–45 war. A curved facade, with cubical and cylindrical forms, and the many windows and doorways forming the main 'decoration' are all typical of the style which originated with Gropius and the Bauhaus (see page 171).

27.21 (bottom) Harry Seidler, Australia Square, Sydney. 1960s. The buildings which this tower replaced completely covered the block. Seidler used the structural strength of reinforced concrete to make a tall tower for office accommodation while creating a space in which people can move freely. The 40 ft high steel sculpture is *Crossed Blades* (1967), by the American Alexander Calder (see page 182 and 184).

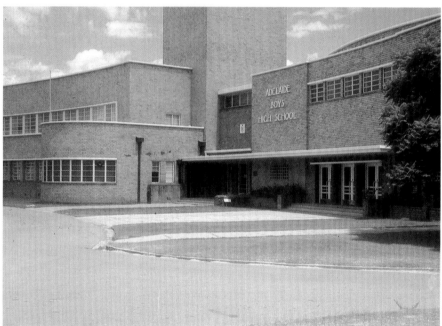

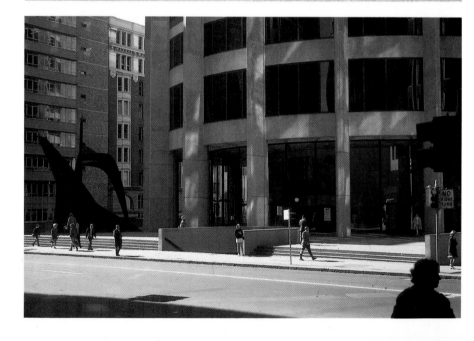

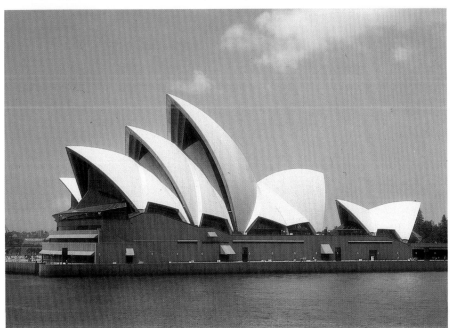

27.22 (top left) Grounds, Romberg and Boyd, Australian Academy of Science, Canberra, 1959. Designed to fit one of the semicircular plots created by Griffin's plan of Canberra, this copper-sheathed concrete dome echoes the shape and colour of the Canberra hills while providing quiet and shady offices and meeting-rooms.

27.23 (top right) Jörn Utzon, Sydney Opera House — one of the shells during construction in 1969, showing how they are supported on ferro-concrete ribs made of sections precast and laid like huge bricks. The engineers had a difficult task working all this out. See also **1.24**.

27.24 (centre) Jörn Utzon, Sydney Opera House. 1959–74. That this building contains a number of concert halls, a restaurant, dressing rooms, etc. is disguised by the complex superstructure of shells, which the designer considered appropriate for a harbour setting which often features sailing boats. This romantic approach, more like that of the Gothic architects than that of the designer of **27.21**, had a world-wide vogue in the 1960s.

27.25 (bottom) The High Court of Australia, Canberra. 1973–80. The designer of this building for Edwards, Madigan, Torzillo and Briggs, Christopher Kringas, died before construction commenced. The waterfall fountain, by Robert Woodward, is a graceful introduction to the appropriately formal building.

27.26 Mitchell-Giurgola-Thorp, Parliament House, Canberra. Commenced 1981. Model, showing how the building is designed to complement the shape of Capital Hill, on which it is being built, and the plan of Walter Burley Griffin (see **27.17**).

27.27 (centre right) Grounds, Romberg and Boyd, National Gallery and Cultural Centre of Victoria, commenced 1960. The rectangular gallery building — functionally designed for the exhibition of works of art — was opened in 1967, but the cultural centre was not completed until 1982.

27.28 (bottom left) Thomas Griffiths Wainewright, *Rev. Dr Bedford*, mid nineteenth century. Crayon and sepia wash on paper. An excellent character study, which could have been painted in Europe. Tasmanian Museum and Art Gallery, Hobart: bequest of Miss Ruth Bedford

27.29 (bottom right) John Glover, *A View of the Artist's House and Garden, Mills Plains, Tasmania*, *c.* 1834. Oil on canvas. Glover, an artist in England before he migrated, was one of the first painters to tackle successfully the Australian light and landscape. His garden of English flowers seems incongruous in the midst of the Australian bush, just as the first settlers themselves did. The heat of the midday summer sun is convincing. The Art Gallery of South Australia: Morgan Thomas Bequest

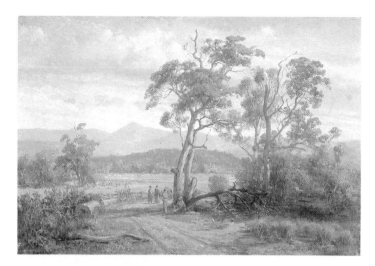

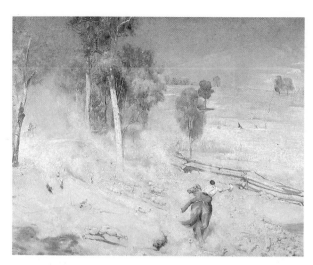

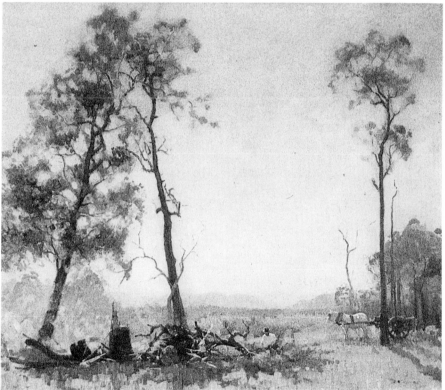

27.30 (top left) Louis Buvelot, *Lilydale*, 1878. Oil on canvas. A fine representation of an Australian landscape which shows Buvelot's debt to the Barbizon School (see **23.13**). Bendigo Art Gallery

27.31 (top right) Tom Roberts, *The Breakaway, c.* 1890. Oil on canvas. 137 × 168 cm. In style and technique influenced by French Impressionism, but of a typically Australian subject — thirsty sheep stampeding to a water-hole. The Art Gallery of South Australia: Elder Bequest

27.32 (left) Elioth Gruner, *Morning in the Clearing*, 1920. Oil on canvas. A beautiful scene, convincingly represented and showing the influence of Impressionism. Ballarat Fine Art Gallery

capture the light of our skies, the darkness of eucalypt foliage and the bleak, primeval quality of our mountain crags and gorges. All were trained to paint in the neoclassical tradition and many of their works can be judged on their aesthetic merits apart from historical interest.

Thomas Griffiths Wainewright (1794–1847; **27.28**), who was transported to Tasmania as a convict, was a good portraitist who had had contact with the circle of neoclassical and romantic artists in England, and had exhibited in the Royal Academy. Other painters influenced by European romanticism include Eugen von Guerard (1811–1901), Benjamin Duterreau (1767–1851), William Piguenit (1836–1914), S.T. Gill (1818–80), and W.B. Gould (1804–53).

In the Middle Period, Australia was emerging as a nation with its own individual character, culminating in the development of the Anzac tradition in the First World War. Many artists were born in the colony or migrated here as children and knew the landscape more intimately than

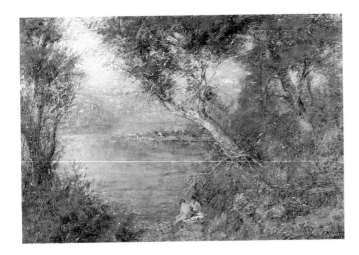

27.33 (top left) Frederick McCubbin, *Golden Sunlight*, 1914. Oil on canvas. In this later picture, McCubbin's use of broken colour and interest in light for its own sake, take him closer to French Impressionism than his better-known pictures did. Castlemaine Art Gallery and Historical Museum

27.34 (top right) John Peter Russell, *Mrs Russell in the Garden at Belle-Île*, 1907. Oil on canvas. One of only two paintings by Australians in the Museum of Modern Art, Paris (the other is by Emanuel Phillips Fox), it indicates Russell's connection to French, rather than Australian, art — Pointillism hardly touched Australia. A French garden painted by an Australian (cf. **27.29** and see **26.6**)

27.35 (left) Norman Lindsay, *Benediction*, 1938. Oil on canvas. Norman Lindsay's art is a celebration of the freedom of the human spirit, yet he expressed this through realistic representations of the nude, rather than through the means of his European contemporaries (the Fauves and Expressionists), whose work he abhorred. Ballarat Fine Art Gallery

27.36 (right) Sydney Long, *Fantasy*, c. 1916. Oil on canvas. The theme of this painting, too, is the freedom of the human spirit, with Pan playing for the dance. Reminiscent of the work of Munch (**24.42**), yet stylisticly Art Nouveau. The Art Gallery of New South Wales: Florence Turner Blake Bequest Fund

their predecessors had. Travelling to Europe for study, they discovered Impressionism, which they very ably adapted to Australian light conditions.

On the other hand, two Europeans influenced by the Barbizon tradition (see **23.13**) migrated to Australia and influenced the artists of the Middle Period here. They were the Swiss Louis Buvelot (1814–88; **27.30**), who settled in Melbourne, and the Italian Girolamo Nerli (1863–1926), who worked in Sydney.

Unlike the European Impressionists, the Australian 'Impressionists' were more interested in painting typical local subject-matter than in capturing the effects of light as such. The best known Australian 'Impressionists' are the artists of the *Heidelberg School*: Tom Roberts (1856–1931) who painted *Bailed Up* (Art Gallery of New South Wales, *The Breakaway* (**27.31**; Art Gallery of South Australia), and many other famous pictures in oils; Charles Conder (1868–1909), painter of *The Departure of SS Orient* (National Gallery of Victoria); Sir Arthur Streeton (1867–1943), painter of landscapes such as *The Purple Noon's Transparent Might* (National Gallery of Victoria); and Frederick McCubbin (1855–1917; **27.33**), who painted the bush in a romantic, literary vein.

The time-lag between the development of styles in Europe and their adoption in Australia which was evident in our study of architecture also occurred in painting. Streeton was about the same age as Matisse and he

was in Europe from 1900 to 1914 when Matisse, Picasso and Braque were developing a new art which rejected most of what Impressionism stood for. But Charles Conder, when he returned to Europe in 1890, associated with artists such as Toulouse-Lautrec (**25.12**) and Beardsley.

Rupert Bunny (1864–1947) and Sydney Long (1878–1955) were influenced by Symbolism and Art Nouveau; and Norman Lindsay's (1879–1969) versatile range of drawings, cartoons, prints and paintings, with influences from a wide range of European art, frequently shocked the public with their satire and an eroticism half a century ahead of its time (**27.35**).

Other painters of the period were David Davies (1862–1939), Emanuel Phillips Fox (1864–1915; see **27.34**), Elioth Gruner (1882–1939; **27.32**), G.W. Lambert ARA (1873–1930), and Hugh Ramsay (1877–1906).

27.37 (top left) Margaret Preston, *Grey Day in the Ranges*, 1942. Synthetic enamel on board. 92 × 122 cm. One of first Australians to understand modern European art, in this period Margaret Preston was influenced by Aboriginal bark painting. The Art Gallery of New South Wales

27.38 (top right) Ralph Balson, *Abstraction*, 1951. Oil on board, 92 × 107 cm. One of the first Australians to paint non-representational pictures. The Art Gallery of New South Wales: gift of Mr W. Balson, 1965

27.39 (lower left) Sir Russell Drysdale, *A Football Game*, 1947. Oil on canvas. The loneliness and isolation — as well as the colours and forms — of the outback expressed in a style influenced by both Cubism and Surrealism. Ballarat Fine Art Gallery

27.40 (lower right) Leonard French, Stained-glass windows in the National Library, Canberra.

27.41 (top left) Sir William Dobell, *The Billy Boy*, 1943. Oil on board. One of a series of penetrating portraits of construction workers painted during the Second World War. Australian War Memorial, Canberra

27.42 (top right) Noel Counihan, *The Good Life*, 1969. Drypoint. A Socialist Realist, Counihan here is expressing his disgust at the hedonism of life in Australia while soldiers die in the Vietnam war. The black sun and dark glasses symbolise moral blindness. Private collection

27.43 Danila Vassilieff, *Labourer*. Gouache on paper on board. This Russian-born painter and sculptor used a Fauvist technique to represent human emotions. Ballarat Fine Art Gallery

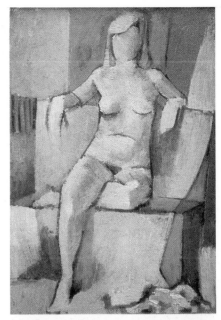

German-born Sir Han Heysen (1877–1968), Sir Ivor Hele (b. 1912), Max Meldrum (1875–1955), and Sir William Dargie (b. 1912), who won the Archibald Prize for portraiture the record number of eight times, are accomplished painters who continued the Australian 'Impressionist' tradition long after it ceased to be novel.

In the Contemporary Period, the pattern of Australian-born artists visiting Europe for study and experience was repeated but, in this century, the artistic climate in Europe has been Post-Impressionist, Expressionist or Abstract. During the Second World War and in the immediate post-war period Sydney painters seemed mostly to choose abstract styles, whereas those in Melbourne chose expressionism.

27.44 (top left) Charles Blackman, *Girl Dreaming*, 1953. Oil on board. A typical Blackman painting of the spiritual experiences of childhood. The Art Gallery of New South Wales.

27.45 (top right) Eric Smith, *Seated Nude*. Oil on cardboard. Acquired 1966. A study of the nude heavily influenced by Analytical Cubism (**24.25**). City of Mildura Arts Centre

27.46 (lower left) Donald Friend, *Three Negroes*, 1953. Watercolour and inks on paper. Like Gauguin, Friend renounced the materialism of Western civilisation and lived in places like Bali. His art expresses his love of natural and exotic things. Ballarat Fine Art Gallery.

27.47 (lower right) Jeffrey Smart, *The Dome*, late 1970s. Colour aquatint. Smart juxtaposes common objects incongruously — like the Surrealists. Private collection

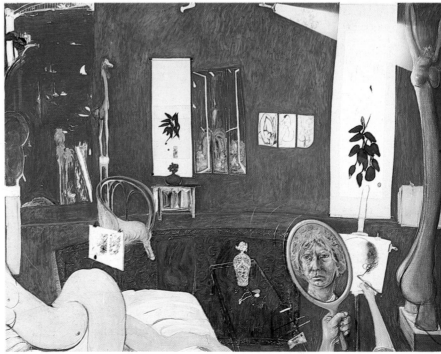

27.48 (far top left) Fred Williams, *Trees on Hillside II*, 1964. Oil and tempera on board. 91.5 × 122 cm. Williams' highly individual style of dabs and short strokes of paint expresses the character of the Australian landscape more truly than earlier, more photographic paintings did. The Art Gallery of New South Wales

27.49 (far bottom left) Sir Sidney Nolan, *Rainforest, Queensland*, 1957. PVA on hardboard. Nolan manipulates this medium expressively — using brushes, spatulas and fingers — as no other artist does. National Gallery of Victoria

27.50 (far bottom right) Brett Whiteley, *Self-Portrait in the Studio*, 1976. Oil and collage on canvas. This highly original picture was awarded the Archibald Prize for portraiture in 1977. The Art Gallery of New South Wales

27.51 (top left) Jon Molvig, *Ballad of the Dead Stockman, No. 2*, 1959. Oil on canvas. Expressionist art applied to an Australian theme. The Art Gallery of New South Wales

27.52 (left) Dr Lloyd Rees, *Three Boats, Lane Cove River*, 1978. Oil on canvas. A prolific painter of the Australian scene, Rees' style has become freer and more expressive with the years. The Art Gallery of New South Wales: Florence Turner Blake Bequest

27.53 (bottom left) Lyndon Dadswell, decorative relief panels on the R.G. Menzies Building, Australian National University Library, Canberra. 1964. A non-representational work fabricated from copper sheet, the colour and texture of which suit the building. 175 cm high.

27.54 (bottom right) Gerald Lewers, *Relaxation*, 1953. Carved sandstone. A human figure, simplified and adapted to suit stone form. University House, Australian National University, Canberra

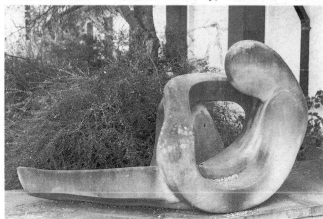

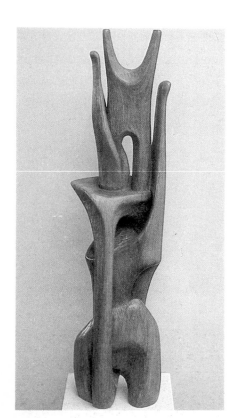

27.55 (top left) Clifford Last, *Tower of Aspiration*, 1966. Carved out of Tasmanian oak in such a way that the grain, texture and colour of the wood complement the theme. City of Mildura Arts Centre

27.56 (top right) John Coburn, *Summer*, 1980. Silkscreen print. Coburn uses non-representational symbols to convey ideas. Private collection

27.57 (lower left), Clement Meadmore, *Curl*, 1969, in the grounds of Columbia University, New York. A non-objective work of welded steel sheets and painted black. It is hollow.

27.58 (lower right) John Perceval, *Acrobat Angel*, 1958. Glazed ceramic. One of a series of amusing ceramic angels made by Perceval, one of the Antipodeans, and perhaps better-known as a painter. The Antipodeans rejected abstract art. The Art Gallery of New South Wales

One Australian painter, John Peter Russell, was actually in the thick of the *avant-garde* movements in Europe at the turn of the century, however. Russell (1858–1930), a contemporary of Streeton and Roberts, lived mainly in Europe from 1880 to 1921 and became a close associate of van Gogh, Gauguin, Monet, Rodin and Matisse. He married Mariana Antoinetta Matiocco, one of Rodin's models, in 1888 and, having independent means, established a large house in Belle-Île, Brittany, where he entertained many of his artist friends. It appears that influence among them was mutual (**1.16, 27.34**); however, because he lived out of contact with art in Australia for so long, he made no contribution to its development.

A number of Australian women artists spent a good deal of time studying Post-Impressionist and Cubist art in Europe in the period between the two World Wars and painted excellent and relatively advanced pictures which were, however, little appreciated at the time by the conservative Australian public. These include Margaret Preston (1883–1963; **27.37**); Bessie Davidson (1879–1963), whose work hangs in French galleries and who was awarded the Legion of Honour in 1931; Grace Crowley (1891–1979); Dorrit Black (1891–1951); Grace Cossington Smith AO (b. 1892); Norah Simpson (1895–1974); and Kathleen O'Connor (1876–1968).

27.59 Margel Hinder, *Captain Cook Fountain*, Newcastle, 1961–66. The abstract copper forms are only part of this fountain — the rest is the water, the disposition and movement of which the sculptor also designed. The combined effect is well illustrated in this photograph by Ellen Waugh.

27.60 (lower left) Lenton Parr, *Orion*, 1963. Welded steel. National Gallery of Victoria

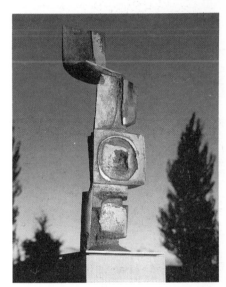

27.61 Norma Redpath, *Dawn Sentinel*, 1963. Bronze. 204 cm high. It is evident that Redpath models directly in plaster — not clay — and casts the bronze by the lost wax process. National Gallery of Victoria, Felton Bequest

Better known as a teacher of others and as a founder of the Contemporary Art Society of Australia than for his own paintings, the Victorian George Bell (1879–1966) was one of the first to understand the art of the twentieth century. In Europe he came into contact with the art of the Post-Impressionist painters and transmitted their values to young Australians, many of whom are now our leading painters. A similar role was played in Sydney by Julian Ashton (1851–1942).

Just before the Second World War and immediately after it a number of European artists migrated to Australia and greatly contributed to its cultural life in the 1950s and 1960s, although some of them received their initial art training in Australia and not in Europe. They will be recognised among those listed below by the un-Anglo-Saxon ring of their names.

During this period, one of the most famous painters in Australia was Sir William Dobell (1899–1970), and he is still generally recognised as one of our best portraitists (**27.41**). He painted in a highly original style in which thin paint and impasto were laid alternately on smallish hardboard panels in well designed compositions. He was a fine draughtsman and his penetrating characterisations were achieved through clear

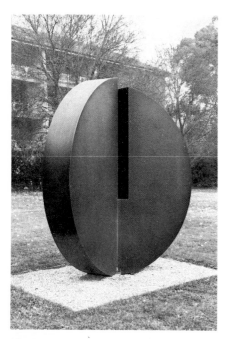

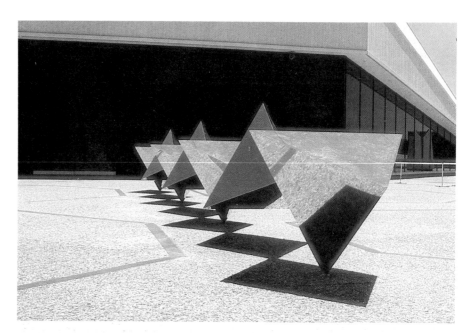

27.62 (top left) Inge King AM, *Black Sun*, 1977. Welded steel, painted. University House, Australian National University, Canberra

27.63 (top right) Herbert Flugelman, *Festival Sculpture*, 1974. Stainless steel. Adelaide Festival Centre Plaza. 2073 cm long. A simple string of triangular pyramids, but their arrangement and the reflective surface makes a sculpture of complexity and beauty.

27.64 Kenneth Unsworth, untitled stainless-steel sculpture, Australian National University, Canberra. A deceptively simple arrangement of three curved slabs of steel held in tension by steel cables.

observation and some distortion of natural appearances in the manner of the Expressionists. Some of his best portraits are: *The Strapper* (Newcastle City Art Gallery); *Margaret Olley* (Art Gallery of New South Wales); *The Billy Boy* (Australian War Memorial, Canberra; **27.41**); and *Portrait of an Artist*) which touched off a famous controversy when it was awarded the Archibald Prize in 1944.

The major interest of Sir Russell Drysdale (1912–81) was capturing the essence of the outback people and landscape. His style, though highly original, shows the influence of Cubism in its bold simplification and strong, balanced design, and also of Surrealism in his handling of the mystery of the ancient landscape. Good examples of his work are *Albury Station, The Rabbiters* (both in the National Gallery of Victoria), *Snake Bay at Night* (Tasmanian Art Gallery), and many other pictures in which people are placed against the harsh background of the inland (**27.39**).

Sir Sidney Nolan (b. 1917) was the first Australian painter to achieve a

27.65 Margaret Dodd, *Holden Bride*, 1976–77. Glazed ceramic with fabrics. One of a series of characters which the artist made for use in her film, *This Woman is Not a Car*. Both the film and the Holdens are amusing and disturbing at the same time — as was Dada (see page 160).

world-wide reputation. He has a remarkable ability to originate powerful imagery which he records with a free, expressive, and seemingly careless technique (**27.49**). His paintings have appeared in series — some the result of journalistic wanderings in lands as remote as Africa and Antarctica — others illustrating the experiences of people from Australia's history. The first of these was the Ned Kelly series, but perhaps the most moving is that inspired by the Gallipoli episode of the First World War.

Dobell, Drysdale and Nolan are by now well known, but other Australian contemporaries of talent are less so. Those practising various forms of non-figurative painting and romantic abstraction include Ralph Balson (1890–1964), Ian Fairweather (1891–1964), Maximilian Feuerring (b. 1896), Guy Grey-Smith (1916–81), Margo Lewers (1908–78), John Passmore (b. 1904), Carl Plate (1909–77), Stanislaus Rapotec (b) 1913), Eric Smith (b. 1919), John Coburn (b. 1925), Lawrence Daws (b. 1927), Leonard French (b. 1928), Thomas Cleghorn (b. 1925), Frank Hodgkinson (b. 1919), Elwyn Lynn AM (b. 1917), John Olsen (b. 1928), William Rose (b. 1930) and Henry Salkauskas (1925–79).

Contemporary painters whose work is mainly figurative and in the expressionistic tradition include *the Antipodeans*: Charles Blackman OBE (b. 1928), Arthur Boyd (b. 1920), David Boyd (b. 1924), John Brack (b. 1920), Robert Dickerson (b. 1924), John Perceval (b. 1923), and Clifton Pugh (b. 1924); also Jon Molvig (1923–70), Albert Tucker AO (b. 1914), Joy Hester (1920–60), and Frederick Williams, OBE (1927-82).

Danila Vassilieff (1897–1958), Yosl Bergner (b. 1920) and Noel Counihan (b. 1913) are Social Realists and James Gleeson (b. 1915) and Jeffrey Smart (b. 1921) are Surrealists.

Dr Lloyd Rees (b. 1895), Sali Herman OBE, CMG (b. 1898), Jack Carington Smith (1908–72), Ray Crooke (b. 1922), Mervyn Smith (b. 1904), David Strachan (1919–70), Sam Fullbrook (b. 1927), Horace Trenerry (1899–1958; **1.11**), Janet Dawson (b. 19), Elaine Haxton (b. 1909), Donald Friend (b. 1915), James Cant (1911–1982) and Brett Whiteley (b. 1939) all work in the realist tradition but each has a highly individualistic style and approach.

The influence of Op Art and the combination of visual and auditory

material in 'sound-and-image' performances and 'environments' are shown in the work of Stanislaw Ostoja-Kotkowski (b. 1922).

Sculpture

Very little sculpture was made by Australians in the Colonial and Middle Periods. Practically all official monuments, such as war memorials and statues of great leaders, were commissioned in Europe. However, two Australian sculptors of note during this time are Sir Bertram Mackennal (1863–1931) and Rayner Hoff (1894–1937).

There was no parallel in sculpture to the Heidelberg School in painting and contemporary European influences were only felt when Australians returning from study in Europe joined the Europeans migrating to Australia from the late 1930s to the 1950s. Since then Australian sculpture has mainly followed European twentieth century trends.

The two most famous Australian sculptors of the 1950s and 1960s are Lyndon Dadswell (b. 1908) and Tom Bass (b. 1916), both of whom produced mainly cast work in a variety of media. Their styles reveal a deep respect for the inherent qualities of materials, as well as sympathy with, and emulation of, archaic Egyptian and Greek sculpture. Both have produced a good deal of work for government and commercial buildings all over the country. Bass's style is perhaps more abstract than Dadswell's, and he developed a method of casting in metals by electroplating the inner surface of a mould.

Sculptors prominent in contemporary Australian sculpture include Ola Cohn (1892–1964), Daphne Mayo (b. 1897), Victor Greenhalgh (b. 1900), Gerald Lewers (1905–62), George Allen (1900–72), Margel Hinder (b. 1906), Danila Vassilieff (1897–1958; see **27.43**), Andor Meszaros (1900–72), Clifford Last (b. 1918), Kathleen Shillam (b. 1916), Leonard Shillam (b. 1915), Vincas Jomantas (b. 1912), Teisutis Zikaras (b. 1922), David Boyd (b. 1924), Owen Broughton (b. 1922), Steven Walker (b. 1927) and Norma Redpath (b. 1928).

Inge King AM (b. 1918), Lenton Parr (b. 1924), Clement Meadmore (b. 1929) and Ron Robertson-Swann (b. 1941) work mainly in welded steel and Robert Klippel (b. 1920) welds collages from junk metal. Herbert Flugelman (b. 1923) and Kenneth Unsworth (b. 1931) make constructivist sculptures in stainless steel, and George Baldessin (1939–78) casts figures in aluminium.

Michael Kitching (b. 1940), Colin Lanceley (b. 1938), Alekzander Danko (b. 1950) and Margaret Dodd (b. 1941) work in styles which show the influence of Dada and Pop Art.

Ewa Pachucka (b. 1936) crochets and stuffs human and animal figures.

Things to do

1 From books in the library, find out more about at least one painter, sculptor and architect from each period.

2 Find pictures of as many of the buildings, paintings and sculptures mentioned as you can in books in the library.

3 Try to discover the location of any works by artists mentioned in this section in your district or town.

4 Try to find examples of all the architectural styles mentioned in this chapter in your district and make sketches of them.

5 Paint a landscape that you know well and try to make it appear typically Australian.

Index

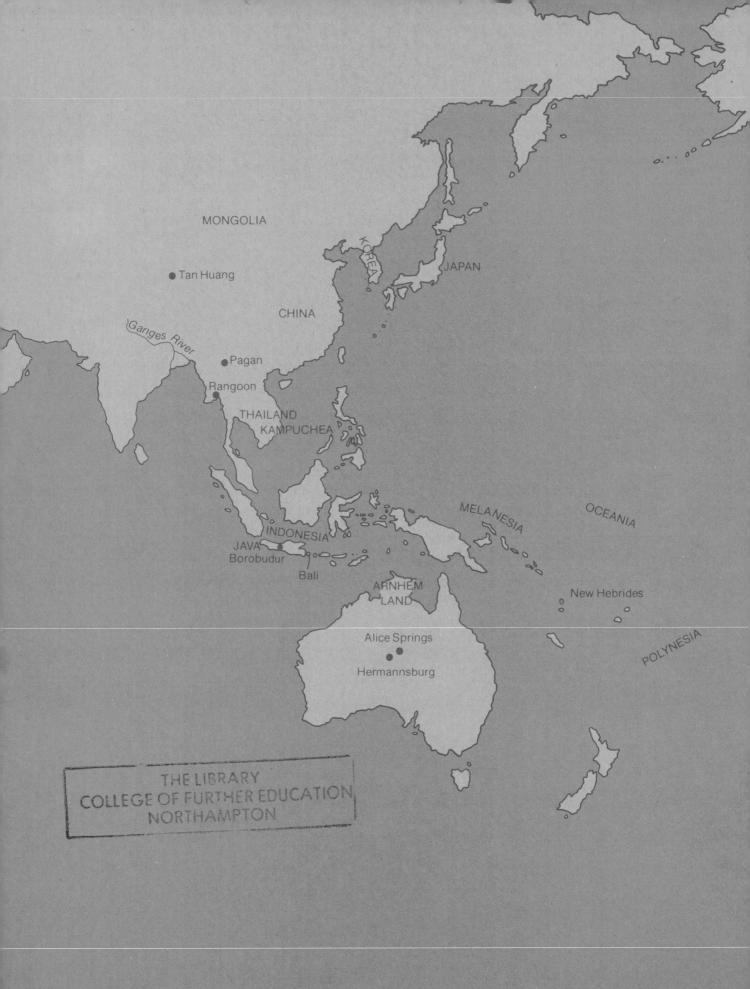

MONGOLIA

● Tan Huang

CHINA

KOREA

JAPAN

Ganges River

● Pagan

Rangoon ●

THAILAND
KAMPUCHEA

INDONESIA

MELANESIA

OCEANIA

JAVA
Borobudur

Bali

ARNHEM
LAND

New Hebrides

POLYNESIA

Alice Springs
●●
Hermannsburg